MOST
OUTRAGEOUS

The Trials and Trespasses of Dwaine Tinsley and Chester the Molester

Bob Levin

FB

This book is for everyone at Fantagraphics — editors, publicists, others — whose encouragement over the years gave me the confidence — and freedom — to write what I wanted to write how I wanted to write it. In particular, I want to thank Gary Groth, whose vision — implemented through his work as a publisher and editor and writer — of what art is about, is as inspiring a one as any author could desire.

Or as Oliver Hardy said, "Here's another nice mess you've gotten me into."

Edited by Kristy Valenti | Designed by Adam Grano | Promotion by Eric Reynolds | Published by Gary Groth & Kim Thompson | *Most Outrageous* is copyright © 2008 Bob Levin. This edition is copyright © 2008 Fantagraphics Books. All rights reserved. Permission to quote or reproduce material for reviews must be obtained from the author or the publisher. Fantagraphics Books, Inc. 7563 Lake City Way, Seattle, WA 98115 | To receive a free catalogue of fine comics and books, call 1-800-657-1100 or visit our website at Fantagraphics.com | Distributed in the U.S. by W.W. Norton and Company, Inc. (1-212-354-5500) | Distributed in Canada by Raincoast Books (1-800-663-5714) | Distributed in the UK by Turnaround Distribution (1-208-829-3009) | Distributed to comics stores by Diamond Comics Distributors (800) 452-6642) | ISBN 978-1-56097-919-7 | Printed in Canada

"let's start a magazine
to hell with literature.
we want something redblooded
[...]
reeking with stark
and fearlessly obscene

— *From a poem by e.e. cummings, framed in silver, seized by police in the home of Dwaine Tinsley, for use as evidence against him.*

Ridicule is a distinct kind of expression; its substance cannot be repackaged in a less offensive rhetorical form without expressing something very different from what was intended. That is why cartoons... have for centuries... been among the most important weapons of both noble and wicked political movements.
— *Ronald Dworkin.*

Only by examining the most extreme factions of our culture can we really understand ourselves.
— *Douglas Wright, quoted in a journal of Dwaine Tinsley's.*

INTRODUCTION

I had no idea what to do next.

For fifteen years, while practicing law in Berkeley, I had been writing about cartoonists for *The Comics Journal.* It had become apparent early on that the more off-beat the cartoonist was in his life or art, the more I would be drawn to him. Once my bias had become clear, someone at the *Journal* would have another cartoonist for me: a schizophrenic and an alcoholic and a speed freak and a suicide and a misanthrope and one fellow whose career off-tracked when he became a woman. Their work was often grotesquely violent, often bizarrely sexual. If there was an envelope to push, it was shoved with both hands. If there was a toe to step on, it was stomped with both boots. (Often these hands were bloody and these boots hobnailed.) I championed such work. I cheered such excesses. My point — laced with my own inappropriate humor and over-the-top effronteries — became that it was not the peculiarity of the personality that mattered but the value of the art and that this value heightened when the vision that produced it was extreme.

The attraction to me of espousing this belief, I suspected, lay in the stature I derived, at least in my own eyes, from connecting to the outlaw. I lived a life of modesty. The same wife for thirty-five years, the same house for thirty, the same car for twenty-five, the same office for twenty. I did not drink. I took a hit from the passing joint, maybe, once a year. Double espressos, I liked to say, were my last remaining vice. I required something more to set me apart from a culture that seemed as lethally seductive as flypaper, from a society that blithely returned to office those who seemed determined

to bomb and pollute their way across the twenty-first century. I admired the way these voices said, "We are not you. You are not us."

"You have never seen anything like it," I had said to Robert the K, a glass artist and critic whose idea of a good time was attending four operas and three museums during a week in New York City. We were on our weekly walk, coming down a steep hill under grey skies in Tilden Park. Overhead, a solitary turkey buzzard hovered on the breeze. The "it" to which I referred was the scene the previous Sunday in *Deadwood* in which Al Swearengen, the saloon-and-brothel owner, bloody from his beating by the marshal, wracked with the pain of his inflamed prostate, declaims his acerbic view of the world while being fellated by a whore.

"Is that a true ground for artistic measure?" Robert said.

"Absolutely," I said. "That's the job of art. Show things that have never been seen. Say things that have never been heard. Explode people's heads."

"Do you ever feel a disconnect," he said, "between yourself and these people and activities you write about? You are such a gentleman in other areas. It's a question I often ask myself."

It was a question I did not. But in early 2005, following the completion of a piece on Vaughn Bode, I was stuck. Bode, a successful and influential cartoonist of the early 1970s, had been a bisexual, sadomasochistic transvestite who believed he was the Messiah, and had died of autoerotic strangulation. It had been a wonderful and thrilling article to write. But it wasn't like I could now write about a cartoonist who was *only* a bisexual sadomasochist. My job — my aesthetic position — required the continual breaking of new ground.

Then, Eric Reynolds, publicity director for Fantagraphics, the company that publishes the *Journal,* e-mailed me: "I think I've found your next subject, Bob." Attached was a two-year-old Internet posting commemorating the third anniversary of the death of Dwaine Tinsley, a cartoonist for *Hustler* magazine, whose major creation had been "Chester the Molester," a monthly jest steeped in pedophilia, which had been nipped in mid-flowering when the cartoonist had been accused by his oldest daughter of several years of sexual abuse.

"Whoa!" I thought. "Are you sure you want to go there?" I could see the angry villagers, led by Andrew Vachss and Bill O'Reilly, marching on my

castle, brandishing their torches and pitchforks.

Then I thought, "If you believe what you have been writing, you have to write this story. This is absolutely your next step. This is what you have been put on earth to do."

A few weeks later, Gary Groth, the *Journal*'s editor-in-chief, called. "What are you working on?" he said.

I told him I had been thinking about Tinsley.

"I met his widow at a convention recently. She wanted me to do a collection of his cartoons. Really vile stuff. Want her number?"

I carried it around in my wallet for a few weeks. Once I checked the area code and saw it was Louisiana. "Great," I thought. "The cost of interviewing her will be more than the *Journal* will pay. Besides, she probably won't want to revisit the subject."

Then, late one afternoon, I called.

Three weeks after that, my wife Adele and I arrived in New Orleans. Our first night, we ate at a restaurant where several adjoining tables had been covered with sheets of newspaper. When the last of about two dozen young men had been seated — in town, it turned out, for a bachelor party — for a bachelor party for a wedding to be held in *Minneapolis* — the waiters dumped bins of crayfish on the table. Then they dumped shrimp on the crayfish. Then they dumped crab on the shrimp. Being from the Bay Area, the way of life in other cities does not often impress us. But New Orleans kicked our ass. There was the cultural mix: French and Spanish; Caribbean and African. There was the music roaring from the bars — bars already open at 7:00 A.M., when we left our hotel in pursuit of egg-white omelets. There were the cemeteries roosting their dead above ground, more firmly planting them in sight and mind than did their more customary billeting. There was the Mississippi — Huck Finn's Mississippi — the Mississippi that brought Chicago jazz — that utterly myth-resonant Mississippi, wide and dark, rushing past and vanishing into the gulf. Turn the corner and there was a bluegrass band or an illusionist or a hip-hop acrobatic troupe or a man or a woman, motionless, mute, made up to replicate a Greek god or plantation lady, to be observed or posed beside for a (hoped-for) donation. Each act was so skilled you might have been strolling through a fresh air *Talk of the Town*. Each

was so startling — if a shade shabby, if the illusionist's cuffs were somewhat frayed, if the silver paint on Hermes did not quite erase the desperation that froze him on his corner — that they seemed a civic planner's slap into *satori*, designed to rouse one from fixation on the common into the richness and unpredictability of life. ("And in Berkeley," Adele said, "they expect a quarter if they say, 'Nice hat.'") One night, in an occult shop off Rue Chartres, I purchased an African clawed frog — gigantic, hideous — pickled in formaldehyde. "Not to be taken internally," the pierced-and-tattooed salesman said. "May cause hallucinations, convulsions and death."

Ellen Tinsley lived with Mike Campbell and three dogs in Jefferson Parish, twenty minutes outside the French Quarter. The living room, with its stacks of CDs — Robert Johnson and Emmylou Harris and John Prine — and its bookshelves filled with the accumulations of decades — Dorothy Parker and W.H. Auden and a warts-and-boils biography of J. Edgar Hoover — would not have looked out of place on our block.

Mike, who is one size short of leading sweeps for the Dallas Cowboys, had a shaved head and Fu Manchu mustache. A former inspector for the Texas Food and Drug Administration, he had decided in his mid-forties to become a Delta blues musician. Now he played in front of the courthouse on Royal Street. When tourists give Mojo, one of the dogs, a dollar, he put it in Mike's hat. Ellen, a handsome, red-haired woman from the Smokey Mountain region of North Carolina, wore a washed-out tank top, black jeans and sandals. She had come out of the University of Connecticut in the late 1960s to work with multiply handicapped children in the Detroit ghetto. Her father, a Lt. Commander in the Navy, was descended from Harry Morgan, the pirate, and Charles Kingsley, co-founder of the Christian Socialist movement. Her mother's family had followed *The Mayflower* into port; and, later, the process of "civilizing" the natives had brought some Cherokee genes into her mix. She was a Daughter of the Republic, a Daughter of the Confederacy, and a former Miss Country Club, who describes herself, with a wicked smile, as someone who could be "a perfect lady in public, but, then, close the door…"

Ellen was neither the mother of the daughter who had brought the charges against Dwaine, nor the woman to whom he had been married when the offenses were said to have occurred. But she had been married to him the

last five years of his life; and she fervently believed him the innocent victim of a vengeful, drug-addled young woman, a politically ambitious district attorney, and the lynch-mob mentality of an ultra-conservative community. She had attempted, unsuccessfully, to interest other writers in Dwaine's story and, when that failed, to write it herself. Now a mammogram had revealed a lump upon which a biopsy had been inconclusive. "You have made my Monday," she had said when I called.

Ellen had sent me twenty-five pages she had written, so I knew she considered Dwaine to have been a wonderful husband, a fine father to his two other daughters, and a masterful satiric artist, who had lifted himself, through extraordinary effort, from dire poverty to a professional peak. He was also "an enormously complex man," "a non-stop talker, [who] in a five minute conversation could tell you a truly awful joke, discuss Monet's use of light, dispense 'Uncle Dwaine' advice, and give you the latest in political intrigue," someone who "mixed a massive vocabulary with a gutter mouth," who "read everything from cereal boxes to Sartre," who "laughed as easily as he cried," who was "quick to anger and to admit mistakes," who had friends "from every ethnic background, all different colors, sexual orientations, economic groups, and social classes," who was "as comfortable with auto mechanics as he was with movie stars." Now she asked why I was interested in him.

I told her about cartoonists with extreme visions and extreme lives.

She and Mike waited for something more.

"I don't have an agenda," I said. "This will be a lot easier to write if I believe he didn't do it; but, right now, I don't know. All I can promise you is an open mind."

Ellen answered my questions for two hours. Then she asked us to dinner. Mike had smoked a turkey. Ellen had made red beans and rice. After dinner, she invited us into the garage. When we left, we took away two storage boxes filled with Dwaine's case documents and personal papers. Back in our motel, two items caught my eye. One was a picture of Dwaine and his daughter. She is in her teens, when the abuse was supposedly raging. She is seated behind him on a rock. Both her arms are thrown around him and her chin rests on his right shoulder. She has a broad smile and he a light one. She appears totally relaxed, totally at ease, totally trusting. The other was a shot of Dwaine and Ellen. He is nuzzling her neck from behind. Both his arms embrace her and she holds one of his hands. Deep affection fills both their eyes. "This is

a man who desires women," Adele said, "not little girls."

I was happy to hear that. However it turned out though — whatever madness or perversion explained the behavior at the story's core — it could not be treated with my accustomed style. Whether I was to meet a bestial father or deranged daughter — whether I was to find doubloons in the storage boxes or Pandora's demons — I saw pain and tragedy dripping from this tale like Spanish moss. I heard shrieks and moans and skeletons rattling and garments rending. I saw no place for humor — no room to layer in effrontery. I felt terribly excited. I felt the thrill of entering the realm of the taboo. I felt like a character in a Hitchcock movie, drawn into a plot over which he has no control, headed for a destination he cannot foretell.

Across the room, the frog grinned through its formaldehyde cloud.

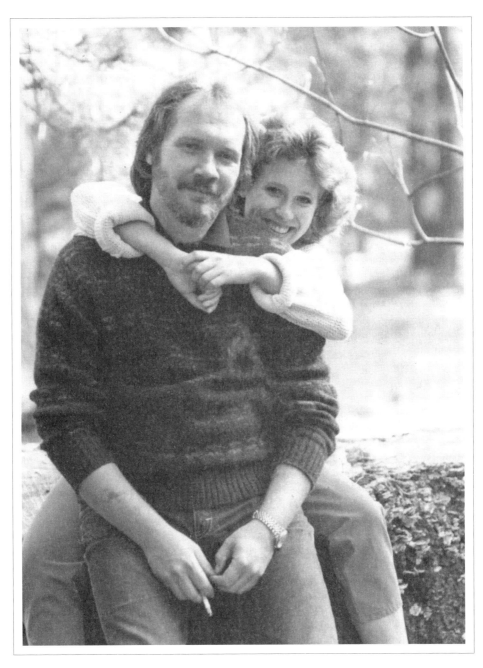

Dwaine and "Veronica" in 1985: photo taken by John Billette.

PART ONE

1

At 2:03 P.M., on May 18, 1989, two detectives of the Simi Valley, California, police department followed a year-old, black Mustang from its owner's home — a single-story, yellow stucco building, with white wood trim and brown asphalt-and-tile roof — at 3091 San Angelo Street. The detectives had been detailed to that house an hour-and-a-half earlier and instructed to arrest anyone who left. The Mustang turned right on Corpus Christie, left on Walnut. One block later, at the intersection with Travis, the police brought it to a stop.

The Mustang's driver, Dwaine Beverly Tinsley, was forty-four years old. He was six feet tall and weighed one hundred ninety pounds. He had collar-length, bushy brown hair and a full, close-cropped beard. His brown eyes had a roguish glint. (People often said he resembled the wild-living former Oakland Raiders quarterback Kenny "Snake" Stabler.) He wore a blue shirt, black sweatpants, white shoes. He had a gold chain around his neck, a gold bracelet on one wrist, and a gold earring with a diamond stone. Tattooed on his left arm were the devil and a heart with a dagger through it. Tattooed on his right was a spider. He gave his occupation as "cartoonist" and his employer as Larry Flynt Publications, Beverly Hills. His off days and work hours were noted to "vary." The Arrest Report described him as "conservative" in appearance, "nervous" in demeanor, and "talkative."

But after being advised that he was being charged with four felonies — child molestation, oral copulation, sodomy, and penetration with a foreign object — he responded, "I think I need to talk to my attorney." When he was

told that the complainant was his eighteen-year-old daughter Veronica,[1] he not only denied the charges but stated that she was a cocaine user retaliating for his having kicked her out of the house. She and Steven Gold, her twenty-five-year-old boyfriend — and a small-time drug dealer — had fabricated this story in an attempt to extort from him two thousand dollars and a car.

An Isuzu that had thrown a rod.

Veronica Tinsley was five foot four and weighed one hundred five pounds. She worked as a waitress at the Lamplighter, a coffee shop in nearby Chatsworth. She had dark brown eyes, curly, light brown hair, and a body that, in her words, "turned men on." (She was "striking," people said. "Almost too pretty," they said. "I'd do her," is how a colleague of Dwaine's at LFP put it. "Not if I was her dad.") The day before, she had called the Simi Valley police and reported her father had been abusing her for seven years. Detective Gary Galloway of its Sexual Assault Section had immediately arranged to interview her at her apartment.

Galloway is broad-shouldered and soft-spoken, with a faint stammer. He wears glasses and has a mustache and close-cropped gray hair. His mind is open to the probing of interesting corners of human behavior, and he possesses enough dash to allow him to sport a Dirty Harry necktie to an interview with a visiting writer. Veronica told Galloway that, when she was eleven, she had come from South Carolina, where she lived with her mother, to visit her father. The night before she was to fly back, he took her to the Sheraton near the Los Angeles International Airport, where he fondled her and penetrated her digitally. Veronica's mother was physically abusive, so, on May 2, 1983, she had come to live with Dwayne, his second wife, Debbie, and their four-year-old daughter, Lori, in Sherman Oaks. Two weeks after that, shortly before the family moved to Simi Valley, her father forced her into oral copulation and sexual intercourse. This behavior continued, approximately three times a week, for the next three years. During this time she was "constantly exposed to pornographic material," to which her father, as the cartoon editor of *Hustler* magazine and creator of Chester the Molester, had unlimited access. Many of her father's cartoons depicted sexual encounters that had

1. This is not her real name. I have changed it, as well as those of her friends, her mother, stepmother and step-sisters. I have also altered biographical facts about these people which do not impact upon the events of my story.

occurred between them. Many times he posed her nude while he held his Nikon or Minolta and, she assumed, took pictures. Many times she heard him tell co-workers, "You can't write this stuff if you don't experience it." In late 1986, when Debbie was in Virginia for a funeral, she and her father engaged in intercourse and oral copulation every night for three weeks. Once he penetrated her with a vibrator. Once he sodomized her. When she was sixteen, he put her on the pill. He tried to prevent her from dating; but when she turned eighteen, she left home and moved in with Steve Gold. He had convinced her to report her father to the police. She had been too frightened of her father to do this before — and she had not wanted to be sent back to live with her mother; but now she wanted to protect Lori.

The only charge Dwaine would ever even partially credit was the episode at the LAX Sheraton. Among the papers Ellen Tinsley had given me, I found a portion of a draft of a narrative Dwaine had written for the county probation department. In it, he describes checking in, dinner, watching TV in the room, ordering champagne — and allowing Veronica two glasses. The next morning, the wake-up call came. "Semi-awake," he writes:

I lay there and felt a warm soft feminine body pushed against me. I cuddled and stroked the legs and hips. Suddenly I sprang awake and jumped. I realized it was Veronica — my daughter! I was mortified. If fondling her — unknowingly — weren't bad enough, I had a semi-erection.... Nothing was ever said to anyone about this. I was so ashamed I dared not discuss it. This whole episode bugged me for many years. I finally came to grips with the fact that I had done nothing wrong. I certainly wasn't in command of my faculties. My conscience is clear about this but some guilt lingers.

Dwaine's willingness to confront this incident — even on paper — may deserve commendation. His admission — even if never passed to a third party — may fortify the believability of his other denials.[2] But his behavior may also cause eyebrows to be raised. Certainly, it raised Adele's. "Someone who wakes up in a state where he doesn't know whose bed he's in and whose

2. In the version of the letter Dwaine sent, all that occurred post-champagne was that he and Veronica talked, watched more TV, and went to sleep. "I categorically deny that anything improper happened between us," he reassured the probation department.

hips he's stroking," she said, "was in *quite* a state when he went to bed. And I am not at all convinced we can take that person's word for what he did before he got there."

The day following Veronica's charges, at about 12:30 P.M., Galloway had her make what is known as a "cool call" to Dwaine from the police station. Galloway told her to have him admit the abuse but not what to say or how to say it. The conversation, which Galloway taped, went like this:[3]

"Hello."

"Hi."

"Who's this?"

"Veronica. How you doing?"

"I'm all right. Where are you?"

"I'm at work."

"What do you want?"

"I just wanted to talk, say hi, and, you know, I was just concerned about what you all are doing these days."

Dwaine did not say anything.

"What's wrong?" Veronica said.

"Nothing. I just don't have much to say to you. I have been going through a lot of heavy shit between you and Steve in the last couple of months."

"Why? You haven't heard from us."

"You still with him?"

"Yeah. Things have been fine. I am not living with him anymore. I am trying to get my own place. But we're still together. How's the baby [Kimberly, Dwaine and Debbie's second daughter]?"

"She was born Tuesday. Nine pounds, fourteen ounces. She's fine."

"How's Lori?"

"Pretty good."

"She ever say anything about me?"

"No. Lori doesn't talk about you, Veronica."

"How about you? Do you miss me?"

"Of course I miss you. Sweetie, I miss you more than words can say."

"Yeah. Well, I have just been afraid to talk to you."

3. This conversation — and portions of the court transcripts quoted later — has been edited slightly.

"Why, honey?"

"Well, I have been thinking about things that went on and I have been trying to establish a relationship with my mother, you know, because I have been trying to think about things."

"Yeah, things have been kind of weird for about the last year."

"I am not talking about my problems. I am talking about us."

"I don't know what you are talking about."

"Yes you do. I would like to talk privately."

"Where you working?"

"The Lamplighter, DeSoto and Parthenia. I have a very good job. I am making a lot of money. It's just, you know, I don't have a place to stay or anybody to really talk to. I have friends, but I have been having problems. I am not happy at all about things that have happened between us."

"Well, you know, Veronica, what I don't understand is this. You and I had a perfectly wonderful relationship for three years, and then suddenly you got into the drug scene, and everything just went so goddamn downhill. Now, I don't think you realize how incredibly hard it was for me to ask you to leave, but you've got to understand, you've got your own life to live, and I am not going to stand in the way of it."

"I understand this. You are standing in the way of a big problem in my life. Things are really starting to come to my mind and really hurt me mentally. I've had a very tough time controlling things, and I am talking about the sex."

"Veronica, I don't want to talk about that. I don't want to talk about that at all."

"Well, I want to talk about it."

"If you want to talk about it privately…"

"We can talk 'cause right now there is no one here, and I want to talk about it. I've no one to talk to, you know. I know in the past I've threatened about it, but I'm thinking more along the lines that I have to see someone about it because I am having nightmares every night."

"Veronica, I'm not going to go into it. I'm not going to go into it."

"Then I'm going to have to go into it somewhere else."

"I don't understand where you are coming from."

"You know. I have to…"

"I want to explain something to you, Veronica. Understand this. I gave

you my heart. I gave you my soul. As a matter of fact, I gave you entirely too much, okay? I am so incredibly hurt that I find it damn difficult to deal with sometimes."

"Why were you hurt?"

"I could see what the drugs were doing to you, Veronica. I told you, you know, you and I need to re-establish some humor in our relationship, because if there is one thing that you and I always had, sweetie, that was the fact that we could talk to one another, that we could be friends to one another, and that we could deal with things, you and I, as long as we could talk about it. But you started closing me off, and that mental anguish that I went through was more than I could stand. I asked you… I said, Veronica, how would you describe our relationship, and you said pretty shitty. I said okay. I said what would you think was the reason for that, and you said the drugs, and you know what? You put your finger on it. So what's happened is I finally had to make up my mind about what I was going to do and that was that I was going to have to turn you loose if you were going to trash yourself. If you were going to go for it, then I couldn't stand in your way, sweetie. I told you long before, and I mean it. I mean it. I mean it to this day. Go ahead and trash yourself if you want. I will always be there to help you pick up the pieces."

"Well, the one thing I would like to know is who is tooken [sic] my place?"

"I don't understand what you are saying."

"You understand."

"Nobody's taken your place, Veronica."

"You understand what I am trying to say."

"Veronica, listen, nobody has taken your place. Nobody could ever take your place."

"How do you think that I can go through, day to day, thinking that I had a sexual relationship with you?"

Dwaine sighed.

"It's hurting me," Veronica said. "It's eating me up inside. That's the only thing I can think about."

"Then I suggest you stop thinking about it. I have. But let me say this, Veronica…"[4]

4. Detective Galloway considered this the "key" exchange in the conversation. In standard cool-call practice, the victim solicits help from her molester to afford him the chance to control the

7.

"You can just… You can just forget about it? You can just…"

"Veronica, listen. I am not going to talk to you about this over the phone. If you want to meet me somewhere and you and I talk, fine. I'll go for that, but I am not going to carry on a conversation like this over the phone."

"Okay."

"Now let me explain something to you, sweetie. After our little meeting at the hospital, when you started grandstanding on me, I was there for you. I didn't come there to argue with you. I was there for you, and I know that, when Steve was out of the room, you were just as sweet as you could be to me, and as soon as they wheeled him back into the room, you started playing him against me, Veronica. I still don't know why."

"I don't think Steve has anything to do with this."

"Steve doesn't have anything to do with everything? Hold on. Are you there?"

"Yes."

"I am going to tell you something. I've had a little talk with your momma Debbie.[5] I mentioned to her the conversation the last time we were on the phone about everything that came down. Your momma Debbie doesn't believe anything. She doesn't want to believe it, and that's as it should be. Your mama says she tried for about three or four days to call you, okay, and then she realized that you were so caught up into a drug situation that she couldn't talk to you; but your momma Debbie basically said that as long as you stick to that story, you're not welcome in that house."

"That's fine. But look, I have to go back to work. I want to think about this. I really want to talk to you about it, okay?"

"Okay."

"I'll meet you in person. I'll think about it, and I'll call you back."

"Well, Veronica, I'm going to be in and out. I'm going to be in and

situation. Here, Veronica had expressed her pain; and Dwaine, instead of suggesting she seek help, had urged silence. Dwaine would explain his response by saying that Veronica had accused him of sexual misconduct before, and since this misconduct had never occurred, he could not have thought about it; so his suggestion that she "stop" such thinking as well was simply an example of his sarcastic humor.

5. In this portion of the transcript, the typist recorded Veronica as having said "your mom and Debbie." But Veronica referred to her step-mother as "momma Debbie," and given the singular verbs in the sentences that follow — not to mention Dwaine's relations with Veronica's mother — I believe my version is accurate.

out."

"But, look, I want you to know one thing."

"I love you too."

"No. I didn't like the sex. I just want you to know that, okay?"

Dwaine did not say anything.

"Do you have anything else to say?"

"Yeah. I just said I love you."

"Okay. Bye bye."

Though Dwaine had not admitted a single instance of abuse, Galloway was satisfied. He thought Dwaine had "sidestepped" Veronica's accusations. "If it had not happened," he now says, "I would have expected a flat-out denial." He would have expected a "What're you talking about?" Instead, Dwaine had delivered "I'm not going to go into it" and "I don't want to talk about that." Galloway believed he had "a confession by omission." Certainly, looking at the cool call from the vantage point of Veronica's accusations, as Galloway did, it is easy to share his conclusion. (Even viewed from a more neutral plane, one might conjure up visions of father and daughter at coital play.) But if one were to filter the conversation through Dwaine's later explanation — that Veronica's drug use had worried him for months, that she and her boyfriend had already threatened to find ways to hurt him, that he could not be sure exactly what she was saying or why she was saying it — the conversation assumes a less definitive cast.

Once Dwaine had been brought to the Simi Valley police station, Detective Galloway obtained a search warrant for the premises and grounds of 3091 San Angelo. The warrant sought photographs or video tapes of Veronica, nude; photographs, film, video tapes, books, magazines, or other publications depicting sexual acts involving children or which depicted children fully or partially nude; copies of *Hustler* that contained Chester the Molester cartoons; notebooks with ideas for or sketches of cartoons; cameras or photographic equipment; a vibrator; any writings by Dwaine describing sexual relations with Veronica.

In his declaration establishing good cause for the issuance of the warrant, Galloway noted he had been a police officer in Simi Valley for eight-and-a-half years. For the last two he had been a detective in Sexual Assault. He had investigated over one hundred twenty sexual assault or child abuse cases. He

had attended seminars and conferences and had over eighty hours training in the investigation of such cases. He was "thoroughly familiar with the manner in which sexual offenses are committed; the method of operation used; and all aspects of the commission of sexual offenses." Based on his training and experience, he believed that a search would yield nude photos of Veronica and her "encounters" with her father. He had learned "that child molesters usually collect and keep pornographic material which they use for their own self-gratification and lowering the inhibitions of their prospective victims... that [they] rarely, if ever, destroy any pornographic photo they may have of their victims... [and] often keep writings and description of their sexual activity with their victims."

The warrant issued at 5:15 P.M., and at 6:30 four policemen searched the Tinsley residence. They found dozens upon dozens of magazines, mostly *Hustler* and others that were sexually explicit, but also *MAD*, *The National Lampoon*, and *Punch*; six pornographic video tapes; five photographs of nude women; a Minolta and a Nikon camera; and a dildo. None of the photographs depicted Veronica nude. None of the magazines depicted nude or partially nude photographs of — or depicted sexual encounters with — minors. And no writings or drawings were found which described or depicted sexual acts between Dwaine and his daughter. While the existence of such "often" kept, "rarely" destroyed material might have gone a long way toward confirming Dwaine's guilt, its absence did not seem to suggest his innocence. He had, the police thought, ample time to get rid of it — not that it may never have existed.

On May 23rd, Galloway took Veronica to the Ventura County District Attorney's Office, where she was interviewed by Matthew Hardy III. Hardy had been a deputy district attorney for over a decade. He was aggressive, confrontational, and known within the local criminal justice community as someone willing to push as far as he could, as often as he could, whatever he could in order to gain a conviction. It knew him as "Mad Dog Matt."

Veronica told Hardy that her father first molested her three weeks after she began living with him and Debbie. (She did not mention the fondling she had told Galloway occurred two years earlier.) She now stated that it was not Steve Gold alone, but also her boss, Dennis Rohde, who had convinced her to come forward. ("He asked what was wrong," she said later, "I had held

that secret in for five long years, and he was a comforting voice. He was this big, overpowering man. I just told him.")

The sexual encounters with her father usually occurred when she returned from school. He would tell her to take a nap in the master bedroom. Then he would orally copulate her; she would orally copulate him; they would have intercourse, but he would pull out and ejaculate on her stomach. When she turned sixteen, he had Debbie put her on the pill. She was trying to avoid him now, so except for the three weeks Debbie was in Virginia, they had sex only once or twice a week. Once, when she was in ninth grade, following a wedding they had attended in Ventura, when she refused to "give him head" in their car, he forced her to have sex and ejaculated inside her. When they got home, he orally copulated her, put a vibrator in her until she complained of the pain, and anally copulated her until she screamed and began to bleed.

At this point, Veronica became "rather emotional," and the interview stopped.

On May 31st, Galloway had Veronica examined at Ventura County General Hospital for signs of forced sexual abuse. (There were none.) Later that day, Hardy resumed his interview.

Veronica now said her first sexual encounter with her father was when she was thirteen and they were living in Simi Valley. She was sitting on his lap beside the pool in a black two-piece bathing suit, when he kissed her and inserted a finger in her vagina. Later that summer, in the pool, he kissed her and put a finger inside her. Then he sent her into the bedroom, where he had her orally copulate him. Then they had intercourse. Once school started, the sex became regular. It would begin with oral copulation, followed by intercourse. Once they did it "doggie style." Once, after she had returned from a trip to Sweden, she orally copulated him in the bathroom. Once, when she came home from school sick, he rubbed his penis up and down on her "butt," then had intercourse with her. On her first day of school her senior year, he had her orally copulate him; then they had intercourse. Halfway through her senior year, she began using cocaine. She saw this as a way to keep away from her father. A few days before her prom, he had her put on her gown. He said he "wanted to be the first one to get her in the dress." Then he took it off and had sex with her.

By this point, Veronica had developed a headache, and the interview ended. Hardy appears to have concluded that the differences between what Veronica told him and what she had told Detective Galloway were the normal inconsistencies that occur when a person describes the same event on different occasions. Every experienced attorney has had his share of those.

II

I love getting into polite society's face… I've made a choice to stay on the outside and look into [its] windows. Sometimes I throw [a] brick through those windows. My bricks are my cartoons. I get a kick out of watching them scurry like rats.
— *Dwaine Tinsley. Journal note. 1992*

He was born Beverly Dwaine Tinsley, 11:33 P.M., December 31, 1945, in Richmond, Virginia. He hated his name. (He began calling himself "Dwaine B." at fourteen.) He resented his mother's timing. (If she had held out twenty-seven minutes, he would have been the famous first baby of 1946.) And he was not that crazy about Richmond — its institutionalized segregation, its microcephalic Babbitry.

His father, Walter Franklin ("Frank") Tinsley, was ex-navy, an alcoholic, and chronically unemployed. His mother, Margaret Edna Foster Tinsley, was a hairdresser — and an alcoholic. His brother, Donnie, two years older, had been born when Margaret was seventeen. When Dwaine was three months old, Frank caught Margaret in bed with another man and left. Frank would die of lung cancer in 1974. Margaret would die of heart failure brought on by cirrhosis of the liver in 1978. Donnie would die in 1983. When his own drinking had left him spitting up blood and a doctor told him alcohol would kill him, Donnie had switched to heroin.

After Frank left, Margaret opened a beauty parlor. After hours, she would

take Dwaine and Donnie to bars where she picked up men. Once she left Dwaine in the back seat of Frank's brother's car while he fucked her on the hood. His uncle had a broken arm, and his cast banged and banged against the steel. Once she sat Dwaine in the front seat between her and the man with whom she had been drinking. When the man slammed on the brakes, Dwaine split his head on the gearshift. His mother cursed and screamed because his blood had stained her camel's hair coat.

When Margaret wanted a longer binge, she left Dwaine and Donnie with her parents. Doug, her father, was a brick mason and his wife, Nell, a housewife. Their home was in a lower middle class neighborhood, each building on its own lot, a half-acre or less. Sometimes, it was months before Margaret reclaimed her sons. She visited, but Frank rarely did. When he came, Donnie received his attention and presents. When Dwaine visited Frank in the hospital in which he was dying, his father told him he looked so much like Margaret it had hurt to see him.

Dwaine began drawing when he was five. He doodled constantly. He copied *Dick Tracy* (his favorite), *Superman*, any comic strip or book character he saw. It was the only thing he did better than the smarter, more athletic, better-looking Donnie. Forty years later, Dwaine would begin a notebook that contained ideas for future projects, with the story of Jackea, a "little ghetto black kid," who escapes a horrific home life through a "journey book," in which he draws an imaginary world. "He's an artist," Dwaine wrote, and "[this] his way of coping with the pain, loneliness, [and] lack of understanding…"

When Dwaine was nine, Margaret married John "Mac" McNealy, a barber — and another alcoholic. They brought Dwaine and Donnie to a three-bedroom house on Mac's family's tobacco farm in Callands, a small town near Danville, with few neighbors and few children with whom the boys could play. The McNealys used a ditch for a latrine. They hauled water from a creek. Their cow's milk tasted of the onion grass on which it fed. When her sons misbehaved, Margaret beat them with a cane. Their half-brother Doug was born in May 1954, followed by another boy and girl, both victims of fetal alcohol syndrome. (Dwaine's first wife, who would meet Margaret and Mac when they were living in a junk-strewn trailer park, recalls them as pluperfect Caldwellian white trash. "I brushed my teeth, and they didn't know

what that was.")

Doug, a carpenter — and recovered alcoholic — who still lives in Virginia, remembers his parents as a happy, loving couple — when they were sober. "For six, seven months, things would be fine. Then they would go haywire." Mac was especially hard on his step-sons, whom he called "big-headed dagos" because Frank was part Italian. But Doug believes Dwaine's dark view of his mother was more a product of his own needs than a reflection of reality. "He resented her because of the drinking, but she never treated him badly."

Ellen Tinsley says, "Dwaine was a Southern boy; and Southern boys take more seriously than most the injunction: 'Honor thy mother.' He tried; but his was the town drunk, and everyone knew it." Pudgy, uncoordinated, he was beaten up regularly defending her reputation. At twelve or thirteen, Donnie, who hated Mac and Callands, returned to Richmond to live with his grandparents; but Dwaine felt that was disloyal. He wanted to love his mother, even if he could not. "[Even] when momma hugged me or said she loved me, it wasn't for real," he would later write. "She was doing it for herself — not for me." When he was confirmed at the local Baptist church, standing proudly in his only suit, hearing the minister praise his good works, his fine character, his artistic talent, Margaret was in the rear, drunkenly shouting for her own recognition. When he was thirteen, Dwaine, too, returned to "Nannie" and "Granddaddy."

In their barn, he found a stack of *National Geographic*s whose photographs showed him worlds he had never imagined. His new school had students who looked as though they swallowed worlds like these like oysters. Dwaine worked at a hamburger stand to earn the chino pants and Madras shirts and Bass Weejuns the seats at their tables seemed to require. But for these students he still smelled too much of Margaret and Frank's latrine.

Donnie had already wised up beyond chinos and Bass Weejuns into drinking and girls. Dwaine followed his example. "Big" and "Little" Tinsley became part of the Hillside Boys, whose free time was passed robbing parking meters, burglarizing houses, hot-wiring cars. (Dwaine first had sex at sixteen. It was, as were his other sexual experiences, with hookers or casual pick-ups or in lengthier affairs, what the authorities would later deem "age appropriate.") He was arrested over a dozen times as a juvenile. He served several stints in reform school. Once, he and Donnie were in different cabins in the same facility when the school held an intramural track meet. Donnie

won four events; and though his cabin mates pounded him for rooting for a rival team, Dwaine kept cheering. He had picked his side, and he was sticking to it.

Dwaine quit high school at seventeen. He and a friend, Danny Ray Sloope, moved to Washington, D.C. D.C, they figured, had more excitement — and more women — than Richmond. Within the year, Dwaine was living on the street and had become addicted to heroin. (He would also dabble with marijuana, LSD, methamphetamines, and, less frequently, cocaine.) He supported himself — and his habit — with odd jobs, petty thefts, housebreaking, and being paid by men to allow them to orally copulate him. (He always denied orally pleasuring them.)

One night, in mid-November 1965, a policeman in Montgomery County, Maryland, stopped Dwaine and Danny walking through a wealthy neighborhood carrying a suitcase. When the officer seemed skeptical of their explanation that they were visiting friends, Danny slugged him with the suitcase — which contained the silverware and jewelry of the home they had just burglarized — and bolted. Dwaine ran too, but the policeman shot him in the ankle. Dwaine ended up with his foot in a cast and, following a court trial on March 11, 1966, a burglary conviction and six-year sentence to the state penitentiary.

The minister of his grandparents' church, Father Paul Turner, visited Dwaine regularly. On these visits, Father Turner brought him books and art supplies and encouraged him toward self-improvement. Years later, Dwaine found Father Turner in Florida and called to thank him. He was pleased by Dwaine's success — if cool to his line of work.

Early in his sentence, several guards, who believed Dwaine had organized an inmate riot, handcuffed him, beat him bloody, and threw him into solitary confinement. He was there fifteen months, his only regular human contact the voice of Chuck Thompson broadcasting the Baltimore Orioles. Alone, away from outside influences, their disappointments and woundings, scouring his past, turning over days and moments for the worthy, dreading his likely future, calculating odds and factoring risks, Dwaine placed his bet on the long-shot possibility of changing a life that already appeared well damned. He read everything his hands could grasp: multiple Civil War histories (he claimed a distant relationship to the Confederate general Jubal

A. Early); dictionaries; an entire encyclopedia; and the Bible (twice). (His favorite discovery was the Studs Lonigan trilogy, James T. Farrell's saga of a boy destroyed by his inability to overcome the world into which he had been born.) He obtained his GED. He became, via correspondence study at the University of Maryland, the first Tinsley to take a college course. It was in Sociology.

He had decided to become a cartoonist. He would delight the world and shake it.

Dwaine had been nineteen when he entered prison. He was twenty-three when he got out. Not long after his release, he met Charlotte Gaye Lambert in a Richmond bar. Charlotte was five-four, one hundred fifty pounds and a twenty-three-year-old secretary for a personal injury attorney. "He was a good-looking guy, very charming. He made me feel good," she says. "I was a sweet-looking lady, young, impressionable and naïve. I think he picked an ingénue to keep him straight until he got off parole." Charlotte had a schizophrenic mother and a drug-addicted brother. She was, herself, Dwaine would later claim, "unstable," "belittling," "violent," and, especially when it came to his art, psychologically castrating. On June 20, 1969, a month after Charlotte's divorce from her first husband became final, she and Dwaine married. Veronica was born October 6, 1970.

While they were together, Dwaine worked as a clerk at a 7-Eleven, as a brick layer, a salesman — of vacuum cleaners, encyclopedias, and cars — and tried to become an artist. "He was," Charlotte says, "kind of not there very much." He would move them into an apartment, not pay the rent; and Charlotte would come home from work to find him gone and their belongings in the street. After his grandparents died, he left Charlotte in their house with no money and no heat. ("I was going to kill myself," she says, "but I couldn't decide on a weapon.") When she was about to deliver Veronica, he dropped her at the hospital and left, claiming he had a vacuum cleaner to sell. After Veronica was born, he moved them into a tiny duplex in west Richmond and stayed away for weeks at a time. His sex life with Charlotte declined — though once he involved another woman for a three-way. Once, when Veronica was "small," he took a picture of her and Charlotte nude.

One of the other encyclopedia salespeople was Debra Melhew, a nineteen-year-old from Smuckers, West Virginia. Debbie had a pretty face, blonde

hair — and weighed over two hundred and fifty pounds. Her parents had divorced when she was an infant. She had been raised by her gypsum miner grandfather and his wife until she was eight, when her mother reclaimed her. Debbie had begun working — at a Dairy Queen — when she was thirteen. She had graduated high school in Yellow River, Ohio, in 1969. She was bright, strong-willed, and self-directed. She liked night clubs and dancing and dating. Some of the time he was gone from Charlotte, Dwaine lived with her. It was three months into their relationship before he told her he was married with a child.

In early May 1973, Dwaine returned from a two-week absence with a soup pot as a gift for Charlotte. "I was with my dad," he told her.

"Right," she said.

"And now I am going to Atlanta to make my fortune as a cartoonist. I'll call for you."

"Good riddance," Charlotte said.

The day after he left, she filed for divorce in Circuit Court. The decree, which became final on February 7, 1974, awarded her child support of one hundred twenty-five dollars a month; but Dwaine had disappeared, and she could not collect a cent.

Debbie followed Dwaine to Atlanta. She worked as a waitress while he pursued his vision.

He knew nothing about creating a portfolio. He knew next to nothing about submitting to magazines. But he had energy and audacity and the belief that how he saw the world would make it laugh. So he copied addresses off mastheads and sent them cartoons. Editors' notes on rejection slips taught him that submissions ought to be on eight-and-one-half inch by eleven inch sheets of Bristol board; that including self-addressed, stamped return envelopes would save him having to enclose money orders for postage; that making copies of his work would avoid having to send it special delivery to assure its receipt.

He submitted primarily to the "adult" market. But even much of it told him he was "too hot," that his renderings were "fine" but his gags "weak," that his idea for a series on genitalia was "interesting but..." His sales — to *Cavalier* and *Gallery* and *Screw* — fifty dollars for an illustration here, one hundred for a cartoon there — were few; but they kept him going.

In July 1974, Dwaine and Debbie moved to Los Angeles, the center of the adult world. They were sleeping in their car and selling blood to buy food when Larry Ross, an agent/writer/editor/publisher who serviced several small-circulation porn and fetish magazines, began buying Dwaine's work. Soon Ross had set Dwaine up in an office and helped him and Debbie find an apartment in West Hollywood. (She resumed waitressing to pay its rent.) Ross helped Dwaine place cartoons with *Adam, Chic, Penthouse, Playboy, San Francisco Ball*. He received as little as twenty-five dollars for a captionless drawing and as much as two hundred sixty-five dollars for a color cover. For *Players*, which marketed to a hip, black audience, he created the character "Satch" — and received the compliment of having Richard Pryor tell him he could not believe it was by a honky.

In late 1974, Dwaine made his first submission to *Hustler*, a two-year-old monthly out of Columbus, Ohio. He liked its "hell-bent, kick ass attitude" and the way it "thumbed its nose at self-righteousness." It liked his work so much that, in return for a "first look" at all his male/sex humor cartoons, it guaranteed him two color pages a month, at three hundred-fifty dollars a page. He would be free to submit his other cartoons any place, except *Playboy, Penthouse, Oui, Viva, Playgirl, Gallery*, or *Genesis*.

III

Larry Flynt, *Hustler*'s publisher, was thirty-one years old. He was from the east Kentucky hills, an unapologetic product of its dirt roads and subsistence farming, its alcoholism and illiteracy. He'd first had sex with a girl, he boasted, when he was seven — and with a chicken when he was nine. At fifteen, he had run away from home to join the Army. By 1964, when he bought a hillbilly bar in Dayton, Ohio from his mother for six thousand dollars, he had already worked as a dishwasher, a Bible salesman, a bootlegger, in a mattress factory, at a fireworks company, on the lines at GM and Chrysler — and been a petty officer on the U.S.S. Enterprise. He had been married twice, psychiatrically hospitalized once and had sired three illegitimate children by three different women. Over the next three years, he bought three more bars in Dayton, the last of which, where he required his go-go dancers to mingle between numbers with customers, he named "The Hustler Club." By 1973, it had eight branches in Akron, Cincinnati, Cleveland, Columbus and Toledo, each clearing close to a hundred thousand dollars a year.

Flynt had begun *Hustler* in March 1972 as a four-page, black-and-white newsletter, distributed at truck stops, touting the dancers, promoting the clubs. Inside a year, it was thirty-two pages long; and, in November 1973, he decided to take it national. But first he scouted the opposition. *Playboy* and *Penthouse* dominated the men's market by setting naked, air-brushed breasts amidst a garnish of "art," and "literature" and "serious" journalism. Flynt found such fig leaves chickenshit. Sex, he figured, was sex. Everyone knew about it; everyone wanted it; and the more clearly everybody faced this,

the better off everybody would be. By his fourth issue, *Hustler* was showing pubic hair. A few months later, its first vagina hit the stands. (The cultural analyst Laura Kipnis in her essay collection, *Bound and Gagged*, also credits *Hustler* with introducing American newsstands to penises, naked pregnant women, naked obese women, naked middle-aged women, naked amputees, naked hermaphrodites, and naked transsexuals.)[6] The magazine's contents scared off most distributors; but by April 1975, it was grossing five hundred thousand dollars an issue. Four months later, *Hustler* published five pages of photographs of a naked Jacqueline Kennedy Onassis and sold over a million copies.

Flynt was operating, he would write, out of a "hillbilly disgust... [for] the pretentious and phony." He was at war with the government, the rich, organized religion, anything or anybody out to suppress, defraud, or, in any way, exploit "the common, ordinary citizen." Through articles on the tobacco industry ("America's Biggest Pushers"), black lung disease ("The Politics of Coal"), the Bechtel Corporation ("Bad Company"), chemicals in the home ("You are Being Poisoned"), food contamination ("How Much Can America Stomach?"), the legal and medical systems ("The Failures of American Justice" and "Hospital Horrors: Manslaughter by Mistake?"), poverty ("The Tragedy of the Homeless Millions"), TV ministries ("The Business of Televangelism is Big Business"), the Internal Revenue Service ("The Power to Destroy"), and the Reagan administration ("Reagan and the Mob" and "Irangate's Secret Government"), not to mention inquiries into the deaths of John and Robert Kennedy, Martin Luther King, Jr., and Marilyn Monroe and what really happened at Pearl Harbor, based on theories rich enough in logic and paranoia, research and (one guesses) mescaline to rattle faith in any institution or man, *Hustler* would become, to quote Kipnis, "the most openly class-antagonistic mass circulation periodical" in the country.

And one of the most potent weapons in Flynt's arsenal was his cartoons. Naked women were naked women. Narrative text was pages of print that slowed you down before you found the next photographed nookie. But every

6. John Heidenry, a former editor of *Penthouse Forum*, differs. In *What Wild Ecstasy*, his history of the American sexual revolution, he credits *Penthouse* with leading the Fourth Estate, not only into pubic hair (April 1970), vaginas, and penises, but masturbation, lesbians, threesomes, and whips, chains and leather. On the other hand, no one disputes *Hustler* paved the way with "Scratch 'n' Sniff" centerfolds.

grease monkey and hod carrier had time for a cartoon.[7]

In *Cartoon Cavalcade*, his ground-breaking 1943 study of American graphic humor, Thomas Craven had noted its primary characteristics to be a "profane spirit," an "uncouth jesting," and an ability to righteously "hate." "The American," he wrote:

> ...is the most irreverent of God's children. Nothing is too sacred for him to attack... When his noble-minded preceptors try to inject into him a measure of classical veneration, he laughs and screams, "Oh, yeah!" He coined the word 'debunk' and made it the battle cry of a reckless school of writers and cartoonists.... The Americans are the original decriers, the habitual deflaters, the champion reputation bashers of the world...

The gag cartoon had been a basic club in the American humorist's bag for nearly a century, wielded sweetly in the most wholesome of family periodicals and more bawdily on the most scurrilous of postcard racks. Gag cartoons defined a magazine's ethos the way bumper stickers defined drivers of cars. Cartoons supplied an attitude. They created a bonding between readers and creators and publishers. They were paper rep ties. They declared, "We are people who laugh at material like this." Gag cartoons had always allowed room for the decorous kidding of society's foibles, but Flynt wanted his cartoons savage and unhinged. He wanted them expressing "the dark humor [of] the mills, factories and working places of ordinary people... [that provided] a way to let off steam when life was hard." The guts of this humor was an ungoverned outrageousness, an utter tastelessness, an unparalleled lack of respect or sense of shame to the extent that even Thomas Craven might have been calling for the administration of sedatives to its practitioners — and the application of restraints. *The New Yorker* may have been willing to kid the

7. Actually, Flynt was not so much giving voice to a populace that needed an anthem as joining a chorus that was already mid-song. The results of this engagement, however, may not have been what he had in mind when he took the booking. By 1976, the apathy and cynicism fostered by, among other things, Vietnam, Watergate, and a major recession had convinced three-fourths of the country's blue collar workers to sit out the election. Four years later, Ronald Reagan and his right wing corporate/religious junta would ride to power on the votes of only twenty-eight percent of those eligible to have kept him penned in Santa Barbara.

rich for trekking to the Trans-Lux to hiss Roosevelt; but only in *Hustler* were you going to find Gerald Ford, Henry Kissinger, and Nelson Rockefeller gang-raping the Statue of Liberty.[8] In *Hustler*'s case, the cartoons said, "We laugh at this shit. Fuck you!"[9]

"All people," writes Iain Topliss in *The Comic Worlds of Peter Arno, William Steig, Charles Addams and Saul Steinberg*, "see the world restricted by the straightjacket of convention." They perceive — and react to their perceptions — as society conditions them. They are, by this measure, well-behaved. They are obedient and orderly. They make good citizens. But a cartoonist, freed to be transgressive, can subvert the received wisdom, defile conventions, butcher sacred cows. Through distortions and reversals, he may torpedo rigid rationality and tumble dusty pedestals. In Dwaine's work, the comfort of the familiar was shattered through forced marches into alleys most people labored to avoid. (It was not that these people did not recognize what was in these alleys. It was not that they had never heard the words or seen the images. The problem for the people that Dwaine offended was not that he set gibberish before them; it was that they knew too well what they did not want to see.) For Dwaine, the monstrous was ingrained within the most conventional of settings; and his mission was to strip from others their denials of this elementary fact. He did not require the creepy mansions of Charles Addams or the glowering extraterrestrials of Gahan Wilson to make the squeamish squeal. His life had left him with few illusions about what the world could inflict upon its residents, and he saw no reason to deny his public the benefits of his education. For those who dared Dwaine's alleys, there was gold among the fanged rats and aborted fetuses that filled the dumpsters.

"We are all monsters in our own way," Topliss tells us in his chapter on Charles Addams; and cartoons offer us a socially sanctioned way to explore

8. A quick perusal of *The New Yorker Cartoon Album: 1975-1985*, the decade when *Hustler* was making its mark, turns up exactly one overtly political cartoon. A young woman asks a man, "Are you quoting the old Nixon or the new Nixon?" Not too profane, uncouth or hating, that.

9. A word should be said here about the editorial cartoon, a direct cousin. Traditionally, such cartoons have been confined to particular pages of newspapers, where the wounds they inflict can be salved or balanced by the ragings of other opinions. Most magazines forbade their cartoonists from engaging the political, officially because the lag time between creation and publication could cost them currency but, more likely, because publishers preferred not to risk alienating advertisers.

To his credit, this did not trouble Larry Flynt.

impulses we are required on most occasions to suppress. In elaborating this idea, Topliss passes into a discussion of the object relations school of psychoanalysis. The object relationists — Melanie Klein, Donald Winnicott, Wilfrid Bion — posit that an infant feels both helpless and destructive. It fears the consequences of its destructive fantasies, so it projects them onto its mother. She not only withstands them but continues to love the infant, enabling it both to be more comfortable with itself and to relate more to the rest of the world. Similarly, Topliss says, cartoonists allow us to derive pleasure from our hostile wishes while avoiding the penalties of overtly acting upon them. We can witness our darkest imaginings played upon the page, where we can join our neighbors in laughing at them. They do not make us outcasts, we learn, but part of a fellowship.

The forbidden impulses to which Charles Addams most notably provided access were the homicidal: arsenic and ticking bombs and cannibals' pots; iron maidens and death rays and boiling oil. By the time Dwaine came to affect human betterment, that ground had been plowed for forty years. He needed to look elsewhere to make his contribution. And the fact that this would lead him to set his drawing board upon what many might regard as an artistic cliff's edge did not guarantee his fall over it.

On the other hand, no Christmas caroler ever accused Addams of actually dumping his boiled oil upon her.

IV

By late 1975, Dwaine's work was appearing monthly in *Hustler*. His page rate had progressed from one hundred, to two hundred, to two hundred fifty, to three hundred fifty dollars for a full-page color cartoon. His personal grievances and grudges, his resentments and furies easily blended with those that fueled Larry Flynt. His cartoons excoriated politicians and preachers and the rich. They raked blacks and Hispanics, Arabs and Jews. They found humor in amputations, bestiality, blindness, enemas, farts, necrophilia, nose pickings, paraplegia, and sex dolls.[10] He drew exterminators using a Negro baby to lure rats from hiding. He drew a husband exclaiming to his wife who has caught fire in the kitchen, "Aw shit! You burned supper again." He drew one derelict crapping into a bag, while another offered it for sale as "dog food." He drew a minister praying for a young woman congregant to be saved — as soon as she finished fellating him. But Dwaine's most significant contribution to *Hustler*'s gut-shot effrontery followed his recognition that most successful cartoonists had one memorable character at their command. So, spinning off from Buck Brown's *Playboy* granny, who lusted after young men, Dwaine produced a leering, overweight, blond fellow, dressed in saddle shoes and herringbone slacks, who carried a baseball bat and craved prepu-

10. I can't resist noting that a *New Yorker* description of a 1996 novel by Scooter Libby, vice-president Cheney's former chief-of-staff — and convicted felon — included its "generous mention" of snot, urine, pus, menstrual blood, incest. I mention this both as a what's-sauce-for-the-goose kind of defensive shield to protect my subject from knee-jerk rightist abuse and also to wonder if Mr. Libby has ever expressed his appreciation to *Hustler* for its ground-breakings.

bescent girls. He named him "Chester," after Chester Gould, the creator of Dick Tracy, and "the Molester" because, well, as he put it, "the Dirty Old Man lacked snap."

Chester made his debut February 1976, with a hand puppet on his penis, inviting a young girl to "give widdle Rodney a kiss-kiss."[11] In March, he was excitedly reading *Hansel and Gretel* while lurking in an alley, his bat at the ready. In April he was asking a hotel desk clerk for a room with a waterbed for himself "and... uh... my daughter." During the next two years, Chester was seen asking a mother if little Alice can come out and play; in bed, composing a letter that begins "Dear Kinky Korner," while surrounded by several bound girls; lying beneath a children's slide with his tongue primed for the girl at the top; attempting to lure a Jewish girl into an alley with a dollar bill tied to a string; in drag (with ball bat), at the White House, being introduced as Amy Carter's new babysitter; at the manger, beside baby Jesus, exclaiming, "Aww shit! It's a boy"; disguising his penis as a hot dog, a flower bouquet, an American flag (for the Fourth of July), and a bobbing apple (for Halloween) while offering it to various little girls' hands or mouths.

In the spring of 1976, Dwaine had arrived, uninvited, in Columbus to ask Larry Flynt for a job. He had driven solo, across country, sleeping in his car. Flynt, impressed by his willingness to lay everything on the line, asked him to become *Hustler*'s cartoon and humor editor. Dwaine's predecessor had departed leaving nothing but cartoons scattered around an office; and he had no idea what being an editor required. "Sure," he said.[12]

They signed a five-year contract for Dwaine to draw, edit and consult about cartoons exclusively for *Hustler*. He was to receive twenty-eight thou-

11. Chester seems to have derived from a similarly garbed and shaped, dark-haired fellow named "Newton," who had appeared the month before tutoring his sons on the fine points of self-abuse, while his disconcerted wife looked on.

12. Flynt's hiring policies, perhaps inspired by the success someone as unlikely as himself had achieved, often led him to choices that would have seemed unusual additions to other corporate boards and executive washrooms. His brother, Jimmy, became his vice-president and Althea Leasure, a former go-go dancer, drug addict and hooker, who, at age eight, had witnessed her father murder her mother, grandfather, her mother's best friend and himself — and whom Flynt would later marry — became his executive editor. (Those who worked with her say that the one error in Milos Forman's film *The People vs. Larry Flynt* was in Courtney Love's portrayal. "Althea," they say, "was never crazy.") Under her direction, *Hustler*'s circulation increased three hundred seventy-five percent, and she became the country's most highly paid female magazine executive.

sand dollars a year, which was about double his earnings as a freelancer, plus cost-of-living increases, an office, supplies, expenses, professional dues, acts and omissions insurance, accident and health insurance for himself and his dependants, and two weeks annual vacation, as well as fifty percent of any income from Chester-related merchandise, and ten percent of the profit from any collections of his work. (He was still paid separately for his cartoons.) And Debbie was hired as his assistant.

As an editor, Dwaine proved ambitious, hardworking, and vision-driven. (He could also be abrasive, overbearing, and confrontational.) He wanted laughs that came with something greater — and grimmer — behind the jocular curtain: man's inhumanity to man; governmental corruption; corporate greed; racist evil. He had the ability to identify cartoonists who could say what he considered worth saying but who had, to date, lacked the ability to put it across — and he could get them to deliver. He viewed his cartoonists as "family," each possessing a specialty — male-female warfare, gore and splatter, small town-America psychosis — to be blended, a pinch of one, a dash of another, so much per issue, to deliver his message. "He wanted cartoons that no one else did," says Dan Collins, a house painter dabbling with cartooning when Dwaine recruited him to full-time work. "Cartoons so in-your-face they couldn't be ignored." "If you sliced somebody open," the cartoonist George Trosley says, "he wanted the guts spilled out, the fluids and everything that comes with it. *Playboy* indicated. *Hustler* showed it to you."

Larry Flynt had the final say on cartoon selection; but Dwaine believed he knew how to present each month's selection so that the ones that received his okay were the ones that he, Dwaine, favored. If he believed in a cartoon, he fought fiercely for its publication — but he was often exasperated by Flynt's decisions. The man had street smarts — and many admirable qualities — but his formal education was scanty. He often said he wanted cartoons that any fourteen-year-old could understand — an interesting commentary on *Hustler*'s readership, since most actual fourteen-year-olds were barred from its purchase — and if Dwaine had to explain a cartoon to him, which was more often than he liked, its chances for acceptance were slim.

Still, under Dwaine's stewardship, with contract cartoonists like Collins, Trosley, John Billette, Tom Cheney, Mike Cieron, and Eric Decetis, *Hustler* would slice and dice two decades of American life into a mind-blistering stew. Fuck "subtlety" and "politeness," Dwaine would write in a 1996 an-

thology of their work:

> We wear our shitty manners with the same pride a blue-collar worker wears the grease under his fingernails…. [We are] the mischievous kids from the wrong side of the tracks… [who have endured] a peanut farmer who didn't have a clue about the Presidency, a sorry ex-actor who didn't have a clue period, a rich boy who sucked up to special interests like a bimbo hooker at a party full of Shriners, and a crack-er who can't keep his dick in his pants…. [We have lived through] anti-abortion militants, Cincinnati waterheads stomping on artistic expression, Jerry Falwell and his group of wild-eyed fungoids known as the Moral Majority, a Supreme Court packed with senile pussies, a bullshit war fought in a foreign desert for the high rollers in the oil business, Ethiopia, Jim Jones, Oklahoma City… and Oprah's latest diet.

Dwaine, himself, was never a cartoonist to lead a reader off-message with a panel's visual delights. His standard offering was some pleasant colors, some basic elements to establish scene — a carnival midway or city street — an emotion economically conveyed through eye angles or perspiration drops and, then — WHAM!!! — the sock of a central gaping vagina — or gigantic cock — or anus on legs. And with that image came a point. "You could feel his cartoons," Trosley says. "Dwaine believed in them, so he thought them through fully. He had a genuine love for the art of cartooning and the ability to get a laugh from anyone — and combine that laugh with a twinge of pity or sadness. With a cartoon, you expect the laugh, but if you can also mix in a lesson, so that someone walks away enlightened, you feel successful. You know, like when you're in a convenience store and taped to the cash register with forty pieces of tape is this old cartoon? That means it meant something to a person, and he wanted to share it."[13]

Dwaine's political cartoons may have represented his most significant

13. His mind was also amazingly fertile. In the boxes I received from Ellen was an envelope for airline tickets from a trip to Chicago upon which he had jotted ideas for over a dozen cartoons: "Airport sign: 'Welcome to L.A.' Black guy getting blow job from a nun. Mother/daughter (mid-west) arrive. 'Watch the men in this town. They're slick.'" "Priesthood is so much harder now that we can't screw kids." "Confessional. Uncle Sam with boner is fucking the Little Guy. 'Forgive me father for I have sinned.'"

achievement. Earlier in the decade, Hunter Thompson had introduced onto the lexicon of domestic political punditry terms like "stench" and "gibbering" and "scumbag," which had escaped the pens of Walter Lippman and James Reston. Thompson had called Hubert Humphrey a "treacherous brain-damaged old vulture," Gerald Ford a "bonehead Rotarian sonofabitch," and Richard Nixon "a wooden Indian full of Thorazine"; but even these sobriquets entailed an evasion, a poetic softening, a humorous misdirection away from the still-suppressed belief at their core. It took Dwaine to show an artist in his studio, sighting along his thumb, appraising the asshole of the dog that is his model, in order to complete his portrait of Newt Gingrich. (He said of Gingrich in another cartoon that he gave "good reason to believe Jesse Helms once had sex with a pig.") It took Dwaine to characterize "Right-wing welfare reform" by showing two men tossing a screaming black woman off a pier, her feet encased in cement. It took him to show Billy Carter in a hospital bed receiving transfusions from bottles labeled "Greed," "Ignorance," and "Racism." And it took him to sum up many peoples' feelings about their elected representatives through a hospital delivery room in which a doctor is saying, "Congratulations. Looks like you've given birth to a politician…" while cradling a steaming pile of shit.

Flynt honored Dwaine by promoting him as "*Hustler*'s Most Outrageous Cartoonist" — and publishing two collections of his cartoons. And he honored Flynt by stewarding the magazine into publication of the most kick-ass social/sexual cartoons in history. This "linkage of the sexual with the political," wrote one critic, had made *Hustler*'s cartoons "a particularly powerful cultural [voice]."[14]

14. To be fair, this critic, Gail Dines, was noting this achievement, with which I have no disagreement, in the context of what she believed to be *Hustler*'s "production and promotion of racist ideology," a conclusion with which I differ.

V

> "'offensiveness' is frequently but a synonym for 'unusual'; and a great work of art is of course always original, and thus by its very nature should come as a more or less shocking surprise."
> — *"John Ray, Jr. PhD,"* in his foreword to *Lolita*

Hustler had bought Larry Flynt a red Bentley, a pink Gulfstream jet, a six-bedroom home with sauna, steam room, and koi pond. It had also made him the publisher of a magazine that was despised by all right-thinking citizens beneath the purple mountains and across the fruited plain. Few men who had started with so little had accumulated so much against the opposition of so many. (Even Hugh Hefner, *Playboy*'s publisher, and Bob Guccione, *Penthouse*'s, believing his excesses fouled their own backyards, wanted nothing to do with him.) The extent and ferocity of this opposition made it not, therefore, unreasonable for Flynt to assume that he had uncovered a valuable truth whose repression had been sought by those who meant to keep the Bentleys for themselves. The ruling class, he believed, sought to "regulate our loins and libidos... [in order to] bring our whole lives... into submission."

Flynt's battles, through the pages of *Hustler*, against these forces of loin suppression would lead him to be sued by Guccione for having doctored a photograph to make him appear to be engaging in a homosexual act, by Guccione's girlfriend for saying he'd given her V.D., and by Guccione's girlfriend's lawyer for naming him *Hustler*'s Asshole of the Month. He would be

sued by the radical feminist Andrea Dworkin, for calling her a "shit-squeezing sphincter," and the reactionary televangelist Rev. Jerry Falwell, for claiming he had been initiated into sex by his mother in an outhouse while she was drunk. Flynt's zeal — motivated, in part, by Big Tobacco's refusal to sully its advertisements with appearances in *Hustler* — would lead him to run full-page anti-smoking ads that depicted cancerous lungs and tongues. It would cause him to sue the United States government for barring reporters from covering the invasion of Grenada. It would embolden him to claim to possess video tapes proving that federal agents had framed the maverick auto maker John DeLorean on drug charges — and to be fined twenty thousand dollars a day for refusing a court order to release them. It would spur Flynt, when prosecuted in Cincinnati for obscenity, to mail out four hundred thousand pamphlets with gruesome photographs of war victims, asking that city's citizens what was truly obscene. It would inspire him to offer President Carter a million dollars to fund a presidential commission to prove pornography posed no societal threat. Then, having been shepherded by Ruth Stapelton, the president's sister, into becoming Born Again, it would impel him to provide free day care for his employees, double his company's minimum salary — and embrace vegetarianism.

In March 1978, while under prosecution in Laurenceville, Georgia, on new obscenity charges, Flynt was shot in the spine by an unknown assailant. Left without use of his legs and dependent on Dilaudid, morphine and pharmaceutical cocaine to control his pain, he abandoned Jesus and moved his company to Los Angeles — and himself into a Bel Air mansion whose former owners included Tony Curtis and Sonny and Cher. He also elevated his public behavior into a realm that teetered between genius performance art and board-certifiable insanity. He sent free subscriptions of *Hustler* to every Supreme Court justice and congressperson, provoking two hundred sixty of them to file complaints with the Postal Service to force him to stop. (The USPS sued him in federal court but lost.) At oral argument of the appeal of one of his cases, he rose in the spectators' section of the United States Supreme Court and addressed the justices as "eight assholes and one token cunt." (He had dressed for the occasion in a FUCK THIS COURT t-shirt.) He appeared before another federal judge on contempt charges in a diaper made from an American flag. In yet another court proceeding, his behavior

led to his being bound and gagged. And in 1984, while running for president as "A Smut Peddler Who Cares,"he called Ronald Reagan "a dumb fascist bigoted motherfucker" and fought for the right to air sexually explicit television ads. (Dwaine contributed to his employer's campaign a cartoon of a wild-eyed, wheelchair-bound Flynt with a nervous hen on his lap. "I promise a chicken in every pot," the candidate is saying, "after I finish fucking it.") He was, Kipnis wrote, a "one-man bug up the nation's ass... [a] loud-mouthed whistle-blower on what he regarded as our national hypocrisy."

While Flynt's actions may have stimulated *Hustler's* sales and — not incidentally — expanded the First Amendment's protection of the press — See *Hustler Magazine v. Falwell*, 108 S.Ct. 876 (1988) — for vast segments of the population, including those apt to serve as jurors in Ventura, California, being on his payroll was not likely to rebound to your credit.

One casualty of Flynt's Born Again phase had been Chester. In the spring of 1978, he had been recast as "Chester the Protector." (Dwaine had protested publicly against his creation being neutered "into some kind of Zorro for Christ" — but Althea had reminded him of his paycheck's source.) That Chester wielded his bat against physically abusive parents, schoolyard drug pushers, vermin menacing inner city children, even an older man coming onto a young girl in an ice cream parlor. (The man resembled Charles Keating, a leading anti-pornography crusader.) When Flynt's conversion lapsed, though, Chester reverted to his socially unredeeming ways. But now his focus had broadened. The harbinger of this awakening, Hester — tall, skinny, outfitted in an assortment of fetishistic gear — appeared in his doorway in November 1978. "Hi, Sugar," she announced, as hearts floated above their heads, "I'm the girl from the computer dating service..."

"Chester and Hester" lasted four years. Dwaine's sources of humor now expanded to include vinegar douches, chicken suits, smelly underwear, prostate massages, and one partner lying beneath a glass table while the other defecated upon it. Then, in November 1982, Hester vanished and "Chester the Molester" returned — but with desires beyond young girls. He had not renounced them entirely — in one memorable moment, he attempted to lure a blind girl into his clutches by dangling a steak in front of her seeing eye dog; in another, he masturbated to pictures of missing children on a milk carton — but the objects of his lust now included cats, poodles, sheep, an

organ grinder's monkey, a teddy bear, nuns, and a vacuum cleaner. He had become, Dwaine would explain, "a broader parody of sexuality."[15]

It should be noted that, except in his "Protector" phase, Chester was never portrayed as someone to be admired or emulated. (To make this clear, Dwaine once hung a Nazi flag from Chester's pecker.) He was not physically attractive. ("Loutish" is the first adjective his appearance brings to mind.) He was not even particularly successful. (To be blunt, he never achieved penetration — let alone orgasm — with any of his prepubescents.)[16] He always ranged within a characterological spectrum between the ridiculous and the depraved. (In Dwaine's terms, Chester was "a ludicrous sexual outlaw" in pursuit of "anything with an orifice.") Certainly, his choices for gratification would have appalled most people. Certainly, even most of those open-minded enough to have found humor in his hungers shook their heads in disapproval while they laughed.

But there is humor in these cartoons — and it is humor with a social value. Dwaine would defend Chester on the grounds that he focused attention on a major societal problem or that he satirized the consequences of uncontrolled sexual desires, but I believe the value of these cartoons is both deeper and more subtle. What seems significant to me is the extent of outrage provoked by Dwaine's selection of this topic as a subject of humor. It may be that one of the nobler — and more courageous — functions of art and artists is the probing of societies for tender points. Does it bother you here, such art asks. What about here, it inquires. When society yelps, the artist may have found an area that warrants further exploration. For art is only words and pictures; and if it causes discomfort, those areas may benefit from open airings. What are you hiding, the artist asks. Why are you hiding it? Would you care to discuss it?[17]

15. In Dwaine's view, his Late Chester period represented a maturation on his part. "As creative people grow older," he wrote — about these poodles and vacuum cleaners — "they become mellower, …more conscious and finer tuned in their work. They round off the rough edges of youthful exuberance."

16. In this regard, Chester lagged far behind, not only *Lolita*, but the underground comics of the late 1960s, most notably the work of R. Crumb. See, for instance, his notorious "Joe Blow," in *Zap* #4, whose inter-family frolics had vendors busted from New York to California.

17. The argument against this position is that certain expressions are so repugnant to a society's core beliefs, values, customs, and traditions that they cannot be permitted lest they destroy all that binds that society together. The counter-argument to *this* position is that its implementation did not work out so well for Nazi Germany and Soviet Russia.

In his superb study of humor in post-World War II America, *Going Too Far*, Tony Hendra celebrates the work of such now-iconic figures as Lenny Bruce, Mort Sahl, Jules Feiffer, and Richard Pryor. These cultural heroes shared a dedication to an anti-establishment humor that a majority of the public at the time considered "black," "gross," "sick," and "tasteless." This humor dealt with topics that had previously been off limits. It challenged societal norms instead of affirming them. It replaced reassuring stereotypes with jarring caricatures. And it disobeyed all cautionary signs "at all times and at every conceivable speed." It functioned best, in fact, when it was "most outrageous." For Hendra, this "Boomer humor" peaked in the early 1970s, when two former colleagues at *The Harvard Lampoon* launched *The National Lampoon*, a magazine with "no punches pulled, no words forbidden, no idea too outrageous," (and for which Hendra served as managing editor) and crashed in 1975 when NBC, via *Saturday Night Live*, co-opted many of those behind it into "conformist rebellion against unthreatening authority."[18]

I am with Hendra for about two-thirds of the above paragraph: I, too, favor humor that is uncompromisingly "black," radical," etc.; I fully agree such humor functions best when outraging most. But having immersed myself in several volumes of *Hustler* cartoons, it is hard to credit the *Lampoon* as much as he would have it. From my perspective, many punches seem pulled, words swallowed, ideas closeted. It is only in *Cartoons Even We Wouldn't Dare Print*, a collection billed as submissions the *Lampoon* had previously deemed "unprintable," that one finds abortions and bestiality, necrophilia and sex dolls. And even in this viper's nest which its editors yellow-flag (tongue-in-cheek) as a warehouse for the "degenerate," the "egregiously outrageous" and "insalubrious," one finds only a single entry Chester-like in its daring. The scene is a pet store. A leering man in an overcoat offers a bird cage to a young girl who recoils aghast, for the bird rests, not on a perch, but his penis, thrust

18. A more positive view of *Saturday Night Live*, at least in its early years, is presented in *Mr. Mike*, Dennis Perrin's biography of its brilliant contributor (and *Lampoon* alumnus) Michael O'Donoghue. But while O'Donoghue may have led television to new heights of satiric savagery — an impersonation of genial talk show host Mike Douglas having fifteen-inch steel needles slammed into his eyes, for instance — corporate sponsors and network censors only allowed transgressions of a certain level. *SNL* might suggest President Ford could not walk across a room without tripping over a hassock, but it was not going to show him sexually assaulting a national monument.

between the bars.[19]

Black humor did not die when John Belushi went "LIVE… from New York City." In fact, it grew bolder, more confrontational and had more people calling for the disembowelment of its practitioners. But this occurred in a forum where it was less comfortable for men of Harvard to hang their names and reputations. They were content to leave it at proclaiming, "Boy, *Animal House* was really something!" "The *Lampoon* wouldn't go near as far as we would go," says Dan Collins. "It was a more thoughtful, more cerebral brand of humor, as opposed to ours, which was 'Smack you in the face with a two-by-four'; or if that doesn't work, 'Try a four-by-six.'"[20]

For Tony Hendra, the purpose of satiric art is the challenging of social norms. In his novels, Gustav Flaubert sought to *épater le bourgeois*. Marcel Duchamp believed a painting that did not shock not worth painting. Franz Kafka wrote that books should rouse us like blows to the head. What is the point of drama, Edward Albee asked, while promoting his play *Who is Sylvia*, about a man in love with a goat, if it is not offensive to the point of provocation? For this common credo to be sustained, the artist who adopts it must constantly be moving forward, antennae raised, toward a frontier far removed from his audience's comfort zone, for once the audience grows cozy with the subject at hand, it sits unskewered, unshocked, unroused, politely turning the page or pacing the gallery or clapping the cast on stage for another curtain call. And if this credo has value, it seems unfairly elitist to apply it only to artists whose work is free of beaver shots in the immediate vicinity.

"As a cartoonist," Dwaine Tinsley said, "I'm going to make you laugh or make you mad or make you think." "*Hustler* cartoons," he said, "allow people to laugh at the taboo, the sacred and the controversial…. Most people laugh at our cartoons, feel guilty about laughing, and end up thinking about it for years — that's impact!" It was also, he recognized, "art." And as fervidly as any clutch of assistant district attorneys might deny it, much of his humor contained social comment. Take his cartoon where the exterminators lure

19. All cartoons in this collection are undated, so one can not say if this work was a theft from (or homage to) Dwaine, an inspiration for him, or an example of two bent minds sharing a similar vision.

20. Even *Hustler* had its standards. In these years, its cartoonists were forbidden to show insertion or people *actively* engaged in bestiality or sexual acts with children.

rats with the baby: one does not identify with the exterminators; one's sympathies are with the child. That is why one is upset — why one is outraged — why one thinks, "That sick-bastard fuck of a puke-doodler ought to be flogged." But if Mr. Outraged Viewer reflects, he must recognize the cartoon was not created in a vacuum. It was created in reaction to actual reports of actual ghetto babies being actually bitten by actual rats. And if he reflects further, he may recognize that he has been more outraged by this cartoon than he was by these reports — that he is ready to fling the cartoonist to the nearest hyena while tolerating the society in which the rat bites occur. Perhaps he makes the connection that this society often builds economic success — in this case a successful exterminating company — on the physical mutilation of others. Silicosis may come to mind. Asbestosis. "Build," the society instructs, after all, "a better mousetrap…"

Dwaine had nurtured his wounds and resentments like a lioness her cubs. Each rat cartoon (*maybe*), each shit cartoon (*maybe*), each crab-infested vagina and fetid douche, each degenerate Falwell and demented Reagan, each big-cocked black and big-nosed Jew, each severed limb and ravaged fetus (*maybe, maybe, maybe, maybe*) was a blow against his round-heeled mother (the TRAMP!!!), his drain-the-dregs father (the LUSH!!!), the regimented, narrow minded, madras-wrapped high school squares, the bloody-fisted, no-necked, cracker prison guard cretins, who had ganged upon him, shunned him, shamed him, clubbed him in their combined totality into that solitary hole of hell, from which he had emerged like some vengeful horror comic creature of the fens, dripping, not gore or rotted flesh, but ink and Wite-Out, reconceived and reconstituted by unknown gods of unknown motives for unprecedented assaults, pursued with pride and courage, determined to provide a meaning to his life beyond that mirrored in his childhood's latrine. He was saying, in effect, that there is value in the most foul and repugnant, as there is value in me.

Of course, the portion of this contribution that provoked the most thought and laughter and anger — that took the most courage and in which he invested the most pride — was Chester. Dwaine had not planned to tread the tightrope walk above the razor-bottomed pit of time that is a career hand-in-hand with a ball bat-wielding pervert; but he had pursued his artistic vision, and his vision had produced Chester. If he took his art seriously, which he did — which he certainly did — it was his responsibility to push it to

extremes, to grind Chester against the most noses, to fling him into the most eyes. Any serious artist works out of a belief that the virtue of his devotions will bring him rewards. If he is an artist who works in the stuff of outrage, he knows he may also be reviled. And while he may have hope for an ultimate payoff, he can't know in advance the outcome — if his faith may equal hubris — what jackpot exactly is in the mind of the gods. (They may be black humorists too.) "He had followed his extraordinary destinies through to the end," Yasunari Kawabate wrote in *The Master of Go*. "Might one also say that following them meant flouting them?"[21]

21. The author apologizes for the verbal liberties of the preceding few paragraphs, but he was reading *Absalom, Absalom!* at the time of their composition; and Faulkner has that effect on impressionable imaginations.

VI

The 1960s had promised America revolution. But no New Frontier had been attained or any New Society awakened. People did not ask what they could do for their country instead of what it could do for them. Each did not give according to his ability or receive according to his need. No thousand flowers bloomed. When people came to San Francisco, they did not wear blossoms in their hair. They wore Brioni suits and draped gold chains around their necks and headed for the nearest fern bar.

One area where the Sixties had delivered was sex.

Hustler had ridden the crest of a permissive wave which had swept away resistance to premarital boffing and monogamic insistency. It had left the country awash in sexually explicit books and movies and magazines. It had created employment opportunities for sex surrogates and doctors of human sexuality. It had enriched our language with "glory holes" and "golden show-ers" and "fist-fucking" (brachioproctic eroticism), the first new act of sexual gratification in eons. In its wake had sprung up anything-goes bathhouses and swingers' clubs and utopian sex communes and, for all anyone knew, bondage Tupperware parties and S&M picnic groves. The mass-market ac-ceptable *Joy of Sex* sold two million, eight hundred thousand copies. The X-rated pornography industry was reputed to gross four billion dollars a year. The number of teenage girls who admitted having sex had doubled between 1960 and 1984. (Among those under fifteen, between 1950 and 1975, it had more than tripled).

Of course, these breakthroughs had not gained cultural acceptance as easily as had, say, "The Rite of Spring" or Elvis Presley's hips. One arm of the resistance — that striving to cleanse the nation of porn — was led by two groups that otherwise had as little in common as Janis Joplin and The Singing Nun. Political and religious conservatives of the New Right — organized as the Moral Majority or Citizens for Decency Through Law or Citizens Concerned for Community Values — inveighed against this manifestation of run-amok, libertine self-indulgence for its threat to the moral, ethical and spiritual pillars that were all that elevated society above the primordial muck. (To the conservative columnist David Frum, the turning away from the prairie-virtues of sacrifice and self-restraint that had made this country great, which pornography represented, constituted "the greatest rebellion in American history.") And radical feminists — Women Against Pornography, Women Against Violence, Women Against Violence Against Women — demanded the abolition of all publications whose denigration of women, they feared, incited men to rape and assault women, and whose reduction of women to dehumanized objects helped perpetuate male social dominance. (To this movement's media analyst Judith Bat-Ada, Larry Flynt, Hugh Hefner, and Bob Guccione were "every bit as dangerous as Hitler, Mussolini and Hirohito…")

The anti-porn forces held marches and rallies. They sent letters and signed petitions and disrupted businesses that sold the objectionable and foul. These groups often set *Hustler* squarely in their sights. The Rev. Jerry Falwell, a leader of the anti-homosexual, anti-abortion, anti-Equal Rights Amendment Moral Majority, believed its calculated program of taboo-defiance made all forms of deviance — drugs, crime, divorce — appear permissible, placing the innocence of American children and the sanctity of the American home squarely at risk. Laura Lederer, a founder of Women Against Violence in Pornography and Media, said that *Hustler's* depictions of women shot or stabbed or, on one notorious cover, run through a meat grinder had created "a culture in which real violence against women is not only perpetrated, but accepted as normal." Lederer specifically singled out "Chester" for its contribution: "Each month," she wrote, "he molested a different young girl, using techniques like lying, kidnapping and assault." (She did not mention that he was a character in a cartoon.)

Diana E. H. Russell, a professor of sociology at Mills College, took Lederer

one step further. Citing a study which found "a connection between exposure to violent pornography and violent behavior toward women," Russell wrote that child pornography, because it "commonly portrays children as enjoying sexual contact with adults," "may create a predisposition to sexually abuse children in some adults who view it." In other words, because *violent* pornography had an undefined "connection" with *violent* behavior toward women, *non-violent* child pornography might incline some adults to have sex with minors.[22]

A second front in the sexual behavior wars was fought on this neighboring terrain.

In the late 1970s, articles in *Forum, Penthouse,* of course *Hustler,* and other, even more scholarly journals had argued in favor of consensual sex between adults and minors — including parents and their children — and recommended lowering the age of legal consent to twelve. (At the time, it ranged within the fifty states between fourteen and twenty. A century before, it had been as low as seven.)[23] If you were old enough to want it, one sex education manual bluntly posited, you were old enough to have it. These articles contended that such relations harmed no one and might prove a healthier, more satisfying way to introduce youngsters into erotic pleasures than forcing them to fumble through adolescence with nothing to guide them but the muddled backseat gropings of their peers. Minors were said to gain "status" from relationships with their more amorous elders. They were reported often to be pleased to receive this attention. (Girls were described as being especially "grateful" when their fathers took such interest in them.) The fear of criminal prosecution, it was said, could lead youngsters to stifle normal impulses and inhibit parents from engaging in nurturing hugs and cuddles. To refer to such sexual conduct as "abuse," the argument went, was to unfairly demean it through the application of a narrow-minded, judgmental,

22. American art and industry was not entirely averse to capitalizing on teenage sexuality during the late 1970s and early 1980s. For instance, Martin Scorsese's 1976 film, *Taxi Driver,* featuring the thirteen-year-old Jodie Foster as a New York streetwalker. For instance, Louis Malle's 1977 film, *Pretty Baby,* featuring the thirteen-year-old Brooke Shields as a resident of a New Orleans brothel. For instance, Calvin Klein's multi-million dollar advertising campaign for his jeans, featuring the fifteen-year-old Shields, intoning, "Want to know what gets between me and my Calvins? Nothing."

23. This still represented an advance over the days of the Talmud, which permitted girls to be married at three.

retrograde standard. (Some advocates even cast their argument in Darwinian terms. The initiation of early sexual excitements, they said, would induce a longer period of procreation in the participants, increasing their offspring and the chances for species survival.) In 1975, an article in the prestigious *Stanford Law Review*, noting the difficulty of distinguishing "appropriate displays of affection" from more "disturbing behavior" — and citing the paucity of studies documenting either short- or long-term "negative effects" of sexual abuse, and expressing concern for the harm that could be inflicted on children and their families by the criminal justice system — advocated the abolition of criminal penalties in *all* sexual abuse cases involving parents and their offspring.

Needless to say, these views received about as warm a welcome as a pack of syphilitic mandrills at the White House Easter Egg Roll. Child abuse, the opposition countered, was "the cruelest of crimes." Children were "among the weakest and most defenseless of human beings." They were "powerless" to effectively consent to adults demanding sex. (Father-daughter sex, in particular, was tantamount to "rape.") Studies were rapidly marshaled to show that children were inevitably damaged by such experiences. They were subject to life-long guilt feelings, nightmares, depression, self-loathing; left seeking solace in drug and alcohol abuse; programmed to fall into one abusive relationship after another. (Long-term father-daughter sex was deemed especially devastating.)

This debate played out at a time when the sexual abuse of children, in the words of Amy Adler, a professor of constitutional law at New York University Law School, had been recently "'discovered' as a malignant cultural secret, wrenched out of its silent hiding place and elevated to the level of a 'national emergency.'" (It had become, Adler went on to say, "an obsession," a "passion," "the master narrative of our culture," comparable to the Red Scares following World War I and during the McCarthy Era.) This "wrenching" had followed the medical profession's focusing of the country's attention on the physical abuse of children a decade earlier through its uncovering of "battered child syndrome," "shaken baby syndrome," and "Munchausen syndrome by proxy." Once the reality of this shame had been established, members of the women's movement now focused on its more even strongly hidden sister.

These women believed many — some would say most — a few would say

all — women had been abused sexually as children. (The extent of this abuse has never been accurately documented. One study, in 1985, put the figure at sixty-two percent — but included exposure to "unwanted" sexual remarks as abuse. Another, a year later, restricted the definition of abuse to forced sexual contact and reduced the figure to six percent. Anti-abuse activists then averaged the two and arrived at thirty-four percent, a figure they found to their liking.) In any event, since girls were unarguably the most frequent victims, speaking out against childhood sexual abuse became a means of speaking up for — and allying one's self with — the rights of all women.[24]

These speakers believed that male-dominated societies had conspired to conceal the extent of this outrage. They accused Sigmund Freud of having repudiated his discovery that actual childhood sexual traumas had caused his adult female patients' neuroses, attributing them instead to the patients' repressed sexual fantasies, in order to protect the Viennese burghers who had perpetrated these offences. They charged Alfred Kinsey with cooking the books on his research on contemporary sexual behavior to minimize the epidemic of child sexual abuse he had uncovered in order to prevent a backlash against his campaign to rid America of its Puritanical hang-ups. As a result of these fabrications and cover-ups, these women argued, most people had been duped into being skeptical of claims of childhood sexual abuse.

Such skepticism appeared institutionalized within the male-dominated legal system, which seemed to presume that any woman (or girl) who charged a man with sex abuse either desired revenge or blackmail or fame — or was deranged. In 1904, the dean of American evidentiary law John Henry Wigmore had written, "It is time that the courts awakened to the sinister possibilities of injustice that lurk in believing such a witness without careful psychiatric scrutiny." Over three decades later, the American Bar Association still recommended that any woman who brought a sexual abuse charge be psychiatrically evaluated to see if she was insane.

24. It was also unclear what the consequences of such abuse were. Joan Acocella, in *Creating Hysteria*, writes there is "little or no research support" for claims that childhood sexual abuse "causes adult psychopathology." Moreover, she reports, it appears some girls from middle-class homes who suffer abuse actually "overachieve" in life, as if to compensate for the trauma. (However, even if every illicitly fondled girl grew into a marathon-completing MBA from Harvard, with a four-bedroom Tudor in Scarsdale and an orthodontist husband, Acocella would criminally punish the man who touched her.)

By the 1980s, though, things had changed. Suddenly child abuse stories seemed to be in every newspaper and magazine and bookstore. Television talk-show hosts — Phil Donohue, Oprah Winfrey, Geraldo Rivera — spiked their ratings with discussions of this plague. Celebrities energized careers with accounts of their personal victimizations. (Confessions came from, among others, sitcom stars Suzanne Somers and Roseanne Barr, a former Miss America — and Spider-Man.) Abuse charges became as common in child custody battles as boasts about the benefits of competing neighborhood schools. As if to make amends for having overlooked the issue for so long, the press teemed with stories of child brothels, child auctions, and ritualized abuse of children by satanic cults, motorcycle gangs, and entire preschool staffs — sixty-three in the Los Angeles area alone — almost all of which ultimately proved to be unfounded. Under one popular theory, a cult involving Nazi scientists, a Kabala-schooled Jew ("Dr. Green" — formerly "Greenbaum"), the CIA, NASA, and the heads of Fortune 500 companies was involved in victimizing tens of thousands of children. Another implicated some of the same suspects, along with Hallmark Greeting Cards, FTD Florists, and the Jerry Lewis Telethon, in an international ring that had been engaged in gang rapes, infanticides — sometimes by decapitation, sometimes by live burial — and cannibalism for centuries. It had reached the point that, Lawrence Wright reported in *Remembering Satan*, half the social workers in California believed that Satanic Ritual Abuse not only existed but "involved a national conspiracy of multi-generational abusers and baby killers." By the mid-Eighties, fifty-to-sixty-thousand satanic murders were supposed to be occurring in the United States annually, despite the fact that no one had been convicted of *any* of them, the total number of homicides reported for *all* reasons was less than half that, and investigations by the FBI and the National Center for Child Abuse and Neglect had not turned up evidence of a single one.

Most commentators eventually concluded that these stories were unfounded, attributable to children (or adults) who had been carried away by other traumas or fears or fantasies or whose memories had been polluted by over-zealous therapists or prosecutors. One or two dissenting theorists suggested that clever rings of non-denominational sex deviates may have deliberately spiced their own practices with pseudo-satanic elements in order to discredit any victims who dared report them. Louise Armstrong, author of

Rocking the Cradle of Sexual Politics, took hope in a British study of eighty-four reported cases of "organized abuse," which had found evidence of *non-*satanic rituals in three, and concluded that future studies might yet "turn up ... [abusers] with ties to pornographers or other criminal elements, or even to some unconventional belief systems." And others retained a grip on their original belief because of the elusiveness of truth. "We may never know what happened," the law professor John E. B. Myers wrote about one mass abuse case. "There is no single, simple answer." "All the questions may never be answered," the journalist David Hechler echoed. "The full explanation of what occurred [in many cases] may not yet be available."[25]

Within the child-abuse arena, father-daughter incest commanded special attention. For the Harvard professor Judith Lewis Herman, incest — dependent, as it was, upon the authority of the father, the silence of the mother, and the submissiveness of the child — was practically as integral to the dreaded patriarchal family as dad carving the Sunday roast. For the anti-porn crusader Andrea Dworkin, incest was how girls were acculturated to their future role in society. It was, Florence Rush wrote in agreement, "a process of education which prepares them to become the wives and mothers of America." (Armstrong, from whose book Rush's quote is taken, then posits that the sexual abuse of boys is society's way of schooling them to abuse girls when they become adults.)

With certain exceptions — the royal families of ancient Egypt and Incan Peru among them — human societies have always condemned incest. (Experts differ about the reason for this condemnation, attributing it variously to a fear of the genetic degeneracies of inbreeding, to a desire to promote stability within the family — or marriage outside it, or simply to establish a behavioral line in the sand, the crossing of which signified utter moral rot.) Every state outlawed incest; but until the mid-1970s, prosecutions were rare. Only a small percentage of father-daughter incest cases were believed to be reported, and less than one-tenth of those resulted in convictions and imprisonment. The private nature of the act made corroboration of the victim's charges difficult. (In some states, the child was considered a consenting partner or accomplice, making conviction without corrobora-

25. As I write, no new SRA rings have been uncovered within the United States in over a decade. Some may, therefore, conclude the fiends have become more skilled at concealment.

tion impermissible by law.) Many victims were too young to recall events with the specificity successful prosecutions required. Many were pressured by mothers and siblings into recanting in order to keep their families from being destroyed. Many dropped their charges out of embarrassment or a fear of a criminal justice system which, Judith Herman wrote, afforded "more comfort and protection to the male sex offender than to the female victim." (As examples of this "comfort and protection," she cited his rights to a public trial, to cross-examine his accuser — and to be presumed innocent.)[26] And when cases were prosecuted, victims were forced to re-experience the traumas of the abuse — and a defendant's acquittal could be emotionally devastating for his accuser.

As with general childhood sexual abuse, it was unclear how pervasive father-daughter incest was. Contemporary activists ridiculed previously accepted texts which claimed that only one woman in a million had been an incest victim, preferring more recent studies that put the figure between one in one hundred — or even one in twenty — or ten — or four. (A survey of the statistical studies of incest by Adele Mayer in 1985 found them to be "unreliable and inaccurate and the methodology... fallacious," with data having been culled from small, skewed portions of the population and then used to support "morally and politically determined conclusions...." Mayer reported that incest had been declared "statistically minor," when compared to other forms of child abuse, as well as "many times larger," suggesting that when it came to picking a number in which to believe, the selections were about as great as those on the racks at Loehmann's.)

Whatever its extent, incest had a compelling grip on the public imagination. It was a staple of a subset of pornography, usually set in good, old, home-as-castle, Victorian days, with fathers boldly rogering their reluctant daughters (or wards). During the swinging Sixties, when incest provided the climax for the black comedy *Candy*, it was meant to elicit a shocked guffaw; but, by 1975, when its revelation ended the Oscar-winning *Chinatown*, viewers were expected to gag and shudder. The fact that six of the seven books on the subject I grabbed from the shelf at the main branch of my pub-

26. Louise Armstrong proposed that this last unfairness be balanced by a presumption that all child victims in abuse cases were telling the truth. How else, she wondered, could they receive justice, when their testimony "fundamentally challenges the historical rights and privileges of a patriarchal society... [the] sexual exploitation of children."

lic library system had been published between 1981 and 1986, suggests that, by Dwaine's arrest in 1989, incest was a crime whose time had come.

By the late 1970s, the fear of the consequences of America's new sexual freedom had led to major changes in its legal system. Local prosecutors became more aggressive in their enforcement of existing statutes and legislative bodies more creative in enacting new, censorious ones. Child abuse laws were expanded to cover even nonviolent sexual acts. The time limit within which such prosecutions could be brought were extended. Zoning ordinances and public nuisance laws were used to curb the spread of adult businesses. Magazines, like *Hustler*, whose covers were seemingly viewed as capable of converting casual observers into rampaging Visigoths, were ordered sheathed in wrappers of burka-like opaqueness.

The federal government also leaped into the fray. Between 1977 and 1988, Congress enacted a Child Protection Act, a Protection of Children Against Sexual Exploitation Act, and a Child Protection and Obscenity Enforcement Act. It created a National Bureau for Missing and Exploited Children and granted the National District Attorneys' Association one-and-a-half million dollars to create a center to train investigators and prosecutors to handle abuse cases. Ronald Reagan's election as president, in 1980, coupled with the Republicans gaining control of the Senate for the first time in decades, seemed to symbolize the triumph of those who desired a return to the calm and soothing, everything-in-its-place, and Lucy-and-Desi-in-separate-beds 1950s. As part of that restoration, a newly convened Attorney General's Commission on Pornography, embracing the testimony of the feminists and fundamentalists, sought to overturn the conclusions of a presidential commission ten years earlier that no causal relationship existed between explicit sexual material and criminal acts by, among other things, redefining "cause" and relying on its members' "common sense" rather than scientifically validated evidence.

In 1982, the United States Supreme Court joined this campaign with its decision in *New York v. Ferber*. Ferber had been convicted of violating a statute which criminalized visual depictions of "sexual acts or lewd exhibition of genitalia" by children under the age of eighteen, through his distribution of a film that showed two teenage boys masturbating. The New York Court of Appeals had reversed his conviction because the film had not been found to

run afoul of the existing standard for establishing obscenity, which required that a work, as a whole, be without artistic, political, or social merit. But the Supreme Court held that "the exploitive use of children in the production of pornography" was so great a social problem that states ought to be allowed leeway in combating it.[27] To assist these states, the court declared pornographic works depicting children ineligible for the protection of the First Amendment of the United States Constitution and held that such works, even if not obscene, could be banned.

Congress took advantage of this ruling to enact legislation that outlawed non-obscene but sexually provocative pictures of children — and by raising the age of a "child" from sixteen to eighteen — resulting in nearly ten times as many convictions for child pornography in the next two-plus years as there had been in the prior seven. Lower courts were emboldened to sustain convictions in cases when the child depicted was fully clothed — or if it wasn't even an actual child being depicted but a representation of one. (The reasoning in these decisions was that the state had the right not only to protect children used in the making of pornography but the children who might be led into sexual acts by being exposed to seductive material.) Such decisions eventually led to criminal prosecutions of nationally known art photographers, a sixty-five year old woman who took nude photographs of her grandson, an NPR reporter researching a story on child porn, and a video-store clerk who rented *The Tin Drum* to a customer.

This climatic shift in attitudes toward child abuse, as with so many sociopolitical issues in America, seemed to have been effectuated less by studied logic, scrupulous research, and patient wisdom than by a combination of crusader spirit, self-righteous zeal, blind-eyed stupidity, steel-knuckled meanness, inquisition-strength intolerance, star-shine idealism, teeth-chattering terror, and bugfuck looniness. It was also unclear how much it accomplished. Within a decade of the passage of the last bill mentioned above, activists were reporting that not only was the number of confirmed abused children

27. The problem was, according to the court, that the psychological damage caused such children could handicap them in developing into healthy citizens. It is not clear in reading the opinion that the boys in the film whom New York was protecting by prosecuting Ferber were, in fact, from New York — or even America. It is also unclear what evidence had led New York — or the court — to conclude that teenage boys who would masturbate on camera would grow up to be less healthy than those who, for instance, considered the activity a mortal sin.

rising by ten percent a year, but the percentage of them receiving aid was declining. And the purported advances in the delivering of punishment to identified abusers often seemed offset by abuses levied by prosecutors pursuing them. The poster child of these cases involved the McMartin Preschool in Manhattan Beach, fifty miles south of Simi Valley, where, in 1983, seven child care workers were charged with abusing three hundred sixty children. Their prosecution took ten years, cost taxpayers fifteen million dollars, traumatized nearly everyone involved, including the children, and, though at one point ninety percent of the population of Los Angeles County was reported to have believed in the crimes' occurrence, never proved anyone guilty of anything. By 1985, a national organization, Victims of Child Abuse Laws (VOCAL), had been formed, claiming to speak for fifty thousand families damaged by wrongfully brought charges of child abuse. To some commentators, it appeared the country was being suckered into focusing on the statistically minor problem of child sexual abuse to distract it from the elimination of social programs, the effect of which has been to condemn twelve million children to lives of poverty, without adequate health care, nutrition, education, housing, or a likelihood of economic betterment.[28] "It is wrong to single out sexual abuse as the worst harm to children," wrote Judith Levine, one of these commentators, when in the United States, "child abuse is business as usual."

The vectors of anti-pornography and anti-child abuse thought converged upon Dwaine Tinsley as a perfect storm through the work of Judith Reisman, PhD. (The former Judith Bat-Ada, Reisman had previously been best known for accusing Alfred Kinsey of torturing children as part of his "research" while pursuing a secret agenda of acclimating the public into accepting homosexual and pedophilic behavior.) In November 1983, the Reagan Justice Department, through its Office of Juvenile Justice and Delinquency Prevention, commissioned Research Project No. 84-JN-AV-K007, with Reisman as Principal Investigator. The project cost seven hundred, thirty-four thousand dollars and resulted in a three-volume, two thousand-page report, entitled *Images of Children, Crime and Violence in* Playboy, Penthouse

28. A study a decade later reported that children in families with annual incomes of under fifteen thousand dollars were twelve-to-sixteen times as likely to be abused physically — and eighteen times more likely to be abused sexually — than those with family incomes of thirty thousand dollars.

and Hustler.

Reisman and ten associates studied six hundred eighty-three issues of these magazines. They established that they commingled forty-four thousand visual representations of adult female nudity (thirty-five thousand breasts and nine thousand genitalia), six thousand visuals of children, and fifteen thousand of crime and violence, for twenty-five million readers a month.[29] This mélange's blurring of age distinctions, Reisman argued, made children "more acceptable" as objects of sexual desire for adults and provided these aroused adults glossy, readily available aides "to lure and indoctrinate" children into performing sexual acts. The cartoons in these magazines, she said, played a particularly insidious role in this process. Cartoons were accessible to and popular with children. Because they appeared "light and guileless," cartoons could humorously trivialize societal taboos, enabling them to slip through normal resistances, arousing their viewers' sexual interests and legitimizing their sexual behavior. *Hustler*, Dr. Reisman calculated, had about twice as many such images a month as *Playboy* or *Penthouse*. And the cartoonist she identified as the chief offender, with one hundred forty-five black-marks to his credit, was Dwaine B. Tinsley. The runner-up had ninety.

John Heidenry, the sex historian, has called *Images of Violence* "the biggest anti-pornography boondoggle of the century." It was so unpersuasive that the Justice Department refused to release it. (Reisman charged that this suppression was the work of the sex industry's previously undocumented "deep personal and economic ties to the conservative movement, the Reagan Administration and the Republican party.") Her thesis did not even seem to fit Dwaine's situation. As the creator of Chester, not the consumer, he presumably had the images that became his cartoons in his head, proud and whole, and did not need to see them on paper to have them made "acceptable." And little in the acts he depicted seemed likely to "lure" children into participating in them. Chester was an unpleasant fellow and his girls generally stunned or shocked by what he had in mind for them. They were clearly to be seen as victims, not fellow-revelers. Yet the Ventura County district attorney's office would herald Reisman's report as "a great piece of work,"

29. *Playboy*'s circulation was about fifteen-and-a-half million, *Penthouse*'s seven million, six hundred thousand, and *Hustler*'s four million, three hundred thousand; one would expect some duplication of readership. (By way of comparison, *Ms.* had a circulation of one million, six hundred thousand, *Vogue* five-and-a-half million, and *Sports Illustrated* thirteen million.)

and it would be crucial to its approach to Dwaine and Veronica. A person sympathetic to Dwaine's claim of innocence, might have concluded that a PhD's mingling, through footnote-bolstered print, of *Hustler* cartoons and child sexual abuse had made the guilt of a *Hustler* cartoonist charged with such crimes seem inevitable to those inclined to convict him anyway — that the Reisman report had lured and indoctrinated the district attorney's office into prosecuting charges of which others might have been more skeptical.

VII

In the spring of 1977, Parent Locator, a service that tracked down dead-beat dads, had found Dwaine in Columbus. He had agreed to pay Charlotte the back child support he owed, keep current, and pay for Veronica's clothes and medical bills. In return, he wanted to see his daughter. In May, he and Debbie visited her in South Carolina. They took her to Toronto and Niagara Falls. After that, Dwaine spoke with Veronica every week. He wrote her letters. He told her how much he loved her and missed her and how wonderful she was. He sent her presents. He showed interest in everything she had to say. He told her she was beautiful.

Veronica visited Dwaine and Debbie every subsequent summer, except 1981, when Charlotte refused to allow it. During these visits, he spent thousands of dollars on her. He bought her toys and books and meals at five-star restaurants. One summer, they visited what seemed like every amusement park in California. He was kind and generous, Veronica would later recall, and her mother was mean and poor. ("You've seen *Mommy Dearest*, the movie? That was her — except without the money.") After a beating by her mother, Veronica would hide in the woods clutching a picture of Dwaine.

In the summer of 1979, following Charlotte's remarriage to a master sergeant in the United States Marines, Veronica asked Dwaine and Debbie if she could live with them. She hated, she said, her stepfather and stepsister. She would sit on their couch, Debbie would say, telling stories about Charlotte "so filled with hate you could literally feel it." The stories, Debbie said, broke her heart.

Dwaine and Debbie believed Veronica too young to decide with which parent to live. They thought she might change her mind. But she kept asking. In February 1982, they proposed to Charlotte that Veronica live with them on a trial basis. Charlotte refused. In September 1983, Dwaine petitioned Family Court in Summerville, South Carolina, outside of Charleston, for custody of his daughter. Charlotte cross-complained that he still owed her $3050 in child support — and asked to have the monthly amount of his payment increased.

Dwaine had come a long way since his days of selling blood for food. He earned over five thousand dollars a month; and Debbie, whom he had married in Las Vegas on his birthday in 1976, earned another fifteen hundred. They had gone from sleeping in their car to living in a four-bedroom house in Sherman Oaks. They had a 1980 Thunderbird, a 1981 Datsun ZX, five thousand dollars in furniture, twenty-five hundred in jewelry.

Dwaine had become a minor celebrity, recognized in public, bought drinks, asked to sign cocktail napkins, offered... well, one can imagine. He had primed his climb — and maintained his perch — with alcohol, black coffee, cigarettes... other stimulants. He went weeks when he was out every night, closing bars, not knowing in what bed he'd awaken. He had stimulated himself in other ways too. He read voraciously. He talked with fervor and conviction on whatever topic conversation offered. He improved how he ate and dressed and spoke. (He compiled lists of Latin words and phrases with which to enrich his vocabulary.) He took up golf. He could not bury his past deep or fast enough. He had been seized by the idea of betterment, which he coupled with a belief that those positioned above him were already his inferiors. He surpassed them through his artistry, his honesty of vision, his triumph over a brickload of hardships the hefting of which would have snapped any of their spines. He then only to smooth some edges to deprive them of their last arguing points.

It had not been easy. The drinking had taken its toll. So had an affair with a woman in the office. Even work had become a problem. Wracked by pain and paranoia, Larry Flynt had locked himself inside his mansion behind steel bars, surrounded by security guards. Dwaine had to visit every month to select cartoons for the next issue. "You'd be patted down by these goons," one *Hustler* employee recalls. "Larry'd be lying there on his four-poster bed, sweat

pouring out of him. Althea'd be spaced out on junk. At some point, Larry'd inject himself with something from this black leather Gucci bag, and you'd realize, 'Well, that's that.' It was not exactly conducive to looking at art."

One day in 1979, Dwaine had pulled onto the side of the freeway, shaking uncontrollably, afraid he was going insane. He had entered therapy with Gary Chase, M.D, a Beverly Hills psychiatrist, whom he saw for the next several months. One result of this treatment was that he had ended his affair. Another was that he had taken a leave of absence from his position as cartoon editor. He and Debbie moved, first, in August 1980, to Houston and then, in February 1982, to Richmond. There, on July 13, 1981, Debbie, who had already miscarried three times due to her obesity, gave birth to their daughter, Lori.

In September of 1982, when his new cartoon editor demanded a raise, Flynt fired him and asked Dwaine to return. He was there within seventy-two hours.

The custody hearing, before Judge Maxey A. Waters, a deacon in the local Baptist church, ran May 31st and June 1st, 1984.

Dwaine's case was presented through his testimony as well as that of Debbie, a teacher at Veronica's school, its vice principal, and two representatives from South Carolina's Department of Juvenile Placement. This evidence established that, when Veronica was ten, Charlotte had made her cut her hair as short as a boy's. When Veronica entered puberty, Charlotte had forbidden her to wear make-up. Charlotte bought Veronica clothes at garage sales and made her wear the same outfit for a week. ("She did a lot of things to make me appear and feel ugly," Veronica said later, "that I was nothing but a loser, that I would get nowhere.") Charlotte had disciplined Veronica by spanking her with her bare hand, a belt, a shoe, a hairbrush, a wood coat hanger. Charlotte had held a scissors to Veronica's throat. Charlotte had locked Veronica in a closet, and had allowed her step-father to beat her with a breadboard. Veronica had done poorly in school and was constantly on restriction. She had been suspended five times for smoking, cutting class, swearing at teachers, possessing drug paraphanalia. (She had been smoking marijuana — and occasionally hashish — since she was eleven.) She had seen a psychologist and drug counselor for a year, but her behavior and grades had continued to deteriorate. She had been arrested for shoplifting. She had been

picked up by police for having stayed away from home overnight. In March, she had sneaked out of the house and come home the next morning, reporting that a nineteen-year-old boy she had just met had raped her. (Veronica had told the doctor who examined her that she had been sexually active for two years. She had been writing in her diary about boys she wanted to "fuck" since she was ten.) Eventually, Charlotte had reported to juvenile authorities that she could not control Veronica and that she should be jailed. Dwaine and Debbie promised to help Veronica by attending to her "educational and spiritual upbringing." (Judge Waters also heard from Veronica in private. She told him she wanted to live with her father because she "could not communicate with her mother.")

Charlotte denied mistreating Veronica. ("The coat hanger, the scissors, the breadboard, never," she says now. "That's a child's imagination. I never forced her to wear old clothes. Veronica cut her own hair. She made all this up, so she could live with Dwaine. Take the wicked mother out of the picture. All I've ever done is pray for her and suffer through all the lies. I was just a mother trying to keep her daughter in control.")[30] She argued that she should retain custody of Veronica because she taught Sunday school, while Dwaine worked for *Hustler* — and had created Chester. She and Veronica had recently "become close," and she was prepared to seek counseling to improve their relationship. Dwaine, Charlotte said, had no experience with teenage girls, and Veronica had deliberately gotten in trouble to provoke Charlotte to send her to live with him.

When both sides rested, court personnel asked Dwaine for his autograph.

On June 25th, Judge Waters found that Veronica's "strained" relationship with her mother had resulted in behavior that must be stopped. While Dwaine's employment raised questions about his "character and morality," Veronica's present situation was already desperate. She was beyond Charlotte's control and had been physically abused by her. The judge believed Dwaine

30. Charlotte reasons that Veronica's bad behavior stemmed from when Dwaine "first did her." But at the time of the custody hearing, the only abuse that Dwaine was alleged to have committed was the digital penetration at the LAX Sheraton; and if Charlotte is correct that Veronica made up the abuses of which she accused her, it makes Veronica seem more capable of having made up those of which she later accused Dwaine.

and Debbie showed a "general concern" for Veronica's welfare and were best suited to provide the "suitable environment" her well-being required. He awarded Dwaine custody. He granted Charlotte reasonable visitation rights, including one week at Christmas and two months during the summer, and awarded her $1625 in attorney's fees. (He also found that Dwaine was not only current in his child support, but that he had overpaid Charlotte by $600, having voluntarily increased his monthly payments by $35 in 1981.)

Charlotte would not see Veronica until she came to her high school graduation. Their phone conversations in the interim would be brief and strained.

Dwaine brought Veronica to California for the Fourth of July. She called it "the best day of my whole life." She considered her father to be her "knight in shining armor."

There are two versions of what happened after that.

VIII

Dwaine and Debbie's version[31] began with the belief that Van Nuys Junior High School, which Veronica would have attended had they remained in Sherman Oaks, had too many gangs and drugs for the educational and spiritual uplift they had promised Judge Waters. So shortly before she was to have begun ninth grade, they moved to Simi Valley and enrolled her in Valley Junior High.

Simi was a bedroom community for Los Angeles, twenty miles to its southeast. Eighty-six percent of its hundred thousand residents lived in parent-child homes. The median family income was fifty-five thousand dollars a year. Ninety-five percent of its work force was employed. That meant, one resident said, "Weekdays, between nine and five, ninety percent of the people in town were under eighteen."

That also meant, for those inclined toward late-afternoon assignations — whether age appropriate or not — few adults were around to rap on the door.

To make up for abandoning Veronica when she was young, Dwaine spent as much time with her as he could. He may have had little experience being a father, he thought, but he knew how to be a friend. He took her to the office, dinner, movies, museums, on walks, when he golfed. They discussed

31. This composite is based upon their testimony at Dwaine's trial and the letters each of them wrote to the county probation department. Where there were conflicts, unless it was insubstantial and improved narrative flow, I have followed the testimony.

everything, from past experiences to future plans. He enjoyed her "spirit," her "fire," her sense of humor. Sometimes he bought her a margarita or let her sip his beer.

One Saturday in December, that first year, while Debbie was visiting her terminally ill mother in Virginia, Dwaine and Veronica crashed a private wedding party at a hotel restaurant, following a round of golf. They danced and mingled and drank wine. On the ride home, Veronica nuzzled against him. She told him she loved him and kissed him on the neck. In her kiss, she used her tongue. "Take it easy," Dwaine said. She lay her head on his shoulder. She kissed his neck again and put a hand on his thigh and kneaded it. He patted her head, and she seemed to sleep. Dwaine felt "shakey/nervous." When they got home, Veronica went to bed. He watched TV and fell asleep on the couch.

He did not, it appears, tell Debbie about this behavior. Nor did he testify to it in court. Nor did he, anywhere I saw, expound upon the nature of his "shakey/nervous" feelings. (While he related this in the preliminary draft of his letter to the probation department, like his account of what took place at the LAX Sheraton, it appeared in the final version heavily edited. In that version, there was one kiss, no tongue, and no hand kneaded anyone's thigh.)[32]

Veronica listened to the usual teen music. She read the usual magazines. She became a fan of no one further out than Madonna. But even in Simi Valley, it did not take long for Veronica to find friends of whom Dwaine disapproved. ("Stoners, heavy metal people," she called them proudly. "Party animals, dopers, low lifes," he scoffed. "A bimbo," he pronounced the girl to whom she was closest.) She began lying to him and Debbie. She stole from them and her classmates. She skipped school. She was disruptive when she attended. Her grades fell. She was so jealous of Lori, Dwaine and Debbie

32. In *Prisoner of X*, a memoir of his twenty years at Larry Flynt Publications, Allan MacDonnell, *Hustler*'s former executive editor, recalls Dwaine with Veronica at the office Christmas party the year of that ride. MacDonnell, whose pages practically quiver with revulsion at each mention of Dwaine, reports he held her in "the seasoned con's embrace of his reluctant punk." "You don't see a little girl this pretty every day," he quotes Dwaine as saying.

Veronica, herself, carried away only favorable memories from the *Hustler* parties she attended. She would never claim to have felt mauled or demeaned or exhibited uncomfortably. She was dazzled by her father's apparent fame and Larry Flynt's — or as she called him, "Uncle Larry"'s obvious wealth. The *Hustler* world was "glamorous" and "exciting" but, at the same time, "normal." "No other kids had that type of lifestyle," she would say. "I thought I was special."

were afraid to leave them alone together. Veronica seemed most comfortable, Dwaine would later remark, "When she'd come across as a sexy little kitten in skin tight clothes." (He kept this assessment from the jury as well.) Debbie would say of Veronica's choice of couture, "She had a Frederick's of Hollywood mentality."

"Dad," Veronica would say, "I'm gonna be a fuckup, just like you."

"No, you're not," he would say.

"I'm gonna be the hottest chick in Simi Valley."

"No, you're not, either."

One night, she said she and a girlfriend were going to a movie. Instead, they went riding with two boys, and she came home drunk. Dwaine and Debbie grounded her. Veronica became more confrontational. They grounded her some more. It seemed they were discussing her behavior for two, three hours every night.

During 1985, Dwaine would come home from work at any hour, six-to-eight drinks to the better. "A happy, mischievous drunk," he saw himself. Often, he'd wake Veronica to have someone with whom to extend his good time. More than once, he passed out on her bed. (He did not relate this behavior to the jury either. Nor did he mention that, on some occasions, when he looked in and saw her sleeping in the nude, instead of turning away, he entered her room and pulled up her sheet.)

Twice, he hit Veronica. Once for stealing. Once for cutting school and smoking marijuana with friends. ("Hey, man," she said, "it's no big deal.") Once, when he was goading her to make something of herself, she hit him. He smacked her back. ("Don't just strike out," he said. "Be prepared for payback.") Once, after another fight with him and Debbie, Veronica went into the bathroom and nicked both wrists with a razor. Dwaine and Debbie took her to Dr. Sandra Greenfield, a child psychologist in Westlake Village, whom Dr. Chase had recommended. Dwaine and Debbie saw her as well. But when they decided Veronica was using what she learned from Dr. Greenfield against them, they terminated all treatment.

On December 31, 1985, his fortieth birthday, after a final glass of Dom Perignon, Dwaine stopped drinking. (Veronica was pleased, though, she later complained, he had been "more fun" before.) He spent more time at home.

He concentrated on being Veronica's father, not her pal. The bimbo moved away. Veronica's grades remained "C"s and "D"s and her behavior problematic; but, overall, things improved. She became active in The Pioneer Players, her high school's drama group. She sang; she danced; she showed real talent as an actress. The friends she made there seemed a good influence. The summer of 1986, on a family vacation at Lake Tahoe, Veronica began dating a pre-dental student at U.C. Davis. Around Christmas, she asked Debbie for birth control pills. But a few months later, Veronica broke off that relationship and began seeing — and having sex with — other boys and, sometimes, men. "It's my body," Veronica told Dwaine and Debbie. "It's what guys expect." ("Sometimes," Debbie said, "she liked it; sometimes she didn't; but it got her what she wanted.")

In the summer of 1987, Veronica took a job at Domino's Pizza. When she wasn't working, she partied. When her senior year of high school began, she kept partying with her friends from work. Her grades fell; so did her attendance. The Pioneer Players expelled her. She became sullen and uncommunicative. Her mood swings were abrupt and deep. She often came home drunk or high. Her weight dropped. Her skin turned "leathery."

In the spring of 1988, Veronica admitted to Dwaine and Debbie that she had been using cocaine. She hated her life. She had lost most of her old friends. She had lost all respect for herself. She had been become "a slut," exchanging her body for drugs. She swore she would stop — but once she graduated, she lost all restraint. ("It was," Debbie said, "like somebody had thrown a time-released fragment bomb into our lives.") She went to the beach every morning. She went out with a different boy every night. Dwaine and Debbie did not know when she would be home. They did not know what lie they would hear when she called. They did not know what pains they would feel after she hung up. If someone rang their bell at night, they feared the Highway Patrol would be asking them to identify her body. ("Don't worry, man," Veronica said.) They fought constantly with her. In August, while they were in Las Vegas, she threw a party that trashed their house.

One morning, Veronica reported that a cocaine overdose the evening before had thrown her into convulsions. That scared her into doing better. Dwaine and Debbie had already promised her a car when she turned eighteen. Now, hoping it would give her a sense of responsibility, they bought her a 1986 Isuzu I-Mark. (Dwaine co-signed for the loan, made the down pay-

ment and paid the first two months insurance.) Veronica quit her job, failed to make any further payments, resumed binging on cocaine, and stayed away days at a time. Dwaine and Debbie cried. They threatened. They pleaded for her to enter rehab. Shortly before Thanksgiving, she attended one Cocaine Anonymous meeting and came home the next day, wired.

Two days later, while Debbie was on a ten-day trip to Virginia, Dwaine ordered Veronica to move out.

IX

Veronica's accusations had led to Dwaine being charged with sixteen felonies: six counts of child molestation; five counts of incest; and five counts of oral copulation. He had pled not guilty, been released on fifty thousand dollars bail, and forbidden to have any contact with Veronica. (He said he had never been as happy to see anyone in his life as he had Alan Isaacman, Larry Flynt's lawyer, when he arrived at the Simi Valley jail with his bond.) His case had been set for a preliminary hearing the afternoon of July 6, 1989, in Ventura County Municipal Court, in the city of Ventura, before the Hon. John E. Dobroth.

At a preliminary hearing, the state is required only to show that it possesses sufficient evidence to, if believed, convict the defendant of the offenses charged. If Judge Dobroth found this burden met, he would pass Dwaine on to Superior Court, where felonies were tried. Since the state has only to establish a *prima facie* case, the defense rarely presents evidence at a preliminary hearing. Instead, it uses the proceeding to learn as much as it can about the prosecution's case in order to combat it later.

The prosecuting attorney in *People v. Tinsley* was Matthew Hardy. Dwaine was represented by Alan H. Yahr, a trial attorney in his early forties from Sherman Oaks. The state's only witness was Veronica. An hour before she had taken the stand, she had listed on a sheet of paper, beginning in 1983, what grade she had entered in what year. With its assistance, she described the following events.[33]

33. In 1989, the statute of limitations for non-forceful sex crimes against minors under the age of fourteen in California was six years. It was three years for those above that age. Since Veronica had

In the summer before ninth grade (1984), she was swimming in the pool in the back yard of the San Angelo Avenue house. Her father called her over to sit on his lap. When she did, he inserted either one or two fingers into her vagina and kissed her. This lasted for about two hours. It was, she said, the first of about fifteen such incidents to occur by the pool over the next four years.

Later that summer, her father approached her from behind in the pool and inserted his finger into her vagina. They went inside, into a bedroom, where he asked her to suck his penis. When it became erect, they had intercourse.

That September, after her first day of school, her father took her into the master bedroom. He asked her to "go down on" him. When he became erect, they had intercourse.

The summer before eleventh grade (1986), following the family's return from a vacation in Sweden, while Debbie was at work but Lori at home, her father took her into the bathroom and had her suck his penis until he ejaculated in her mouth.

In early 1987, her father picked her up early from school because she was sick. They ate lunch at a Carl's Jr. When they got home, she lay down, and he massaged her. Then he rubbed his penis on her buttocks. He asked her to "go down on" him. When he became erect, they had intercourse.

During eleventh grade (1986-87), she worked at Domino's, from 5:00 to 9:00 P.M., Wednesdays through Saturdays. She and her father would have sex, usually on Tuesdays and Thursdays, when she came home from school. One afternoon, when she got home, he asked her to lie down in Lori's room. He took off her clothes and kissed and licked her vagina for forty-five minutes. After putting his penis in her mouth and vagina, he ejaculated on her stomach.

After her first day of school senior year (1987), her father took her into a bedroom and had her suck his penis. After he became erect, they had intercourse "doggie style."

turned fourteen on October 6, 1984, and charges were not filed against Dwaine until June 5, 1989, the state could only go back to June 5, 1983, to prosecute him for sexual acts with her when she was under fourteen, and to June 5, 1986, for acts when she was above that age. It could not prosecute Dwaine for acts committed between October 6, 1984 and June 5, 1986; and since Veronica has stated the LAX molestation had occurred in 1982, when she was eleven, it could not prosecute him for that.

For her senior prom (May or June 1988), she had bought a red gown. Her father said he wanted to be the first person to "get" her in it. After she had removed it, he had her suck his penis until he became erect. They had intercourse, and he orally copulated her.

Sometime between her eighteenth birthday (October 6, 1988) and New Year's, her father ordered her into the bedroom and told her to "give (him) head." When he became erect, they had intercourse.

Veronica explained that she had sex with her father so often — two, three, sometimes seven times a week, until she was sixteen — and twice a week, thereafter — that she could no longer always distinguish one episode from another. And she explained that while she had reported her mother's abuse to many people — friends, teachers, social workers, Dwaine and Debbie — she had told no one about her father's because he had warned her that while their "love [was]… like no other," "society would not understand [it]." If she disclosed it, he would be in serious trouble and would not love her any more, and she would be returned to her mother, whom she hated and feared. Veronica also stated that for a long period she considered her behavior with her father "normal." Other times, she thought it was her fault because she "was pretty and had a sexy body."

Veronica's testimony had taken less than an hour. Allen Yahr's cross-examination of her ran more than three times that.

During this cross-examination, Veronica admitted that there had been "friction" between her and her father since she was thirteen because of her bad grades, drinking, drug use, and wish to date. He yelled at her, called her names, grounded her, and forbade her to see friends of whom he did not approve. Veronica admitted that she had lost her virginity at age eleven. (She also said it had happened ten years earlier, which would have been when she was eight, and that she had lost it to someone named "Ronnie," which was the name of the young man she had accused of rape when she was thirteen.) She admitted that, by 1986, she was smoking marijuana once a week. By the following summer, she was smoking it daily. In early 1988, she began using cocaine. At first, it was a quarter or half-gram, once a week. (There are twenty to fifty hits in a gram of cocaine.) She would stay out all night. She cared about nothing but getting high. Two or three times a week, she came home drunk or drugged. In October 1988, she had used cocaine every day for three

weeks, and her father kicked her out of the house. (She also said she left on her own to avoid having sex with him. She had come to resent his making her do it, she said. She had come to believe "maybe this wasn't normal.")

After leaving home, Veronica said, she had moved in with Steve Gold. She moved back home for a week but was kicked out again. She moved back at least once more; but, by late December, she had moved out for good. By then, she was using a sixteenth of a gram of cocaine a day. Then, in January 1989, her father "took" her car. (When the Isuzu had broken down, Dwaine had paid to have it fixed and kept it.) She was already mad at him for his lectures, his prying, his yelling, his discipline. Now she hated him. Their past relationship was "hurting [her] inside." In March, she told Gold her father had sexually abused her. He told her to tell her mother. Charlotte convinced her to call the police. (She did not mention Dennis Rohde, the Lamplighter's owner, in this account.) Now she wanted her father imprisoned for the rest of his life.

The exchange of the case most quoted in the press occurred during this cross-examination. "Do you have any estimate of the total number of times that your father had some kind of sexual contact with you?" Alan Yahr asked Veronica.

"Thousands," she said.

"Were there more than a thousand," Yahr asked, "a couple thousand we're talking about here?"

"I'm not saying billions," Veronica said, "because maybe that's exaggerating.... About, at least, 100,000."

"... at least 100,000?"

"Yes."

"Did you have math in school?"

"No," Veronica said. "I hated math."

The inference being drawn by those who printed this exchange was that Veronica's estimate was so ludicrous it made her charges laughable. But two points should be made. First, it did not occur at the trial; therefore, it had no effect on the jury. And second, at this point Judge Dobroth had intervened. "If you had sex three times a week for a year," he asked, "how many times would you have had sex?"

"I need a pen," Veronica said. Moments later, she replied, "I can't think right now. I'm really nervous. I'm going to have to say 100."

So she was in the ballpark, not on Mars.

After Veronica's testimony, the hearing was continued until July 13th to allow the defense to have Steven Gold brought from Los Angeles County Jail, where he was being held on unspecified charges.

Gold described Veronica as his "girlfriend." He testified that they had begun living together around Thanksgiving 1988, two weeks after they had met. He said that the first time Veronica introduced him to her father Dwaine told him, "I don't trust you. I don't want you around my girl." From that point on, he suspected Dwaine had molested Veronica. Whenever Gold asked her though, she denied it. He had never seen Dwaine touch Veronica or conduct himself in an improper way around her; but he considered their relationship and her behavior — often withdrawing "into her own little world" — "weird."

Gold said he called Dwaine occasionally to discuss Veronica. In April, in one of these conversations, he called Dwaine "sick" and asked how he "could do something like that to his own flesh." Dwaine "kept saying 'I don't know what you are talking about...'" A week later, he asked Dwaine if he and Veronica could have the car back. He denied asking him to throw in some money too.

After denying Alan Yahr's motion to be allowed to question Veronica further about her sexual history — Yahr hoped to show she had "confused" her father with other men with whom she had sex — Judge Dobroth ordered Dwaine held for trial. Matthew Hardy told reporters he was pleased the judge had "protected" Veronica. It was common defense strategy in such cases, he said, to harass victims "until they break."

X

Because of the nature of the charges against Dwaine, Ventura County's Public Social Services Agency (PSSA) had instituted proceedings to protect Lori and Kimberly from him. He had agreed to move from the family home and have only limited, supervised visits with his daughters until he had completed a course of "appropriate" psychiatric treatment. Debbie had agreed she and Lori would seek treatment as well.

In late June, Dwaine had re-entered treatment with Dr. Chase. (Debbie had selected Dr. Greenfield, Veronica's former therapist, to treat Lori and herself.) Dwaine had also moved into his own apartment. But within a few weeks, Dr. Greenfield had concluded it would be in Lori's and Kimberly's best interests if a "normal family context and setting" was re-established. She was certain Dwaine posed no threat to them. (She was also unconvinced he had molested Veronica. Even if he had, she said, studies showed that fathers who had participated in raising their daughters since birth, as Dwaine had with Lori and Kimberly, were less likely to be sexually drawn to them than fathers who had been separated from their daughters, as Dwaine had been with Veronica.) She believed all Dwaine required was "an educative process" to learn the wisdom of not showing his daughters his sexual cartoons. She saw no problem with them seeing those that were "social commentary."

Harold M. Maller, M.D., Lori's pediatrician, joined in Dr. Greenfield's recommendation. Dr. Maller stated that both Dwaine and Debbie had been "conscientious" about Lori's care. They regularly brought her to appointments, and he had never seen a sign of her having been abused. Since Dwaine had left home,

however, her behavior had gone "out of control." (She had become depressed and was overeating. She feared Debbie would be taken from her too and had unhealthily associated Kimberly's birth with Dwaine's leaving.) The doctor believed the family's immediate "restoration... essential for her mental well-being."

In late July, Debbie proposed to the county that Dwaine be allowed to move home, but that its representative be permitted to visit them, unannounced, as much as she wanted. When that proposal was not accepted, Dwaine moved home anyway. PSAA then petitioned Ventura County's Juvenile Court to have Lori and Kimberly declared wards of the county. In this petition, Carol Pedersen, a Children's Services Social Worker, argued that Dwaine had not yet completed his treatment with Dr. Chase; that Debbie, who refused to believe Dwaine had molested Veronica, could not be relied on to protect her daughters; and that Dr. Greenfield had grown too "enmeshed" with the Tinsleys to see matters objectively.

This lack of objectivity seemed most apparent to Pedersen in Dr. Greenfield's failure to recognize that Dwaine's work could not be "divorced from his character and behavior." (Pedersen did not explain why this would be truer of Dwaine than, say, Stephen King or Alfred Hitchcock or William Faulkner or Vladimir Nabokov.) He had a "perverted point of view [which] approves of, promotes, and makes fun of child molestation..." (Pedersen did not explain how mocking child molesters correlated with promoting or demonstrating approval of molestation.) Even his social-comment cartoons were "blatantly racist and sexist..." (Pedersen did not cite precedents of other parents who had lost custody of their children for being racist or sexist. Presumably these children would have filled many a foster home.) "[His] work," she continued, "... probably represents only the tip of the iceberg. The numerous pictures of adolescent girls found in [his] possession... points to a very disturbing obsession..." (Pedersen seems to have had in mind the photographs of the five nudes seized by the police. All the young women who posed for them, it turned out, were over eighteen.)[34] Pedersen wanted

34. Pedersen had also recognized in one of the photographs seized by the police a snapshot of Lori in a "sexually explicit pose." Since no one else, aside from the prosecution, who viewed this photograph seem to have recognized its salaciousness, one is reminded of the constitutional law professor Amy Adler's warning that one consequence of our society's obsession with child pornography — and our zest to enforce anti-pornography laws — is that we have become "infected by the sexualization of children." We have become accustomed to looking at their pictures in order "to uncover their potential sexual meaning" — to adapt "the pedophilic gaze" — and lost the ability to simply see pictures of children — and enjoy them — as just that.

Dwaine removed from the home or the children taken into custody.

A hearing on PSSA's petition was scheduled for October 5th. But, by then, the Tinsleys had moved to Woodland Hills, in Los Angeles County, and were arguing that Ventura no longer had jurisdiction over them. The Juvenile Court judge, however, ruled that it did. He continued the matter, and ordered the Tinsleys to appear. But when he learned that Dwaine was again living apart from Debbie and the girls, he deferred the matter until the conclusion of the criminal trial.

When Dwaine had resumed treatment with Dr. Chase, he had also begun a journal in which he made about three dozen entries over the next ten months.

In this journal, in the weeks preceding his trial, in a neat, well-measured handwriting — marred by few strike-outs or erasures and with fewer misspellings than I would have managed — Dwaine described himself as "angry," "paranoid," "manic," "depressed," and filled with feelings of "innocence and outrage." He felt that the district attorney's office was "playing games" — and that the PSSA was "fucking" — with his life. He was being persecuted, he believed, on the "flimsiest of evidence," simply because he worked for *Hustler*. Why, he asked, couldn't Hardy see Veronica was lying? (He wanted to rip his head off.) He instructed himself instead to be cautious, relaxed, patient. To treat this threat "as seriously as cancer." To stop calling the prosecution "idiots." To stop behaving like a wise guy. If he did not correct his course, the state's "impersonal machine" would crush him. Shoulders back, he told himself. Smugness and worry out; confidence in. "[M]aintain... righteous indignation but play it in their playground."

He had "doted on" Veronica once. He still loved her. (And why, he asked, couldn't people see the acts of which she had accused him were impossible for someone who felt as he did?) He was "sad" for her. But the Veronica at the preliminary hearing had been a Veronica he did not know. Why was she doing this? Was she schizophrenic?[35] One night he dreamed she was a scor-

35. According to Dwaine, Dr. Chase had posited that Veronica was a sociopath, with "pockets" of schizophrenia. Her problems, formed during her years with Charlotte, had intensified with her drug use. Dwaine's taking her car may have been the final, mind-snapping straw, for psychotics often seek revenge upon those who disturb their view of how the world should be. And Veronica's view seemingly included her possessing an Isuzu.

pion, stinging him with her tail. When Dr. Chase interpreted this as his being stung by her "sex," he became defensive. (Indeed, "tail" may simply have been a pictorial pun on "tale.") The thought of having sex with his daughter was "reprehensible." He liked "mature females…who have stature, a down to earth classiness, and are full in anatomy."[36] Once Veronica had reached a certain age, he had even felt guilty "checking out" younger women.

In his journal, Dwaine declared himself less appreciative of friends' statements of belief in his innocence — he already knew he was innocent — than he was of their "support." He wanted neither "pity" nor "compassion" but "understanding." While he never elaborated upon the meaning to him of these terms, he believed he had found what he sought with Dr. Chase. Dwaine reported himself in tears at the conclusion of one session. "Even hugged the man," he wrote. Dr. Chase had referred to him as "a decent guy," and "decent" was a word that had never been applied to him before.

In November, because of the possibility that he might be asked to testify, Dr. Chase administered a series of psychological tests to Dwaine. ("We hoped to hit a home run…," Dwaine said. "Instead we got something neither good nor bad.") The results showed him to be reflective, passionate, manic, and creative. He was prone to sexual obsession, sexual behavior, sexual adventures, adulterous flings. ("No shit!" Dwaine commented.) While he could be considered a psychopathic deviant with criminal tendencies, he gave "no 'definitive signs' of being a child molester or pedophile." Dwaine worried that Hardy might make something out of his "sexual obsession" and "crimi-

36. While no one questioned that Dwaine cared deeply about his wife — or that they had an active sex life (Dwaine put its frequency at twice a week) — trial analysts could not avoid speculating about what conclusions a jury would draw after viewing the nubile Veronica in comparison to the near three-hundred-pound Debbie. Detective Galloway, who, as chief investigator for the prosecution, probably spent more time studying Dwaine's cartoons than the combined English, Fine Arts, and American Studies faculties of the Pac-10, has noted that they are overpopulated by obese women — usually portrayed hostilely — as well as Chester's little girls, but are short on "Hustler-model" types. He posits that Veronica may have been Dwaine's in-house "model" substitute.

On hearing this theory, Adele suggested that the obese women in Dwaine's cartoons represented, not Debbie, but his smothering, destroying mother. And, she noted, while we had no direct evidence Dwaine had extramarital affairs after Veronica came to live with him, his work certainly provided the opportunity, if all he wanted was a tumble with Miss October. (Ellen Tinsley says Dwaine had told her he'd had "discrete" affairs throughout his marriage with Debbie — and that he'd had sex with more than sixty women. In order to prove, he'd said, "That he was a bit of a celebrity and not just the town drunk's kid.")

nal tendencies." But he also thought that the results proved he had hidden nothing and had spoken the truth.

That entry was dated November 17th. He did not make another until his trial's end.

In the early summer of 1989, Veronica and Steven Gold had been sleeping in the living room of an apartment of friends of his in a drug-and-gang-infested section of Canoga Park. After Gold's arrest, the friends kicked Veronica out for stealing from them. She thought of moving into a hotel, but the four hundred dollars a week they wanted was more than she earned. To supplement her Lamplighters income, she pan-handled and went from man to man. ("All I had to go on," she would say, "was my looks.") She spent most of what she earned on cocaine. She was sleeping on a couch in an apartment she shared with seven Mexican men when the district attorney's office decided it would benefit its case to put her into Pine Grove Hospital for two weeks' detoxification.

When she was released from Pine Grove, a man she had met in group offered her a roach-infested apartment in a ten-unit complex he managed in Reseda. She had no furniture. She slept on a mattress on the floor. The winos at the corner laundromat were her only friends. She passed her time decorating straw hats she purchased at a nearby crafts store. She cried herself to sleep. One night, after his release from L.A. County, Gold broke into the apartment. He smashed her head into the wall and threatened to kill her. She fled — and moved in with a Persian bartender, ten years her senior, she knew from the Lamplighter. When it cut her shifts, she found work at a coffee shop in Encino, ditched the Persian, moved in with a woman she had just met, and started seeing a nineteen-year-old who was in A.A.

But when Veronica started drinking heavily, that was that.

XI

As I had reviewed the material Ellen Tinsley had given me, conducted further interviews and carried out independent research, I had hoped to reach a definitive conclusion about Dwaine's guilt or innocence. (To be honest, I hoped to decide he had not molested Veronica.) But with each step or two I took in that direction, something goosed me in the opposite. That was, perhaps, an effect of my professional training in a field in which an elaborate system has been constructed to determine whether events have happened — and, as a result of these determinations, the fates of those associated with them (lawyers, to some degree, as well as parties). The mainspring of this system is the requirement that the advocates in these disputes take opposite positions, hold to them as if they were life rafts or most-dearly-beloveds, and fight for them with full force and conviction — and then, theoretically, with their next client, be able to take and fight for the reverse. Long participation in such a system can make one less inclined to think of facts and conclusions as entities sturdy and unshakable as Gibraltar but as more molten and fluid, as composing a reality that exists more on the order of what — as my first-year Torts professor insisted we speak — "the evidence tends to show…" Or as a senior partner in a prestigious San Francisco firm told me when I was starting out, "When you hear someone talk about 'truth,' you can be sure he is not an attorney." (This is not a state of mind totally confined to lawyers. To quote Wright Morris, the National Book Award-winning novelist: "Whenever you rely on human memory, you are writing fiction.")

One place where I had sought guidance in determining what had happened between Dwaine and Veronica was the books I had retrieved from the library about incest. These books, in an effort to assist concerned counselors and therapists, often identified the character traits of the participants in such triangles. But applied to the Tinsleys, the light these lists shed produced more blinks than illumination. For instance, the books consistently described the typical mother as "weak" or "passive," "powerless" or "dependent," often withdrawn from a life with which she can not cope under a cover of imaginary illnesses — none of which applied to Debbie Tinsley. Veronica, however, like the daughter in these books, "adored" her father. She shared confidences and spent a great deal of time with him. She had the textbook problems with truancy, promiscuity and substance abuse; and she possessed a low sense of self-esteem. But she deviated from form in her failure to assume the maternal role within the household (Veronica couldn't keep her own room clean); and she did not suffer the checklist's headaches or nightmares or phobias. Trying to match Dwaine to the father's specifications was even more difficult. "Poor impulse control," "low frustration tolerance," "sexual and emotional immaturity," "need for immediate gratification," "faulty super ego," "alcoholic" — that all seemed to apply. But he hardly presented as "passive," "unconfident," and "shy." He was neither "scared of" nor "no longer interested in women." He was not exactly "respectable," "law abiding," "conventional to a fault," and saddled with a "respect for organized religion." He certainly did not attempt to isolate his family by preventing Debbie from working or denying Veronica make-up, nice clothes, parties, or dates. And not one book mentioned a father who voluntarily took his daughter to a psychotherapist in an effort to cover his tracks.

That alone seemed to me to acquit him.

Matthew Hardy had thought it "inappropriate" to discuss the case with me, so I could not test my doubts with him. But he had referred me to Victor Vieth, a former prosecutor who had specialized in child-abuse cases, and who had been, Hardy said, very interested in *People v. Tinsley*. Vieth is currently director of the National Child Protection Training Center, at Winona State University in Minnesota. While he had not reviewed material connected with the case in years, he generously allowed me to toss thoughts and questions at him.

Vieth agreed that taking one's victim to a therapist was "unusual" behavior for a child abuser. "But," he went on, "predators are very manipulative. And this is someone who's smarter than the average predator. You could expect him to think years in advance how to set up his defense." He then suggested I read *Predators, Pedophiles, Rapists, and Other Sex Offenders* by Anna Salter.

In this book, Salter, a nationally known author and lecturer on child sexual abuse, describes the difficulties in detecting molesters. They regularly present, she says, as "charming," "pleasant," "gentle," "warm." They are the friendly neighbor, the concerned coach, the devoted priest — respectable citizens all. "Many offenders," she writes, "will deliberately establish themselves as the kind of person who wouldn't do that kind of thing." Well and good, I thought. Perhaps this does explain Dr. Greenfield as more cover for the trail. But, taking Chester into consideration, it then had to be assumed that one of these Eagle Scouts had been so diabolically clever he had attempted to deflect attention by pinning to his chest, alongside his Merit Badges, a portfolio that said, "If you are looking for an abuser, think of me."

That, in fact, is the position Victor Vieth took when I got back to him. "At one level, Tinsley's defense is no different from most predators. For those predators who are teachers, priests, etc., their defense is *I'm the last person in the world to do this*. I'm so good and so loving toward children. Tinsley's defense is similarly *I'm the last person in the world to do this*. I make fun of predators. If I ever got caught, there would be all this ammunition against me.'

"Having said this, I'm not sure we should focus on the variations of these defenses so much as how they both reflect the arrogance, manipulation, and tremendous thought predators put into getting away with their crimes. Even the priests and teachers make stupid mistakes, such as receiving pornography at work. Tinsley was similarly bold and thought he could get away with it, either because his victim wouldn't talk or because his above-referenced defense would fly."[37]

37. Ellen Tinsley was unimpressed by the theory that Dwaine had concocted Veronica's therapy sessions as part of an in-case-of-emergency criminal defense kit. "Lord, the man operated on impulse and spontaneity. He couldn't plan further ahead than a golf game. He once decided to go see the Alamo and got four folks to go with him. Didn't pack. 'We'll buy what we need when we get there.' He just wasn't capable of creating an elaborate plot to use some years down the road."

When I raised the prosecution's theory with a prominent criminal defense attorney I know, his response was, "Oh, Jesus!"

But then there was Dwaine's journal.

Why, I asked myself, if Dwaine had molested Veronica, did he keep a journal premised upon his innocence? He could not offer it as evidence. If it was not a true record of his feelings, it seemed an entirely self-directed conceit — a pulling of wool over no eyes but his own. Even if he had not kept a journal before, it seemed perfectly natural that he would begin one now. He was flooded with new thoughts and new emotions. And that is something creative people do; that is a way they find order amidst chaos.

One friend to whom I put this question suggested that Dwaine expected to be acquitted, planned to write about his experience, and wanted this record to draw from. But there was no suggestion by Dwaine, when he discussed future projects in his journal, that this would have been one. Another person posited that the journal was a form of reinforcement to keep at bay the remorse and self-disgust that would have overwhelmed him if he had accepted all that he had done.

When I asked Victor Vieth about the journal, he tended toward this view. "First, how does he know that it's not coming into evidence? Maybe he was hoping it would be used. I find it more interesting that he started it *after* his arrest. I think he was probably writing for history, for his family and friends. Molesters have been known to deny their guilt to the end. I know of a priest, who killed two of his victims, who left a suicide note still proclaiming his innocence."

Victor Vieth impressed me tremendously. His commitment to a vision of a child-abuseless future society seemed almost Martin Luther King, Jr.-like in its strength and compassion. But whenever I spoke to him, I could not help being reminded of the Rule of Teddy Zook. Teddy, a college friend, had once remarked, "Y'ever notice that once you decide somebody's an asshole, everything they do confirms it?"[38]

Then again, I also knew that if you were inclined toward the belief that someone was a conspiracy's victim, everyone who challenged your resolve became another strand in its web.

38. This phenomenon has been more elegantly phrased by Marcel Proust in *Swann's Way*. A person, he said, is "no more than a transparent envelope, so that each time we see the face or hear the voice it is our own ideas of him which we recognize and to which we listen."

It was the conclusion of another walk with Robert the K. I was thinking of stones along a path. You pick one up. You pick up another. You keep putting them in your hand, squeezing tighter so they do not slip. But each stone you add pushes another to the limits of your grip. You try to squeeze the stones more tightly, as if you could compress them into solid rock. Facts, I thought, are like that. You collect the ones that seem attractive. You try to form a thesis from them, solid as rock, before they slip away.

"Won't you have some moral culpability," Robert the K asked me, "for calling favorable public attention to this person, if he did the acts with which he was charged?" We were beside Jewel Lake. In the rushes, a green heron, camouflaged, lethal, frozen stiff-beaked and eye unblinking, waited for a perch to strike. "In point of fact," he went on, "if the worst thing you are accused of is moral culpability, you will be fortunate."

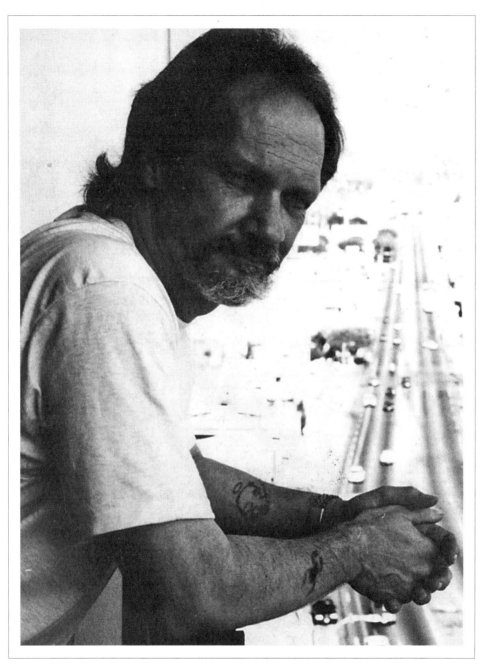

Dwaine Tinsley in 1994: this photo was taken by Ladi Von Jansky.

Original art provided by Ellen Tinsley. Note: this original art is not the penis-puppet cartoon referred to in the trial documents. [©1986 Hustler Magazine, Inc.]

From *Hustler Presents the Best of Tinsley* Vol. 1. [©1979 Hustler Magazine, Inc.]

Original art provided by Ellen Tinsley. [©2008 Hustler Magazine, Inc.]

From *Hustler Presents the Best of Tinsley* Vol. 1. [©1979 Hustler Magazine, Inc.]

Original art provided by Ellen Tinsley. When published, the gag line read "I'd love to go to the drive-in, Jimmy, but my dad has some, uh, extra household chores for me tonight." [©2008 Hustler Magazine, Inc.]

Original art provided by Ellen Tinsley: published in *Hustler*, circa 1992. [©2008 Hustler Magazine, Inc.]

From *Hustler Presents the Best of Tinsley* Vol. 1. [©1979 Hustler Magazine, Inc.]

Original art provided by Ellen Tinsley; also collected in *Hustler Presents the Best of Tinsley* Vol. 1. [©1979 Hustler Magazine, Inc.]

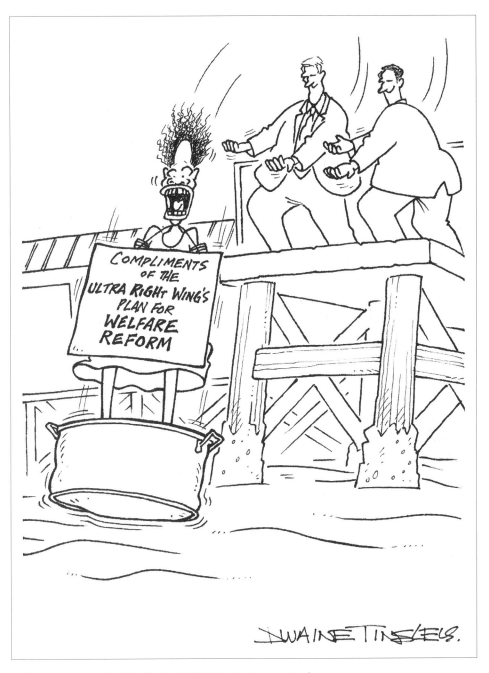

Original art provided by Ellen Tinsley. [©2008 Hustler Magazine, Inc.]

"They say he was once a judge who presided over an obscenity trial. Sumbitch hasn't been the same since…"

From *Hustler Presents the Best of Tinsley* Vol. 1. [©1979 Hustler Magazine, Inc.]

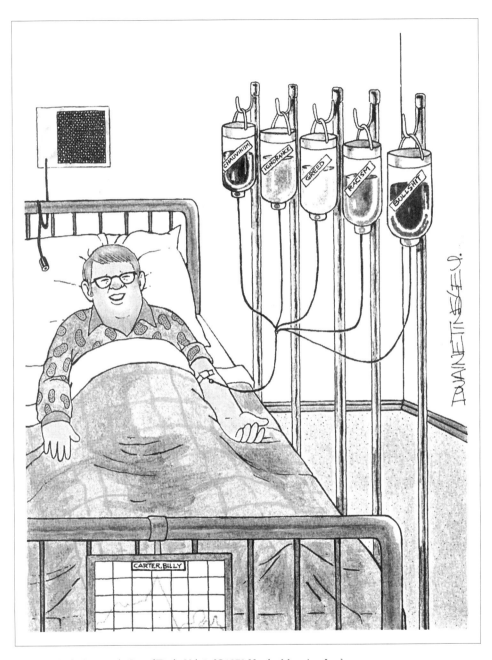

From *Hustler Presents the Best of Tinsley* Vol. 1. [©1979 Hustler Magazine, Inc.]

"Oh, dear God, save this poor sinner from her wayward ways — _after_ she's finished!"

From *Hustler Presents the Best of Tinsley* Vol. 1. [©1979 Hustler Magazine, Inc.]

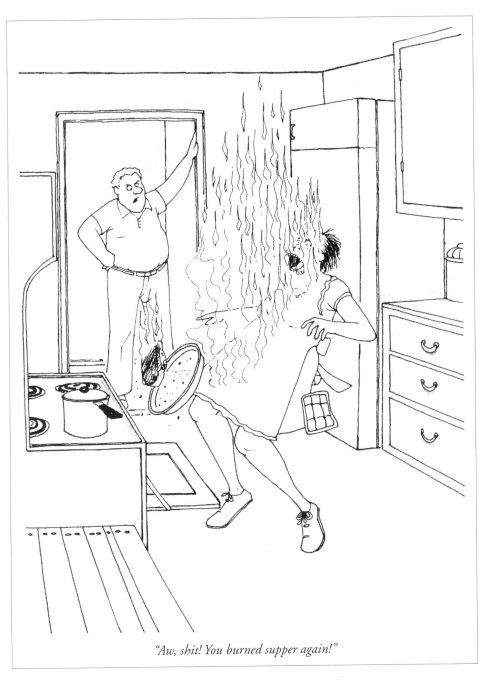

"Aw, shit! You burned supper again!"

From *Hustler Presents the Best of Tinsley* Vol. 1. [©1979 Hustler Magazine, Inc.]

Ellen Tinsley found this Tinsley sketch and finished it (circa 2000), thus becoming one of the rare females to be published in *Hustler*. [©2008 Hustler Magazine, Inc.]

Original art provided by Ellen Tinsley. [©2008 Hustler Magazine, Inc.]

First row: Larry Flynt, Eric Decetis Second row: Dan Collins, George Trosley Third row: John Billette, Dwaine Tinsley and Jimmy Flynt. Probably taken by a waiter at Mr. Chow's.

This portrait of Dwaine and Ellen Tinsley was a wedding gift from Ladi Von Jansky; taken in the *Hustler* studio.

PART TWO

XII

On August 1st, Dwaine was arraigned in Ventura County Superior Court, in Ventura, on the sixteen felonies for which Judge Dobroth had found a case could be made. If convicted of each and sentenced to serve his full terms consecutively, he would spend the rest of his life in prison.

Matthew Hardy had made a bold choice. He could have charged Dwaine simply with one count of continuous illicit sexual conduct — that is, having engaged in three or more sexual acts, over a period of three or more months, with a child under the age of fourteen with whom he resided. Proving this pattern of behavior would have been easier than proving each element necessary to convict Dwaine of the individual crimes with which he had been charged. Dwaine and Veronica had discussed no particular acts in the cool call; defense attorneys were adept at confusing victims of long-term child abuse on the details of what occurred, casting doubt upon their entire story; and Veronica had already proved vague and contradictory about many of the incidents she had described.

Human memory is not the most accurate source for reconstructing past events. It is not as if the mind records a mental video that can then be retrieved by pushing some intra-psychic "Play" button. Memories degrade with time; they are highly susceptible to the suggestions of policemen and therapists and discussions on *Oprah* and *Geraldo*; they blend fantasy into actuality easily. Even the most impressively credentialed experts cannot reliably distinguish true memories from false ones. "Our problem with Veronica was getting her to put things together," Detective Galloway says. "That, at a

particular time, this happened in this fashion. Not that abuse did or did not occur. She tried as hard as she could, but it was easy to mess her up. When things go on two or three times a week, for years, nobody can put individual events together and stay with it. They all glom into one big one." But continuous conduct carried only a sixteen year maximum sentence, and Hardy "wanted a grand slam."

The case had been assigned to the Hon. Lawrence Storch, a former trial attorney, active in progressive causes. He had been appointed to the bench by Jerry Brown, a Democratic governor known for nontraditional, even convention-defying nominations. Judge Storch had developed a reputation for being tough, straightforward, and intolerant of nonsense. He gave Dwaine until August 29th to enter his plea.

When that date arrived, Dwaine had replaced Alan Yahr, whom he had come to consider "too Hollywood," with George Eskin. Eskin was a fifty-one-year-old former UCLA theater arts major. He had been in private practice for nearly a decade, after having served as an assistant district attorney in both Ventura and Santa Barbara counties. He had become a highly regarded criminal defense lawyer — sharp, confident and not overbearing. He and Hardy "had butted heads numerous times," Galloway says, "and Hardy had an ongoing dislike for Eskin."

Eskin, who is now a Superior Court judge in Santa Barbara, does not recall how Dwaine was referred to him. But he does recall liking him immediately. "He was different than most people I had known. He was a creative, down-home guy, with a dialect I found attractive. Like any client, he was in emotional pain. The fact that his daughter was the source made him more so. From the beginning, he was searching for encounters with her where his conduct might have been interpreted to be sexual. Putting an arm around her for comfort. Kissing her forehead. He was devastated by the idea he may have contributed to her having become a drug addict. He felt manipulated by her and her boyfriend. He was wrestling with all these kinds of issues. But there was never a hint he'd done anything that could rise to the level of a criminal prosecution. I believed in him to the end."

Dwaine pled not guilty. Judge Storch set the case for trial on October 27th. (It was later continued until December 11th.) Discussions about a guilty plea went nowhere. Hardy insisted on a felony conviction, which

meant state prison; and Dwaine was unwilling to consider anything beyond a misdemeanor and probation.

Any significant criminal case is fought preliminarily by motions to determine aspects of its conduct. It is as if, before every tennis match, locker-room scuffles resolve the placement of the lines. George Eskin went at it as if the net's height, the balls' weight, the racquets' lengths, the identity of the chair umpire's mother were up for grabs.

Eskin's motions included requests to have the charges dismissed because Judge Dobroth's refusal to allow Alan Yahr to cross-examine Veronica further had denied Dwaine due process of law (Denied); to permit inspection of Veronica's records from Pine Grove Hospital to see if she had made statements to her doctors that contradicted her testimony in court. (Denied — to protect Veronica's right to privacy); to have prospective jurors questioned in small groups in the judge's chambers, rather than altogether in the courtroom, in order to insure their answering candidly (Denied — to save time and maximize court efficiency); to exclude from evidence Dwaine's criminal conviction in Maryland and a *Hustler* cover he had drawn of a woman with a gun to her head (Both granted); to ban the use of the words "victim," "molest," "molested," and "molestation" (Denied); and to allow into evidence the hour-and-a-half statement Dwaine made to Detective Galloway following his arrest (Denied — because once Dwaine had asked for a lawyer, anything he said, even if exculpatory, was inadmissible).[39] Judge Storch ruled that Eskin could introduce evidence of other "false" accusations of sexual abuse made by Veronica against others, because this would establish her proclivity toward a pattern of behavior similar to what the defense claimed existed in this case; but he denied Eskin's motion to allow into evidence proof of false, non-sexual allegations Veronica had made against friends, because this behavior would not. And Judge Storch permitted Eskin to introduce evidence of Veronica's truancy, thefts and drug abuse, because that was relevant to her relationship with Dwaine; but he disallowed evidence that she had stolen from friends to support her drug habit, because that wasn't.

39. All copies of this statement — Eskin's, Hardy's, and the police department's — seem to have been lost. Detective Galloway, however, remembers it as "Nothing but garbage. A bunch of philosophy and questions and his daughter's problems and what he did for a living. He philosophized everything. If you asked him if the sun was shining, you got a discussion."

Then Eskin moved to exclude the fifteen collections of *Hustler* cartoons Dwaine had edited and other cartoons he had drawn — thirty-two hundred cartoons in all — which the prosecution planned to introduce.

To those in the front lines of the war against child sexual abuse, Dwaine must have seemed the Target of the Decade. He worked for the most despised magazine in the country. He had created the most reviled character in cartoon history. And he thought child molestation — the most loathsome bogeyman then rattling our national imagination — a fit topic for humor. One can imagine what the district attorney thought when Veronica told her story. It was a story that had to be true. It was a crime that had to be punished. It was a case that could not be lost. It was, in fact, a case that *must* not be lost, for how humiliating would it have been *to* lose? "You couldn't convict Chester *the fucking* Molester?" There would have been a shitload of laughs at the next convention.

But the case had problems. Veronica's story had no corroboration. (Not so unusual, the district attorney could reassure himself.) Veronica had kept silent for five years. (Not atypical, the D.A. could still say.) Veronica was a drug addict and a tramp. (Bad luck — but that fit those traits checklists too.) The only thing was, when you had a promiscuous, drug-addicted victim, and you had no corroboration, and you had those years of silence, you had a lot of kiddie-fuckers walking out the door. So you could not blame the district attorney for wanting an ace up his sleeve.

You could not blame him for wanting thirty-two hundred.

The rules of evidence control what words from witnesses' mouths may reach jurors' ears. These rules determine what objects jurors may see — what diagrams or documents, photographs or cartoons. It is not as if witnesses, no matter how solemnly sworn to the truth, may say anything, or attorneys, no matter how well-intentioned, may put forward any question. It is not as if the contents of any trunk or drawer or portfolio may be tacked to the courtroom wall. Learned members of the legal profession have written multivolume texts — hundreds and hundreds of pages, thousands and thousands of footnotes — to guide lesser members of the bar to recognize the permissible. But there continue to be words and pictures about which reasonable men disagree.

First, to be admissible, evidence must be relevant. To be relevant, under *California Evidence Code* section 140, evidence must tend to prove the existence or nonexistence of a disputed fact. But relevant evidence may still be inadmissible. Its cost must not outweigh its value. Its proof and rebuttal must not consume too much time. It must not confuse jurors or distract them from more important matters. It must not, as Charles T. McCormick, a professor of law at the University of Texas, wrote a half-century ago in his still-studied treatise, "unduly arouse... emotions of prejudice, hostility or sympathy." It must not, in the words of another commentator, "overwhelm or disable ordinary reason and judgment."

It is within this fertile crevice between relevancy and prejudice that the question of character evidence thrives. The basic rule is that prosecutors may not introduce evidence of someone's "bad" character in an effort to prove him guilty of a crime, unless the defendant has offered evidence of his "good" nature to establish his innocence. The reason for this is that jurors in criminal cases, it has been said, "fret less" over the quantum of evidence necessary to convict a defendant if they believe him a bad person. Jurors are also, studies have shown, easily influenced by evidence that suggests someone is "bad." And evidence of past bad behavior is a demonstrably unreliable indicator of how someone will behave in the future. In one famous experiment, a group of highly trained mental health professionals was provided complete dossiers of individuals who had committed violent acts and asked to predict which had gone on to commit another in the future. In two-thirds of those cases, these professionals were wrong.

There are, of course, as with just about anything that attracts the interest of attorneys, two sides to the question. Some lawyers believe that jurors should always be permitted to consider character evidence. Don't we, these lawyers say, base actions on judgments we have made about the character of people we meet every day? Why, then, shouldn't jurors? Character evidence is always relevant. The only question is how much weight to give it; and a trial affords jurors ample time to cool down from any overheated emotions it might arouse. Besides, as Peter Tillers, a law professor at Yeshiva University, points out in the pages of the *Hastings Law Journal*, the proper "bad character" evidence may have the salutary effect of rousing jurors from the torpor that often besets them during the course of a trial, making them more attentive to the rest of the proceedings. Tillers was answered by David P. Leonard,

professor of law at Loyola Marymount, in the same issue. It was natural, Leonard wrote, for attorneys to wish to "prejudice" jurors with character evidence; but in criminal trials, this prejudice usually can only work against one person — the defendant. Trials should, he said, "reflect our highest aspirations about the search for truth and the protection of individual dignity." Allowing jurors' minds to be poisoned by inferences of someone's evil nature does nothing to achieve either of these goals.

George Eskin did not object to the jury being shown any cartoon of Dwaine's that depicted conduct similar to what had allegedly transpired between him and Veronica. He did not object to it being shown cartoons that had been used to "indoctrinate her or legitimize the conduct in which she engaged." But, he said, to allow into evidence randomly selected, "distasteful and offensive" cartoons served no purpose but to put on trial the tastes that these cartoons expressed. They would "simply disgust most of the jurors." He wanted Judge Storch to evaluate each cartoon individually and weigh the fact-establishing relevance it would afford against the reason-disabling prejudice it would cast.

Matthew Hardy responded that the cartoons were "primarily" Dwaine's work. They showed his "state of mind" was favorably disposed toward child molestation. They indicated his "intent and overall scheme" was to engage in such behavior. He had shown them to Veronica "repeatedly... to lower her inhibitions... and legitimize their incestuous behavior." "They were around the house. She regularly was shown these cartoons... [T]wo...depict things that actually happened to her." She would say, Hardy promised, "that her father... subjected her constantly to these cartoons, showed them to her on a regular basis, discussed [them] with her on various occasions... She will say, 'I remember that cartoon. And that's something that happened between us.' She will say, generally, 'These cartoon books... were in the house.... I looked at them all the time. He and I talked about these cartoons all the time. They were part of our lifestyle, these books."

Hardy's remarks, it should be noted, represented an advance beyond what Detective Galloway had stated in his original report. His "exposed to" — which Webster's defines as meaning "to cause to be visible or open to view" — had now become "subjected to" — which means "cause(d) or force(d) to undergo or endure." The idea, in other words, that Veronica had grown up in the presence of Dwaine's cartoons had mutated into them having been

imposed upon her as a behavioral model.

Relying on the prosecution's ability to prove that Veronica had been "continually bombarded" by the cartoons — that she "on an ongoing basis, read these books or looked at these books or examined these books" and that they had "fostered or generated or induced" her behavior, Judge Storch ruled them admissible.

Matthew Hardy had never specifically said that the cartoons *had* "fostered or generated or induced" Veronica's behavior, but he did not correct Judge Storch when he drew this conclusion.

XIII

On the afternoon of Monday, December 11th, Judge Storch told forty or fifty assembled jurors that the trial for which they had been called could last three weeks. Would that, he inquired, cause anyone financial or personal hardship? He then excused from service a man who was the primary care-giver to a wife with multiple sclerosis, a single mother responsible for her twelve-year-old son, a college professor with one hundred ninety students awaiting final examination, an administrative law judge with a full calendar, a woman under continuous chiropractic care, another with nonrefundable airline tickets, another whose daughter had surgery scheduled.

The names of twelve of the remaining jurors were called. Only when they had been seated in the jurors' box did Judge Storch reveal that the case involved charges of incest, oral copulation, and the commission of lewd and lascivious acts upon a child. Only then did he identify Dwaine as an employee of *Hustler* and the creator of Chester the Molester. Dwaine also, Judge Storch told the jurors, was to be presumed innocent of these charges; and his guilt had to be proved beyond a reasonable doubt. Judge Storch introduced the lawyers to the jurors. He read the names of the potential witnesses. He asked the jurors if they knew any of these people or if they had heard of this case. (Though it had been covered in the Los Angeles *Times* and *Daily News*, the Thousand Oaks *Chronicle*, the Simi Valley *Enterprise*, the Ventura County Star-Free *Press* — and reported on radio and televison — only four of the twelve said they had.)[40]

40. The coverage that I saw was admirably restrained. The L.A. *Times* barely covered the case. *The Star Free Press*, Ventura county's largest daily, limited its accounts to bare bones stories, a few

He told them that they would be questioned, first by himself and then by each of the lawyers, in an effort to select a fair and impartial juror.

This process, known as *voir dire* ("to speak the truth"), allows a lawyer to politely probe prospective jurors for bias and to subtly influence them to adapt a perspective on the case that lawyer favors. ("Brain scanning and brain washing," Hardy called it. Eskin likened it to "a job interview conducted in the presence of a bunch of other people.") It is a critical phase of any trial. Cases are regularly lost because of the juror that slipped through. The search for truth in this case would be conducted within a county not particularly to a defense attorney's liking. Its population was primarily blue collar and conservative. It had voted Republican in every presidential election of the last quarter century, four times by more than sixty percent.

Judge Storch first asked each of the twelve empaneled jurors to provide the information requested on a posted chart: city of residence; marital status; friends in law enforcement; familiarity with adult magazines; knowledge of victims of sexual abuse. He then questioned each juror about their responses. As a result of this process, he excused a woman with a limited understanding of English, a woman with a son in Soledad Prison, a woman who'd been gang-raped when she was sixteen, a woman who'd been sexually abused by her father for six years, and two people who'd known children who'd been abused sexually and believed this knowledge left them unable to be fair in this case.

George Eskin questioned each juror completely before passing on to the next. He asked most if they had ever been falsely accused of anything. Did they, he asked, take the fact of someone's arrest to make likely their guilt of the offense charged? (Six jurors did.) Were they familiar with teenagers who abused drugs? How did they feel about magazines like *Hustler*? Would they afford Dwaine the presumption of innocence Judge Storch had mentioned?

paragraphs in length, always on an inside page. Neither paper identified Veronica by name or as Dwaine's daughter, and the crime of incest was never mentioned. She was a "victim, now in her late teens," "a teenage girl," "a 19-year-old woman," or "a relative." (At least one paper, though of more limited circulation, had stated the victim was his daughter.) Dwaine, however, was unfailingly labeled as a *Hustler* cartoonist or its cartoon editor, as well as the creator of "the adult cartoon character Chester the Molester" (or, alternatively, "a deviant named Chester the Molester"). If a story appeared that did not link Dwaine with Chester or *Hustler* or both, I did not see it. That linkage seemed as demanded by the conventions of the form as classic epic poetry required that Juno be tagged as "ox-eyed."

(One said, given the nature of Dwaine's work and the charges against him, he should be required to prove his innocence.)

Matthew Hardy bounced his questions, almost randomly, from juror to juror and back again. Could they, he wanted to know, convict someone solely on the testimony of a single witness? Could they take the word of a teenager over that of an adult? (Adults, he noted, have had more years to become skillful liars.) Would they find it difficult to believe a drug user? What about someone who had seen a psychotherapist? Did they agree that certain subjects, incest for example, were inappropriate as sources of humor? That something so awful could happen to a person that they wouldn't talk about it for years? That certain repeated experiences could blend together so as to become indistinguishable from one another? Would they be willing to put individual ego aside to enable a group to reach a unanimous decision? Would they be able to put aside normal human sympathies and convict Dwaine in front of his wife and family?

Our legal system's belief that truth is best reached by allowing opposing sides to battle their positions through fully and fervently does not carry into the jury room. Instead, each lawyer is permitted a limited number of challenges to eliminate those jurors he suspects will be most hostile to his position. In that way, passion and partisanship will be left behind when the door for deliberations is closed and decisions made by those people the most middle-of-the-road, the least committed or driven. In that way, reason is expected to prevail.

In his pursuit of such impartiality, Matthew Hardy used his first challenge to strike the retired owner of a linen supply company who read *Playboy*. His second struck a twenty-one-year-old power company lineman who read *Hustler* and admitted thinking a cartoon about a boy with a hook for a hand, who bloodied his nose by picking it, was funny. With his third, Hardy struck the data process manager of a bank who had been the victim of a false accusation (and whose son was active in his church's anti-drug fellowship), and with his fourth eliminated an aspiring magician who stated he was not a member of "any organized religious group" and confessed himself able to enjoy sexual humor.

George Eskin challenged a young woman who had friends who had been molested by their father and, having heard the subject discussed on *Oprah*,

believed it "the worst thing that could happen to a woman." His second was of a deli clerk, active in her church, who knew four people who'd been sexually abused by their step-father, and who'd had four years law enforcement training. Then he eliminated an executive with a real estate company whose wife was an attorney, and an international relations major at U.C. Santa Barbara.

By Wednesday morning, both attorneys were satisfied. Seven men and five women had been selected. Six were childless; the others had twenty children between them. There was a postal supervisor, married thirty years, who had a brother-in-law who worked in the Sheriff's Department. There was a married physicist who had read *Playboy* "in the distant past" but who was made uncomfortable by sexual humor. (His favorite cartoonists were Gary Larson and Gahan Wilson.) There was a woman who worked for GTE West, whose father was an alcoholic. (*Cathy* was her favorite strip.) There was an engineer, married to a church secretary, who found magazines like *Hustler* offensive but believed you did more harm than good by censoring them. There was a widowed, retired medical secretary whose nephew had died of a drug overdose; a bank branch manager who'd seen *Hustler* and heard people kid about Chester; an accountant with the U.S. Navy who'd been a revenue agent; a married data process manager with seven children, aged six to twenty-one; and a nineteen-year-old who worked as a service advisor for Bridgeport-Firestone, and who had seen Chester cartoons. There was a twenty-one-year-old senior at Cal Poly who was very active in the Missionary Church; a twenty-three-year-old Catholic hotel reservations clerk who could find sexual humor funny but had been shocked by these charges; and a single twenty-eight-year-old who had many friends in law enforcement and one who'd worked for *Hustler* in accounting. (She was employed as a customer service representative at American Airlines, dealing with lost baggage. While several jurors were reluctant to serve during the Christmas holidays, she was delighted.) The jury would later select the father of seven as its foreman.

When the selection process was completed, Judge Storch told the jury they would begin every day between 9:00 and 10:00 A.M. They would have a fifteen-minute break, mornings and afternoons, and an hour-and-a-half for lunch. They would have Fridays off. They were not to discuss the case with anyone, including each other. They were to read no newspaper articles or lis-

ten to any news broadcasts about it. They were to undertake no independent research or investigations but were to limit their reasoning to the evidence presented. And they were to keep an open mind until the case was submitted to them for decision.

XIV

An opening statement allows an attorney to summarize the case he expects to present the jury. His statement provides an ordered, complete narrative to which the jury can affix the scattered facts and random items of evidence the testimony will set forth in more hodgepodge fashion. The statement also allows the attorney to influence how a jury regards what it hears or sees before it hears or sees it.

Matthew Hardy's opening statement, of approximately eighteen thousand words, occupies sixty-one transcript pages. (George Eskin's opening runs sixty-four pages and Hardy's rebuttal an additional twenty-nine.) He introduced Veronica. He revealed her early, troubled years. Then he introduced her father — and immediately linked him to Chester, whom Hardy mentioned three times in the first few minutes he spoke: "Chester the Molester cartoons... frequently depict child molestation"; "[T]he Chester the Molester cartoon strip... became part of her way of life"; "That was [their] way of life, the Chester the Molester way of life." These cartoons were what Veronica "was subjected to continually..." They became part of "a way of life that she came to accept."

Hardy next described the four years of Veronica's sexual abuse. Over these years, nine episodes stood out in her memory, and these provided the basis for the felonies with which Dwaine had been charged. Hardy described each of these episodes briefly. He described how these years of abuse had led Veronica to turn to cocaine and how her cocaine use had led her to report her father to the police. Then Hardy turned to the cool call. The last third of his

statement was devoted to recounting it, sometimes summarizing portions, sometimes quoting it directly. Hardy repeatedly characterized Dwaine as being elusive, evasive, non-responsive, and, tellingly, never directly denying the conduct which lay at the conversation's root. At the end of his statement, Hardy said, "[Veronica] is going to tell you what life was like at the house where Chester the Molester was drawn."

He had referred to "Mr. Tinsley" three times and "Chester the Molester" four.

George Eskin began his statement by acknowledging Matthew Hardy's "masterful" presentation.

Then he told the jury the charged events never happened. They were, he said, the lies of a jealous, vengeful coke addict, furious at being expelled from the family home and hoping to extort from her father money and a car. Eskin related Dwaine and Debbie's history of their life with Veronica. He said the cool call was open to individual "interpretation." He urged that Hardy's be rejected and that the jury hear in it instead the "pain and anguish" of a father for a daughter whose life appeared ruined by drugs.

Eskin mentioned Chester once — and then only to point out that he stood in contrast to three-quarters of Dwaine's cartoons, which were non-sexual.

Eskin's lack of engagement with his client's most notable creation is of interest, for while the district attorney (like the media) persisted in coupling the Dwaine who created Chester with the Dwaine accused of molesting his daughter, if one looks at Chester, one does not necessarily see Dwaine. There was no club or ropes at San Angelo Street. While Chester frequently courted oral sex, he rarely suggested an interest in intercourse with his prepubescents. And Chester's girls were always prepubescent. Veronica, during the years in issue, was fully adolescent. Admittedly, a defense attorney is not likely to argue his client should be acquitted because the acts in his imagination are more perverted than the acts of which he is accused; but if one is going to look at the cartoons, one should look at the cartoons.

And, similarly, if one looks, it is difficult to see in them the corruptive "way of life" of which Veronica "became part" — or "was subjected to" — or "came to accept" — by taking residence with Dwaine and Debbie. Chester

is a single male, not a husband with daughters. Chester is not visibly employed. He does not drive a Thunderbird. He does not golf. He expresses no political opinions. He sees no films and reads no books. He practices no art. Aside from 3091 San Angelo harboring a man whose professional life involved drawing cartoons about a character who sexually abused children, it is unclear what malevolency lurked there, unless one concludes that this one fact was enough to override all others and establish a "way of life," entire and complete, simply by virtue of its being.

And if this is so, what about the ways of life of authors who traffic in homicide and mayhem and other socially disapproved sexual actions? What actions may have been incubating in the homes of Norman Mailer and Cormac McCarthy and Joyce Carol Oates — just to pluck names from one bookcase shelf in my study? To what are the children in these homes — or in the homes of people who *possess* these books — being subjected? Or is child molestation so potent a sin that only creative works that contain it can override wills and foster aberrances? For if this is not the case, and other transgressive works can act in a similar fashion, should not society be removing children from the homes of parents who create (or possess) such works before their offspring start reaching for the chainsaws?

If this strikes you as absurd, does it not seem that the County of Ventura was seeking to prove Dwaine guilty of evil acts by showing he expressed evil thoughts that had been, up until the moment the acts were alleged to have occurred, perfectly legal, perfectly Constitutionally protected, perfectly *not-*evil, and had, in fact, become indicative of evil only *because* the acts had been alleged? In other words, evil thoughts were being used to prove the existence of evil acts, even though, absent the acts, the thoughts were not evil. And if the thoughts were not evil, how could they prove the existence of the acts which damned them?

XV

Trials are a struggle between stories. The attorneys are the authors of these stories and their witnesses their characters. Like any author, the attorney shapes his characters so that his audience — in his case, a jury — reacts to them in a desired fashion. Matthew Hardy had told Veronica to temper her make-up, pin back her hair, leave most of her jewelry home. He told her to keep her answers short. To say "cunnilingus" or "oral copulation" or "intercourse," not "fuck" or "blow job" or "go down on me." To be, in other words, "a lady." He had twice reviewed her testimony at the preliminary hearing with her and rehearsed her with the questions he would ask and those on which he expected George Eskin to attempt to impale her.

Veronica began the prosecution's case by identifying her father. ("He's right there. He's wearing a tan suit with a red tie.")[41] She said she had a step-mother ("Mama Debbie") and two half-sisters, Lori and one of whose name she was unsure. (She believed it was "Cammie.") Hardy then directed Veronica's attention to the volumes of *Hustler* cartoons. Veronica confirmed she had recently reviewed them. She identified two of the thirty-two hundred cartoons as "significant" in terms of her relationship with her father. In one, a young girl and older men are lying in bed. "Phew," the girl is saying, "that was the best 20 seconds of my life." In the other, a guy and a girl are in a parked car. "Of course I respect you," the guy is saying. "Now will you give me some pussy." The significance of these cartoons to Veronica was that (a)

41. George Eskin, no less conscious of the trial as "story," than Hardy, had Dwaine well-barbered and his earring in his jewelry box.

her father ejaculated quickly and (b) "Pussy," he had told her, "was all guys wanted." (This was as close as Veronica came to fulfilling Hardy's promise that she would identify two cartoons as depicting "things that actually happened to her." She did say that her father had drawn such cartoons; but because none of them had been published, she could not find them in the collections offered as evidence.)[42]

As for the extent of her "bombardment," Veronica testified that, at the end of each month, her father showed her the forty new cartoons he had created for submission. And he kept the collections in his study, so she could read them when she wanted. She did not testify that she "looked at them all the time" or that she and her father "talked about [them] all the time," as Hardy had told Judge Storch she would.[43]

The first instance of sexual abuse Veronica described was the one that occurred at the LAX Sheraton the summer that she was eleven. (One new detail emerged though. Her father had placed her hand so that she "cupped his balls.") Veronica recalled that the experience had left her feeling "weird." The next morning, she had even wondered if she had dreamt it. The second incident, unmentioned in her initial interviews with Detective Galloway or Matthew Hardy, occurred in Sherman Oaks. Debbie was at work and Lori in day care. Her father lay down next to her on her bed and placed a finger in her vagina. She did not enjoy these acts, she said. But she felt she had to endure them "in order for my father to show me... love and attention" and

42. Only one of the cartoons appeared to deal with incest — and it was drawn while Veronica still lived in South Carolina. A teenage girl is on the phone. An older man stands beside her, his hand inside her pants, his tongue in her ear. "I'd love to go to the drive-in, Jimmy," the girl is saying, "but my dad has some, uh, extra household chores for me tonight."

43. The prosecution also made much of Veronica's testimony that she had heard her father tell another cartoonist he needed to live "this stuff," in order to draw it. It had located the cartoonist to whom this advice had been given, but he had refused to testify. "We figured Flynt had gotten the word out to put a lid on anything that would do damage to his magazine," Detective Galloway says. Perhaps. But to anyone who has had a freshman writing instructor deliver the directive "Write what you know," Dwaine's statement would seem less incriminatory than it would rote tutelage. (It would also seem easily offset by the reminder "Shakespeare was neither a king nor a woman," which was dropped on you around junior year.) And even if it was a "smoking gun," based on the contents of his collections, it seemed to mark Dwaine as more likely to have had sex with barnyard animals than with his daughter.

On the other hand, as Charlie Parker once put it, "If you don't live it, it won't come out of your horn."

114.

to avoid being forced to live with her mother.

For the next few years, she and her father had sex when she came home from school most Tuesdays, most Thursdays, and some Fridays. They would discuss their days, until he suggested she lie down. She would go into the master bedroom; he would follow. The usual pattern was that she would "give him head" until he became erect. Then they would have intercourse, "missionary" or "doggie-style," and he would ejaculate on her stomach. (During these years, they had the house to themselves because he worked at home; Debbie would not return from her job until 7:00; and Lori was at school or day care.) In 1985, on Debbie's Christmas visit to Virginia, Veronica said, she and her father had sex every day. Once, after returning home from a ride on which he had forced her to give him a "blow job," he orally copulated her, penetrated her anally, and inserted a dildo into her vagina, before he had her orally copulate him.

Until she was sixteen, her relationship with her father made her feel "proud" and "loved." Then she realized: "This isn't right." She began finding ways to avoid him — saying she had her period or had to be at a friend's or taking a job or getting in trouble so a teacher would send her to detention. In the fall of 1988, she told her father, "It] was over… that I was sick of it, that I didn't love him, that I didn't want it to happen any more." In retaliation, shortly before Thanksgiving, he had ordered her to leave the house.

Her father had always been strict. If she received a grade below a C, he grounded her. He tried to prevent her seeing friends. He wouldn't let her date. He would come home drunk and wake her. He threatened to send her back to South Carolina. Once he ordered her to "go down on" their dog. Once he pointed a gun at her and threatened to shoot her. His temper frightened her. At one point, after she had made a suicide attempt, nicking her wrist with a razor blade, he took her to a psychologist. But the doctor never spoke. It was like "talking to a wall." She hadn't told the psychologist about her father because she didn't want to get him in trouble. After three sessions, she had stopped.

Veronica admitted that, when she came to California, she had been smoking marijuana every few weeks. By the summer of 1988, she was smoking it daily. In the spring of that year, she began sniffing between a half and a full gram of cocaine a week. This drug use had impaired her memory. That was why she had given different accounts of when or how or where the sexual

acts with her father had occurred. "[S]o many incidents had] happened that it's like a fog in my head and they sometimes intertwine and I get them confused." But she had been off drugs for four months. Her memory had improved. She had no difficulty recalling what had happened now. It was "like yesterday."

Matthew Hardy then brought Veronica to the charged offenses. (The designations that follow are his.)

1. **The Lap-by-the-Pool:** In August 1984, before the start of ninth grade, she was swimming in the pool late at night — not during the day as she had previously testified. Her father came out of his studio and sat on the patio. She went over and sat on his lap. They kissed. He inserted two fingers beneath her black two-piece bathing suit, into her vagina, and kept them there for twenty minutes — not the two hours she had previously testified. (This was also the first time she had said he used more than one finger.)

2. **The Pool-and-the-Bedroom:** Later that summer, she and her father were in the pool. He rubbed his penis on her "butt." He inserted a finger into her vagina — and kept it there for five minutes. Then they went into the bedroom. She orally copulated him until he became erect. They had intercourse, and he ejaculated on her stomach.

3. **The First-Day-of-Ninth-Grade:** She got home about 3:00. She and her father went into the master bedroom. She orally copulated him until he became erect. They had intercourse "missionary style" and he ejaculated on her stomach. (She had told Detective Galloway they had done it "doggie style.")

4. **Back from Sweden:** In the summer of 1986, the family had gone to Sweden. The first day they were back, while Debbie was at work and Lori in the living room, her father took her into the bathroom and had her "go down on" him until he ejaculated in her mouth.

5. **The Carl's Jr./Sick Day:** During eleventh grade, she worked at Domino's four days a week, from 5:00 to 9:00 or 10:00 P.M. One day, her father picked her up at school because she was sick. They got food at Carl's Jr. and went home. They went into the bedroom.

He massaged his penis on her "butt" until he became erect. Then they had intercourse. (She had testified at the preliminary hearing that this had occurred in Lori's bedroom.)

6. **The Sister's Bed:** One day between August 7, 1986, and August 7, 1987, she came home from school, and her father asked her into Lori's room. He orally copulated her for fifteen to twenty minutes. She orally copulated him. When he became erect, they had intercourse "doggie-style" and he ejaculated on her "butt." (She had said he had ejaculated on her stomach previously.)

7. **First Day of Twelfth Grade:** She got home around 3:00. She and her father went into the master bedroom. (She had said they had gone into her room previously.) She orally copulated him until he became erect. They had intercourse and he ejaculated on her stomach. (She had testified at the preliminary hearing they had sex "doggie style.")

8. **The Senior Prom Dress:** In May 1988, he came into her room while she was trying on her new red, satin, strapless gown. He told her he wanted to be the first to have her in it. After she had removed the gown, she orally copulated him until he became erect. They had intercourse, and he ejaculated on her stomach.

9. **The Last Time:** In late October 1988, they went into the master bedroom. She orally copulated him until he became erect. They had intercourse, and he ejaculated on her stomach.

Shortly before Thanksgiving 1988, Veronica testified, she had met Steven Gold. He became her boyfriend — and provided her with cocaine. Between then and Christmas, when she left home for good, her father threw her out three times; and each time she moved in with Gold. He had asked her twice if her father had molested her, but she had denied it. She had never told anyone about the molestations because she felt ashamed and "wanted to forget about it." But, in March, Gold had overheard a phone conversation in which she'd asked her father for a hundred dollars so that she could get a hotel room for herself and, after he'd refused, had said, "I'm going to report you, motherfucker." Gold now confronted her about his earlier suspicions, so she told him the truth. He called her father back. "You sick pig," he said, "why did you do this?" Her father kept repeating, "I don't know what you're

talking about." Some time later, Gold called her father "to make [him] pay" for what he had done and demanded that he sign over the Isuzu to him. Gold demanded that he pay him money as well. Veronica described this call as a "shakedown." Steve, she said, was "the type of person to get a scam out of anybody.")[44]

Having told Gold about her father, Veronica next told her mother. Then she told Dennis Rohde, and he called the police. (Veronica testified Rohde had convinced her to allow this by telling her to "Think about your sisters." At this point, though, she only knew she had one sister.) After telling the police, Veronica told friends to look for her on the news. Any love she had for her father was gone. He was a "sick, inhuman human," and she hated him.

George Eskin's cross-examination of Veronica extended over three days.

Almost the first point he made was that Veronica had hoped to become an actress. If Hardy was going to tar Dwaine with Chester, Eskin would cast his accuser as someone who sought acclaim by playing roles. By speaking lines that someone fed her. By behaving as directed.

Eskin then settled into confronting Veronica with factual errors in her direct testimony and its contradictions with her prior statements. For instance, the LAX incident could not have happened the summer she was eleven, because Dwaine and Debbie were living in Virginia then. (If it happened, it would have been two years later, when she was thirteen, a few months before the custody hearing, at which she had not mentioned it.) For instance, Debbie's Christmas trip east was in 1984, not 1985, the trip to Sweden in 1987, not 1986, Veronica's job at Domino's from 1987-88, not 1986-87, the Sister's Bed incident her senior, not her junior year. For instance, her testimony that she had been forced to orally copulate her father in the car during Debbie's Christmas trip contradicted her earlier statement to the police that she had refused to do so, while her testimony that they had not had intercourse in the car contradicted her earlier statement that they had. For instance, in the spring of 1986 and the fall of 1987 she was rehearsing for

44. Gold had involved Veronica in at least one other "scam." Following a January 1989 motorcycle accident on the Hollywood Freeway, they had sought to sue the other driver for swerving into their lane without signaling. But after independent witnesses said that Gold, while speeding, had run into the other car from behind, they dropped their claims.

parts in school plays — *Bye-Bye, Birdie* and *Spencer's Mountain* — two or three days a week, for weeks at a time, and was rarely home before dinner, so she could not have had sex with her father as frequently as she said. For instance, when the Last Time occurred, the fear of being returned to South Carolina could not have kept her silent, because she was eighteen and old enough to live where she chose.

Eskin's second approach was to confront Veronica with "statements" she had made to or about her father that were inconsistent with the picture of him she had presented on direct examination. Then, she had said that her father's abuse had made her feel "angry," "humiliated," "degraded." She thought him "a jerk." At times, she "hated" or "detested" him. But throughout these years of her degradation, on cards to him on Valentine's Day, Easter, Father's Day, and his birthday, she had written: "I love you more each year;" "You're my heart;" "You're the greatest." Throughout those years, she had proudly given autographed collections of his cartoons to her friends. She had made a video for class in which he starred. And shortly after the Prom Dress incident, she had given him and Debbie a photograph of herself in her red gown. "Keep this close to your heart," she had inscribed. "I love both of you tremendously."

The "contradiction" which Eskin emphasized the most came from Veronica's diary. Veronica had denied keeping a diary after leaving South Carolina. But on January 13, 1987, two-and-one-half years into her years of molestations, she had made this entry:

> When I came to CALIF. I was so fucked up in the head. I had no confidence, self-respect, self-esteem. I was selfish and vain. I didn't care about anything except myself. I was a fucking shambles. Dad & MD changed most of that except for my selfishness, vanity and yes, my big mouth! And we're still working on that…. Don't get me wrong, everything isn't peachy, fights with my dad are unreal but we always manage to work them out. I have 2 yrs. before I'm out in the world of shit.

In South Carolina, she had regularly recorded her mother's abuses. In California, she had made no mention of anything sexual between herself and her father.

Eskin then had Veronica discuss her behavior during the several months that led up to her bringing charges against her father. She admitted that, in July 1988, after overdosing and going into convulsions, she had promised her father and Debbie to stop using cocaine — but hadn't. That, in October, when Dwaine and Debbie told her she was ruining her life and destroying their family by staying out several nights a week binging on coke, she had promised to stop — but hadn't. That Dwaine had told her that if she didn't enter a treatment program or stop on her own, she would have to leave the house. Then, when Debbie was away for Thanksgiving, Dwaine had told her Debbie was pregnant and that they would need Veronica's room.

Eskin had Veronica admit that it was when her mother had become pregnant with her half-brother that she had begun planning to live with Dwaine. Eskin suggested that Veronica had felt hurt and rejected by Charlotte's pregnancy. He suggested that Debbie's pregnancy had been what turned her against Dwaine. He suggested that when Dwaine had refused to give her the money she had requested, she had decided to get revenge by fabricating these charges, just as she had revenged herself upon Charlotte by getting into trouble so she would be sent to live with Dwaine.

As for Dwaine's cartoons, Eskin had Veronica confirm that many of them had nothing to do with sex. They made fun of smokers, drinkers, courts, psychiatrists. They dealt with Ronald Reagan, Jerry Falwell, the nuclear arms race, injustice in South Africa. They scorned and ridiculed their subjects. They were marked by Dwaine's favorite form of humor: gross sarcasm. In fact, Chester, himself, was "a subject of ridicule and derision."

By the time he finished, Eskin was certain he had shown Veronica to be "completely lacking in credibility." In fact, he says now, "I felt sad for her."

In his redirect examination of Veronica, Matthew Hardy also asked about Dwaine's cartoons. He called her — and the jury's — attention to the cartoon in which Chester appeared in bed, naked, with three nearly naked little girls around him. He called it to the cartoon in which Chester lay beneath a sliding board with his tongue out and a girl sliding toward it. He called it to the cartoon in which Chester, his pants around his knees, a puppet on a penis, is saying to a smiling eleven-or-twelve-year -old, "Come on, Sugar, give widdo Rodney a kiss kiss." Then Hardy asked Veronica about her father's non-sexual cartoons. "Some are about blacks, aren't they?"

"Yes."

"And Jews?

"Yes."

"And Catholics?"

"Yes."

"And he uses his sarcasm on those groups, isn't that fair to say?"

"Yes."

"Also about suicide?"

"Yes."

"Abortion?"

"Yes."

"Fetuses?"

"Yes."

There was, of course, no claim that Dwaine's cartoons about blacks or Jews or Catholics or fetuses or abortions had been used to seduce Veronica into having sex with him.

When she stepped down, Veronica left the courtroom without looking at anyone. She was tense — and frightened that no one had believed her. She wanted only to be gone. She would not return until the jury's verdict. While she waited, the uncertainty of its decision occupied her thoughts, her dreams, her nightmares. "I was," she would say, "totally afraid that he would go free."

The other prosecution witnesses were Emerald Barnes Romanoff, Dennis Rohde, and Detective Galloway.[45] (Steven Gold was called by the prosecution but, apparently concerned that his reported attempt to recover the Isuzu and some cash for himself might subject him to prosecution for extortion,

45. A witness on the prosecution's list whom the jury did not hear was Lori. She had reportedly told investigators from the district attorney's office that on two or three afternoons, when her father and Veronica were supposed to be caring for her, they had not been around; but Veronica's bra had been on the living room couch, and the door to the master bedroom had been closed. Because Lori was only eight years old, Judge Storch decided to question her preliminarily outside of the jury's presence to make sure she recognized the importance of telling the truth and to hear what she would say.

Lori now recalled that on these afternoons the door to the master bedroom had, in fact, been open; but Veronica's door was closed. Once when she looked for Veronica, Lori had found her doing homework. Another time she was in bed with her boyfriend. Her father, she had assumed, was in his studio.

Hardy decided not to have Lori testify.

cited the Fifth Amendment's protection against self-incrimination and re-
fused to testify.)

Romanoff, who was nineteen, lived in South Carolina. She and Veronica
had been friends when they were eleven or twelve. Shortly before Veronica
moved to California, Romanoff had confided in her that someone had once
touched her "down there." Veronica then said that her own father had done
that to her. (This conversation would have occurred about six months after
she had spent the night with her father at the Sheraton.) When Romanoff
looked at her peculiarly, Veronica said she was "kidding." (On cross-exam-
ination, Eskin elicited from Romanoff that Veronica's friends generally did
not believe things she told them. It should be noted, though, this disbelief
usually attached to Veronica's accounts of her mother's abuse — accounts
which most others had judged to be true.)

Rohde had been a policeman for fifteen years — five in Minneapolis, fol-
lowed by ten in Los Angeles — before becoming owner of The Lamplighter.
Veronica had worked for him between April and September 1989. One day
in May, she came in crying. She said she couldn't work because her mother
was dying. Then she said she had been upset by a telephone conversation
with her father that day — and that he had sexually abused her for five years.
After Rohde warned her that her sister might be at risk, she agreed to let him
call the police. (It was, of course, untrue that Veronica's mother was dying.
Nor was it true that Veronica had spoken with Dwaine that day. And Rohde
did not know that before coming to work, as Veronica later admitted, she
had done three lines of cocaine.)

Galloway detailed the sexually explicit material seized from the Tinsley
home. The videos — *Undressed Rehearsal, I Want it All, Swedish Erotica,*
Volume *39.* The magazines — *Hustler, Chic, Slam.* The sketches and nude
photographs and cartoons. The dildo and cameras and framed e.e. cummings
poem. (On cross-examination, Eskin drew out that most of the X-rated ma-
terial was in Dwaine's studio. Some was in the garage, some in a hall book-
case, and some in a backroom. None was in plain sight in the living room or
dining room or bedroom or any room to which other family members had
ready access.)

When the prosecution rested, Eskin moved for an acquittal on the grounds

that its promised justification for the admission of the *Hustler* collections had not been matched by the testimony it presented.

Judge Storch denied his motion.

XV I

A major exception to the ban on character evidence permits testimony as to a witness's reputation for truth and veracity. (This exception exists, McCormick tells us, because it captures "the highest degree relevancy that is attainable," while casting the least amount of irrelevant prejudice.) The defense in *People v. Tinsley* hoped to drive a freight train of doubt about Veronica's credibility through this opening.

For this purpose, George Eskin called to the stand three of Veronica's close friends from high school, Cleo Cesari, Eve Donches, and Heather Canton; Heather's mother; and two people with whom Veronica had briefly lived — May Vann, a pale, gaunt coffee-shop manager, and Del Dunnett, a heavily tattooed graffiti artist. Veronica had confided to these people about her rape and her mother's beatings and her own sexual promiscuity. She had told them about a drug use so extensive that, according to Vann, who had snorted coke with her, it had once left her in spasms and hallucinating bugs crawling upon her. Veronica had recounted to these people her fights with her father over her drug use. But as far as most of them knew, she sincerely loved her father. She was proud of him and his work. She said "only good things" about him. Their relationship seemed so "close" and "open" and "understanding" that they "envied" her. Of these people, only Dunnett had heard her accuse her father of sexual abuse. And this abuse, contrary to what she had testified to, consisted entirely of oral copulation when she was fourteen or fifteen, "once or twice, a few times and then she made it stop." (The discussion had arisen in the context of what constituted "abuse." Dunnett's position was, at

that age, if it had been consensual on her part, it didn't. "In my mind," he said, "it's not molestation. It's something bad.")

These people, unanimously, considered Veronica "sneaky," "a dishonest person," "a compulsive liar." "She wasn't very honest," they said. "I don't think she can be truthful."[46]

Two young men testified about more personal relationships with Veronica.

The first, Ronald B. Stratford, was twenty-three years old, an electrician, married, and a father. But in March of 1984, in South Carolina, it had been he whom Veronica had accused of rape. Now he had come three thousand miles, apparently voluntarily since he was beyond subpoena power, to relate his side of the story. The day he met Veronica, he said, they and another couple had ended up at a friend's apartment. There was drinking; there had been hashish; and he had fallen asleep. He had been awakened by Veronica orally copulating him. When he was erect, she had mounted him, and they'd had sex. The next day, upon learning she had charged him with forcible rape, he had turned himself in. He had pled guilty to aggravated assault — and been fined six hundred dollars.

The second young man was Gus Poggi, the pre-med student Veronica had met at Lake Tahoe the summer of 1986, when he was eighteen and she fifteen. They had dated for about a year and had remained friends after they had broken up. (They had sex five times, Poggi admitted to Hardy on cross-examination, all while she was underage.) Veronica had told Poggi that she had a crush on and used to fantasize about her father's best friend, the *Hustler* cartoonist John Billette, and that he had once French kissed her;[47] but she

46. The jury did not hear other testimony which Eskin's investigator had collected: that, as one ex-boyfriend put it, "Everyone that knows Veronica has slept with her." That behavior she had described to these friends — sex in a bathroom; sex "doggie-style" — resembled some of the acts she had said she had engaged in with her father. That her father had disciplined her once after finding a used prophylactic in her bed — and again when he discovered she had been using his and Debbie's edible sex cream. And that, following her father's arrest, she had told friends he had molested many other young girls — no evidence of which had ever surfaced.

47. This was significant because, three months after reporting her father to the police, Veronica had accused Billette of orally copulating her. She had testified that she had told Poggi and Dr. Greenfield, the therapist she had seen in 1985, about this. (Dr. Greenfield testified that she had been told no such thing; and Billette came to court from his home in Bay City, Michigan to deny Veronica's accusations.)

had never accused Dwaine of acting improperly. They had seemed to Poggi to have a "solid" relationship, with nothing unusual about it. She looked up to and respected him. Poggi had come to consider Dwaine a friend. He had never done anything to discourage Poggi's relationship with his daughter.

During the summer of 1987, Veronica had told Poggi that she had tried cocaine. When he had been in high school, cocaine had been "a phase that everybody went through." Most people experimented and passed on, but some "got in trouble;" so he had told her that, while coke could be "a lot of fun," she ought "to be very careful." By the time she turned eighteen, her use had become a problem. She was staying out late, partying. She was angered by her father's attempts to "control" her. She was an adult, she had told Poggi. It was her life, she had said, and she could do what she wanted.

The defense also had three doctors testify.

Neil Brauner, M.D., had been the emergency room doctor who had examined Veronica, following Dwaine's arrest, at the request of the district attorney's office. She had given Dr. Brauner a history of having first had intercourse with her father when she was thirteen. She said they had continued to have intercourse, preceded by oral copulation, three or four times a week. Two episodes involved sodomy and one a dildo. But, according to notes which he had made five to ten minutes after examining her, this had stopped in 1985 or 1986. (On cross-examination, Matthew Hardy had Dr. Brauner read these notes. They said, "At age of 13, he began having sexual contact with her, which included intercourse. And she states there was also sodomy. The last events occurred at approximately the age of 14 or 15." Hardy then suggested that Dr. Brauner hadn't understood the notes; they should be interpreted to mean that the last instance of *sodomy* had been in 1985 or 1986. Hardy's point seems a good one. Since, only two days before being seen at Ventura County Memorial, Veronica had accused Dwaine of having molested her until she was eighteen, it is hard to believe she would have given such a different account to Dr. Brauner.)

Peter Claydon, PhD, an English-born clinical psychologist who specialized in treating chemically dependent adolescents, described cocaine's effect on the brain. Cocaine could, he testified, cause paranoia, hallucinations, memory impairment, and "cocaine delusional disorder," a false belief that one had been "wronged in some fashion... that can only be redressed with

legal actions." Based on the extent of Veronica's drug use — which he termed "significant" — Dr. Claydon diagnosed that she suffered from this disorder and that she likely had "some degree of persecutory delusion." (When cross-examined, Dr. Claydon said that he had never met Veronica; and he had neither heard nor read the transcript of the cool call. He admitted that cocaine-induced delusions usually passed within a few days and that even a delusional person could retain accurate memories of past events. He also admitted that the memory impairment he had mentioned usually involved what had occurred while the person was under the influence of the drug. Memories that preceded its use would have been less disturbed, if disturbed at all.)

And Dr. Sandra Greenfield testified that, during the three months she had treated Veronica in 1985, they had had ten forty-five-minute sessions, not three as Veronica had said. In their time together, Veronica had never given any indication of having been sexually molested. Dr. Greenfield would have expected such a child to be "secretive," "mistrustful," "withdrawn," "depressed," and possessing a "poor self image;" but Veronica had seemed "affable, friendly… quite at ease…," and "very pleased" with herself. She was also someone who "craved being the center of attention." She had never referred to her father as being cruel or abusive but appeared to "adore" him. She exhibited no mistrust or fear of him. Dr. Greenfield had only treated three child sexual abuse victims, but she was familiar with the literature; and she had never heard of a sexually abusive father voluntarily bringing that child to a therapist.[48] (On cross-examination, Hardy faulted Dr. Greenfield for having failed to learn of Veronica's sexual history or marijuana use or suicide attempt. He had her concede that it was difficult to detect child abuse victims unless they voluntarily revealed themselves. He suggested she might be testifying for the defense because she would "look pretty silly" if she had been treating the daughter-victim of the creator of Chester the Molester and hadn't recognized his abuse of her. And he led her into a discussion of Child Sexual Abuse Accommodation Syndrome, where the victim feels compelled to keep her abuse secret, feels helpless to resist her abuser, often gives delayed, conflicted, and unconvincing accounts of her abuse, and, in some instances,

48. Judge Storch did not permit Dr. Greenfield to testify that she had diagnosed Veronica as having a conduct disorder that "was a prelude to a psychopathic personality disorder" or that she believed this rendered Veronica capable of making a false accusation and sticking to it. She had seen Veronica so far in the past, the judge said, that her diagnosis and belief were speculation.

fearing disclosure will destroy her family, even retracts her accusations.[49]

Dwaine and Debbie's testimony provided the crux of his defense. Consolidated and compressed for narrative purposes, this is the story it told:

Debbie was the cartoon and humor editor for Larry Flynt Publications and Dwaine its chief cartoonist and cartoon consultant. ("A better way to put it," Dwaine explained, "is if Mr. Flynt had any problems with the cartoons, he'd yell at me, not anyone else.") *Hustler*, while the best known, was only one of the company's twenty-eight magazines. (Others were devoted to auto racing, boating, computers, fishing, and motorcycles.) It mixed photographs of naked women with controversial, investigative journalism and outrageous humor and fiction. Few topics were off-limits. ("We take on anything," Debbie said. "We are an equal opportunity offender.") Dwaine was required to submit twenty cartoons a month, of which about one-quarter were sexual. His work was, Debbie said, "Social comment. Heavy satire [or]… black humor…" It was designed to be funny; it was also designed to shock or offend. Dwaine said his work stemmed from "imagination and discipline. I take the normal. I make it absurd. I take the absurd. I make it normal." (He denied ever saying that a cartoonist had to experience things in order to create.) He kept his work in his home studio. Veronica was not supposed to look at it, but nothing would have prevented her from doing so.

Dwaine and Debbie related the circumstances under which Veronica had come to live with them. They described her subsequent conduct. Her skipping school. Her stealing. Her lying. Her pot smoking and drinking. Her

49. Roland Summit, M.D., who had been an expert witness for the prosecution in the McMartin case, had identified this syndrome in a paper published in 1983. There were those who swore by CSAAS. There were those who deemed it pseudoscience. (These doubters pointed out Summit had not derived it from empirical data and that his theory made it impossible to tell true abuse victims from false ones, since an account which was long delayed or massively contradictory or strongly recanted could be argued as having all the more powerful signs of being genuine.) Some states barred testimony about CSAAS in criminal cases because its validity was not generally accepted by the psychiatric community. Some states which did allow it instructed jurors not to consider CSAAS as proof of whether or not abuse had occurred but only as an explanation as to why a victim's testimony might be unconvincing — which would seem to immediately translate into proof of occurrence by making the victim more credible on the only matter of substance about which she would have testified.

In any event, Dr. Greenfield was not impressed by CSAAS's application to Dwaine's case. It was more germane, she told Matthew Hardy, to situations involving young children than to those involving adolescents.

promiscuity. They related how her use of cocaine had accelerated her downward spiral. In Dwaine and Debbie's testimony, there was much to suggest things could not have happened as Veronica said.

For instance, the black bathing suit Veronica said she wore during the Lap by the Pool incident in August 1984 was not purchased until a year later. (Debbie had the receipt.) For instance, the dildo which Veronica said was used on her in December 1985 was not purchased until March 1986. (Debbie had the credit card statement.) For instance, from June 1984 until April 1, 1986, a period during which Veronica said she was having sex with Dwaine two or three times a week after school, he was working in Century City, at LFP, and not getting home before 7:00 P.M. — or 9:00 P.M. — or 2:00 A.M. For instance, between January 3, 1985, and April 1, 1986, Debbie was either not working or working part time and, even on those days, was home by 3:00 P.M. in order to pick up Veronica at school. (Debbie had her employment records.) For instance, on April 1, 1986, when Dwaine had begun working at home and could have been available for sex with Veronica, he also had to pick up Lori every day between 4:00 and 5:00. For instance, the Lap by the Pool incident, if it happened, had to have happened within twelve days of the Pool and Bedroom incident and the First Day of Ninth Grade incident, if either of *them* happened, since the Tinsleys had no pool in Sherman Oaks and did not move to Simi Valley until August 31st (Debbie had the lease), and school started September 11th; and during the first week following the move, Debbie was setting up the house, while Dwaine was working.

Dwaine denied ever demanding Veronica have sex with their dog. He admitted handing her a pistol once, out of exasperation, when she had made one of several threats to kill herself, but insisted he was merely calling her bluff with an unloaded antique. ("I'm an excitable kind of guy," he explained.) He denied any sex with Veronica by finger or mouth or penis. In bedroom or bathroom, in car or by pool.[50] Anal or vaginal. Like missionaries

50. As Dwaine now recalled their evening at the LAX Sheraton, he and Veronica had checked in, had supper, and watched TV. He had a couple beers. He may have had champagne. Veronica went to sleep. "And then later that evening I went to sleep, and woke her up the next morning with the wake up call." On cross-examination, Matthew Hardy asked him, "How many beds were in the room?" "Two," Dwaine answered. "And you each slept in a different bed?" Hardy asked. "Yes," Dwaine said.

I do not condemn — not would I convict — Dwaine for that answer; but why, a few months later, he would even consider writing to a county agency that he had awakened nestled against Veronica is a question minds more adept than mine at exploring the human psyche would have to answer. One

or dogs. In her testimony, Debbie denied any indication or hint or whisper of any sexual relationship existing between Dwaine and Veronica. (Then, Matthew Hardy asked on cross-examination, you would not have hesitated to leave them alone together?)

It was Dwaine's testimony primarily that described the months that preceded Veronica's accusations.

Shortly before Thanksgiving 1988, two days after Veronica's post-Cocaine Anonymous relapse, she had gone into her room after lunch to lie down. He had followed her. He told her he couldn't take it any more. He was worried about how her behavior was affecting Lori. And, he said, Debbie was pregnant, and they would need her room.

"If you kick me out," Veronica had said, "I'll do more drugs."

"I don't want to argue," he said — and placed a hand on her shoulder.

She jumped up. "I know what your problem is. You want to mount me like every other man."

He didn't understand.

"I've seen the way you've been looking at me."

Dwaine was stunned. He walked out to his studio. He heard sounds like Veronica was throwing things. When he went back to see what was happening, she told him she was going to the authorities and newspapers.

"What are you talking about?" he said.

"You'll be the one to get in trouble, not me."

He asked what she was talking about again.

"I'll think of something," Veronica said.

Dwaine walked out of the room, out of the house, and to a convenience store down the block. He had a Coke. He was, he said, "absolutely aghasted." When he returned, Veronica was gone. He decided not to tell Debbie about their conversation because he feared it might upset her and cause her to lose the baby.

Between Thanksgiving and Christmas, Veronica alternated between living with Dwaine and Debbie and living with Steven Gold. In mid-Decem-

of these minds, Adele's, posits, "On some level, he may have wanted forgiveness. He may not have known what happened in that bed. But he knew he should not have been there. And he knew he couldn't put his shame and fears and denials in writing, let alone admit to them in open court."

ber, she called to ask them to get her because Steve was trying to kill her. Following a three-day coke binge, he had caught her having sex with one of the men they lived with. She had hit Steve with a two-by-four and broken his arm. A week later, they were back together, and Veronica had moved out for good. By now, the Isuzu had thrown a rod and needed a valve job. Dwaine paid for the repairs — and kept the car, having removed the distributor cap so Veronica and Steve couldn't steal it. Sometimes, Veronica would call two or three times a week; sometimes, they would not hear from her for several weeks. When Veronica called, she was often high and often complaining about Steve or Dwaine or asking for her car. There were times, Dwaine said, "I didn't want to pick up the doggone phone because I didn't know who I was going to talk to or what kind of crap I was going to get."

In early January, Veronica came to Dwaine and Debbie's for dinner. She did her and Steve's laundry; she played Nintendo with Lori. They next saw her at the hospital in North Hollywood where she had been taken following her and Steve's motorcycle accident. She was both pleasant and confrontational. A month later, Dwaine spoke to her again. That conversation went well. In February, when she came to pick up some belongings, Veronica asked Debbie, "When are you going to crack the kid?"

"May 20th," Debbie said.

Veronica called Dwaine around noon on April 3rd. She wanted money so she could leave Steve. "Well, you know, Veronica, your credit's not too good with me, right now," Dwaine said. She became hysterical, said something about going to the authorities, and threw down the phone. Steve began cursing and threatening her. Then someone hung up.

A few hours later, Steve called. "I know where you get your ideas from, man," he said. "How come you did all these things to your own little girl, man, your own flesh and blood?" He told Dwaine he should pay off the Isuzu, sign it over to Veronica, and pay them two thousand dollars. ("He was talking out of the wrong side of his mouth," Dwaine said, "It sounded like he was dropping slick on me.")

Dwaine said, "Man, I'm not going to listen to this any more" and hung up. Then he called Debbie and told her about the conversations. For two weeks, Debbie tried to call Veronica. They wanted to get her away from Steve. They wanted her off drugs. They wanted to find out if she had accused

Dwaine of molesting her or if Steve was making this up in order to extort the car and money out of them. Debbie never reached Veronica.

A week later, Steve called, looking for Veronica. He had kicked her out. He told Dwaine that Veronica had accused him of having sex with her. "I don't know if I ought to believe her," he said. "She lies all the time. Anyway, it doesn't matter to me if it's true or not."

"It does matter to me," Dwaine said, "and I didn't do anything wrong."

On the morning of May 16th, Debbie gave birth to a nine-pound, fourteen-ounce girl by C-section. During her pregnancy, she had developed gestational diabetes, which can cause a child to be stillborn or with underdeveloped lungs, but Kimberly Ann was in perfect health.

Dwaine had stayed up all night to watch the delivery. He had spent the next day phoning friends, caring for Lori, visiting the hospital, meeting deadlines. He was thrilled and exhausted.

The next time he heard from Veronica was the cool call. When it came, he was working on a cartoon.[51]

Matthew Hardy's cross-examination of Dwaine and Debbie had certain recurring themes. Did they believe it, he asked, a good idea to allow a teenage girl unlimited access to issues of *Hustler*? Did they consider the women whose photographs appeared in it appropriate role models for her? Why, he asked, had they not reported Veronica's drug use to the police if they were truly worried about her? Why had they not involuntarily committed her when she resisted treatment? Why had they, at least, not tried another psychotherapist after Dr. Greenfield proved unsatisfactory? Why had they not expressed disapproval of her sexual relationship with Gus Poggi? Did it not mean, if they were both working in Century City when Veronica came to live with them, that they were essentially leaving an already out-of-control teenage girl to run free? The echoing suggestions for the jury were that Dwaine and Debbie were not the concerned parents they professed to be. That there were matters they possibly wished concealed from outsiders. That their defi-

51. It is unusual for defendants in criminal cases to testify. But, George Eskin says, "I believed Dwaine's sincerity, his humanity, his personality, and his straightforward responses would raise doubts in the jurors' minds [about the charges]. And I didn't believe cross-examination would damage him."

ciencies may have permitted other crimes to occur.

Hardy also used the cross-examination to strip any veneer of worth from Dwaine's cartoons.[52] He began by showing Debbie the father with his hand inside his daughter's pants. Was this making fun of incest? he asked

"No," Debbie said.

"It's not poking fun? What is it doing?"

"It's social comment. It is trying to show that this does happen."

"So this cartoon is not drawn to be funny?"

"No."

Hardy asked next about the three nearly naked girls in bed with Chester.

"This is totally social comment," Debbie said.

What about the cartoon of Chester asking the little girl to kiss the hand puppet on his penis?

"It's not meant to be funny."

"It's not funny?"

"No."

"And these cartoons are not placed in *Hustler* to be funny?" Hardy said. "They're placed as social comment, is that right?"

"Some are, some aren't," Debbie said. She had hardly made a ringing defense for the humor of shock and outrage. In fact, it seems that *Hustler's* cartoon and humor editor was asking the jury to believe that its chief cartoonist did not try to be funny as much as he sought to provide public-service announcements. That Chester was some sort of leering Smokey the Bear.

Hardy concluded this line of inquiry by reading into the record a quote from Dwaine that had appeared in newspapers nationwide. The syndicated columnist Bob Greene had asked if he considered dead babies, human excrement, and the female menstrual cycle appropriate subject matter for cartoons. "If it's done with sophistication and wit," Dwaine had answered.

To Dwaine, Hardy put the question: Did he agree that his cartoons were "social comment"?

"Some of them," Dwaine said.

"And what kind of social comment," Hardy asked, "are you making with

52. Hardy's view of Dwaine's work was expressed by his references to them during the proceedings as "slop," "smut," and "porno."

Chester?"

"For one thing," Dwaine said, "that child molestation exists."

"I see," Hardy said. "The social comment is to establish that, contrary to what people think, incest and child molestation exist." (Dwaine, of course, had not mentioned "incest.") Then he showed Dwaine the puppet-on-the-penis cartoon. Is that, Hardy asked, social comment? What social point exactly was it making? What was the social comment in the fact that the little girl was smiling? What was the social purpose of not having her repelled by the puppet on Chester's penis?

"It was no different that giving her a pink bow," Dwaine said. "It was artistic license."

"So you weren't trying to suggest even unconsciously that child molest victims enjoy being molested?" Hardy said.

"No," Dwaine said.[53]

But Matthew Hardy's major area of inquiry for Dwaine was the May 18th cool call. When George Eskin had questioned Dwaine, not much had been made of it. Eskin had hoped to soften its impact by soaking it in context. The context was that Kimberly had been born two days before. That Dwaine had spent most of that day at the hospital and only slept an hour-and-a-half. That he had spent most of the next day at the hospital and work and preparing the house for the return of Debbie and the baby. That he was excited and exhausted and his mind anywhere but on what Veronica was saying. That what may have been on Veronica's mind and in Detective Galloway's mind was not necessarily in Dwaine's mind. His mind may have been on reaching out toward and being supportive of a daughter who was a drug addict. Who was living on the street. Who was involved with a man with whom no one on the jury would want a daughter to be involved. And that even without this context, it had to be seen that Dwaine had not admitted to the commission of a single illegal act. Hardy, on the other hand, went at the cool call word-

53. This aspect of this cartoon was not typical of Dwaine's work. In *Images of Children*, even Dr. Judith Reisman, while faulting him for exhibiting "little concern for the harm of adult sexual assault," noted that he regularly portrayed Chester's child targets as "apprehensive" or "fearful." (It is also true that in this case the girl did not know she was looking at a penis. She thought she was looking at a puppet.) When I pointed this out to Victor Vieth, he still called "Widdle Rodney" a "damning" piece of evidence. It was the one time, he said, that Dwaine "slipped up and let his true feelings through."

by-word, sentence-by-sentence, like a gull at a beached crab, striking at its carapace here, there, waiting to crack through into flesh.

Hardy led into the cool call by way of Veronica's phone call to Dwaine on April 3rd. There was, he said, no threat then by Veronica to reveal any secrets, was there?

"She may have mentioned something about going to the authorities," Dwaine said.

"There was nothing about sexual relations?" Hardy said.

"No," Dwaine said.

"Then," Hardy said, "in the cool call, when you told Veronica you had told Mama Debbie about the 'last time' you were on the phone and she didn't believe any of it, you weren't talking about sexual allegations?"

"Yes, I was," Dwaine said.

"But you just told us there were no sexual allegations in the April 3 phone call," Hardy said.

"I was referring to the conversation I had with Veronica on Thanksgiving and the phone calls I received from Steven Gold," Dwaine said.

"When you mentioned the 'last' phone conversation, you were talking about the Thanksgiving conversation?" Hardy said.

"I was talking about the entire conversation I had up to that point."

"Well, what made you think Veronica would know you were talking about the sexual allegation?"

"I don't understand," Dwaine said.

"You told her Mama Debbie doesn't believe it and doesn't want to believe it. What was the 'it'?"

"The references to sex."

"And they only occurred in the Thanksgiving conversation, correct?"

"I was also referring to the conversations I had with Steve and in the second conversation he'd told me Veronica had said things like that."

"Did you believe Veronica was having a delusion when she said those things to you at Thanksgiving?" Hardy said.

"I believe that would be a correct assumption."

"Do you think what she had told Steve Gold was the result of a delusion?"

"It had to be."

"But you never said anything to her in the cool call about her having a delusion, did you?"

"No, I didn't."

"But that's what you felt it was, some kind of delusion?"

"It had to be."

"At the time you talked to her in the cool call did you believe her allegations of sexual misconduct by you were all a delusion?"

"Actually, what I felt was that a game was being run on me."

"So you thought the sexual allegations against you were possibly delusional or possibly blackmail, is that right?"

"That's correct."

"But you never say anything to her about a delusion or blackmail, do you?"

"No."

"What you say is 'Mama Debbie said as long as you stick to that story, you're not welcome in her house.'"

"That's right."

"Well at that point in the conversation what story were you talking about? The only thing she had said to you whatsoever of a sexual nature was what she said at Thanksgiving."

"That was possibly an unfortunate choice of words. I was referring to all of the circumstances I had been dealing with."

"But until the cool call, Veronica had never told a story about your sexual relations with her, had she?"

"That is correct."

"You were concerned she was delusional."

"Yes."

"You were really concerned about the cocaine."

"I was."

"And you loved her, is that correct?"

"I love her now."

"Were you afraid she was in such a state she might kill herself?"

"It kept flashing through my mind."

"You wanted her to stop using cocaine."

"Yes."

"You knew she needed help."

"Yes."

"But when she said 'It's eating me up inside. That is the only thing I can think about,' you didn't say anything to her about getting help or needing help or straightening out, did you?"

"I didn't say it, no."

"What you said is 'then I suggest you stop thinking about it.'"

"That's what I said."

"Did you think someone with these deep-seated problems would get over them just by not thinking about it?"

"I was being sarcastic."

"Do you remember her saying 'I'm having nightmares every night'?"

"Yes."

"Do you remember her saying 'How do you think that I can go through day to day thinking that I had a sexual relationship with you? It's hurting me. It's eating me up inside?'"

"Yes."

"There wasn't any doubt in your mind but that she was telling you she was having psychological problems, was there?"

"She sounded like she was, yes."

"And no place in this call do you encourage her to see a psychiatrist, do you?"

"Sir, that would be too logical. When you deal with drugs, logic goes out the window."

"Well, did you feel you needed to reach out to her?"

"I thought I did."

"Did you think you were reaching out to her when you said 'I don't know what you're talking about'?"

"No."

"And when you say, 'Veronica, I don't want to talk about that. I don't want to talk about that at all,' did you think you were reaching out to her there?"

"No."

"And when you said 'I don't understand where you're coming from,' did you think you were reaching out to her there?"

"No."

"And when you said 'I suggest you stop thinking about it,' did you think you were reaching out to her there?"

"No."[54]

On redirect examination, Eskin could do little more than have Dwaine say that in their almost daily conversations between May 1988 and May 1989, when he urged Veronica to get off drugs, he had reached for her and reached and reached.[55]

After Dwaine's testimony, both sides rested.

54. To Victor Vieth, Dwaine's failure to deny his guilt in the cool call far outweighed his failure to admit it. "What pedophiles don't say," he told me, "is often more important than what they do say. An innocent person would deny this accusation directly and emphatically. But someone who knows it's true can't deny it, so they'll be evasive." (Similarly, Anna Salter writes in *Predators*, *Pedophiles* that sexual offenders, when interrogated, will often insert qualifying words into their denials or answer questions with other questions.)

But in *Remembering Satan*, Lawrence Wright's account of what seems to be one of the clearest cases of falsely accused molesters of the last twenty years, Paul Ingram, a deputy sheriff in Olympia, Washington, when told that his two daughters had accused him of sexual abuse, replied, "I can't see myself doing this" and that "he could not remember having ever molested [them]." Two of his friends, also law enforcement officers, who were accused by the two girls of participating in their father's ring of satanic baby sacrificers, responded: "I honestly do not have any recollection of that happening;" and "I wasn't present that I know of…" These are hardly the emphatic denials Vieth and Salter would require of the innocent.

55. The defense had called one other witness, Michael McKendry, an investigator with the district attorney's office. George Eskin had used McKendry to verify that Veronica had made statements to him that other witnesses had directly contradicted. However, a *Hustler* article, memorializing Dwaine after his passing, when discussing the trial, described McKendry as "a psychological examiner" called by the prosecution, whose testimony "dismayed" Hardy by concluding that Dwaine did not "fit the profile of a child molester and that Veronica might be less than truthful." "I believe lying is one of the tools she has at her disposal to express her anger and need for retaliation when she feels betrayed or rejected," the article quoted McKendry as saying. In fact, he testified to nothing remotely like this. No witness testified about Dwaine's "profile;" and the remark about Veronica's "tools" was made by Dr. Greenfield. It was contained in a report, *written* by McKendry, after he'd interviewed her; but Judge Storch had forbidden her to express it from the stand.

Efforts to reach *Hustler*'s fact-checking department for comment were unsuccessful.

XVI

This was, Matthew Hardy said, early in his closing argument, "a case about incest… and the broken hearts and the broken lives it causes." It was not, he said, about pornography, though Dwaine's denial that what he produced for *Hustler* was pornographic was relevant, for it mirrored his denial of the acts he had forced upon Veronica.

These acts constituted three types of felonies: child molestation; oral copulation; and incest. The Lap by the Pool incident (finger in the vagina) accounted for the first count of child molestation. The Pool and Bedroom incident (finger in the vagina, oral sex, intercourse) gave rise to three counts of child molestation. The First day of Ninth Grade (oral sex, intercourse) constituted the final two child molestation counts. Back from Sweden gave rise to one count of oral copulation. Carl's Jr./Sick Day was an act of incest. Sister's Bed constituted two acts of oral copulation (him on her, her on him) and one of incest. The First Day of Twelfth Grade and the Prom Dress incidents each involved an act of oral copulation and of incest. And the Last Time was incest. Hardy asked the jury to convict Dwaine of them all.

Hardy recognized that to convict Dwaine the jury had to believe Veronica. And he recognized credibility was not Veronica's strong suit. "[She], of course, has trouble with dates," is how Hardy put it. "[Her] memory has problems." "The ability to remember…" he said, "is not one of Veronica's greatest talents." Each charged offense had, in a sense, two aspects: the actions of the principals; and the surrounding stuff of life — time and place and physical facts. Veronica swore the actions had occurred; just as forcefully, Dwaine had

denied them. But in the "stuff-of" aspect, Veronica's account stumbled. To overcome the weaknesses in his case presented by her problems with dates of trips and periods of employment and when dildos were purchased, Hardy offered different explanations to the jury. Cocaine, he said, had set Veronica's mind "drifting." It is common, he said, to mix up incidents when the same thing happens repeatedly. (He analogized Veronica's problem to someone trying to remember how many times he had played golf or when he had played what course.) And, he asked, why would Veronica make this up? What could a young woman gain by publicly declaring herself an incest victim?

Minutiae aside, Hardy asked, didn't Veronica's story "make sense"? (Making "sense" may not constitute proof beyond a reasonable doubt, but it is certainly a prerequisite for any degree of belief to adhere to a narrative.) In the story Hardy submitted for the jury's approval, Veronica grew up "a freak," abused terribly by her mother and ridiculed by her friends when she recounted these abuses. Then into her life, to rescue her, charged her dashing, successful father, her "knight in shining armor." She loved him deeply — and he loved her. But part of his love was twisted. That part first manifested itself as digital penetration at the LAX Sheraton. This was, Hardy said, an "act of sexual initiation" — a test to see how far Veronica's love allowed him to go. When she did not object, he went further. And further. And how could Veronica protest? She loved her father; and these, he assured her, were the acts of a special love. No one had believed her about her mother. Who would believe her if she said worse things about him? And what would belief gain her? The destruction of a new family that she loved. The banishment to a life in South Carolina that she hated. The chains of love bound her until she discovered cocaine. He was, Hardy said, reluctant to say anything good about cocaine; but "many swords have two sides," and this one had turned Veronica "into an arrogant, selfish, uncaring coke whore," who thought only of herself. And one day, this transformation snapped the chains; and she blurted out the truth in a phone conversation with her father that Steven Gold overheard. Once the truth was out, she told other people; and one of these people, Dennis Rohde, convinced her to tell the police.

To protect his narrative from the defense witnesses who had disputed it and denigrated Veronica, Hardy employed a degree of sarcasm and ridicule worthy of Dwaine. Ron Stratford was "poor Mr. Stratford," whose tale of an innocent sleep interrupted by a thirteen-year-old girl sucking on his penis

was "the most incredible nonsense that will ever be heard in a courtroom." Del Dunnett was "our tattoo man, obviously a leading citizen of the city of Los Angeles." May Vann was "a walking corpse." Gus Poggi was "Mr. Wonderful," who had slept with Veronica while she was underage, and who could be blamed for Veronica's cocaine use because he had told her it was "a pretty good thing." John Billette was a "bastion of public morality." Dr. Clayton was "one of those great witnesses… with a British accent." And Dr. Greenfield was "a gem," "this superhuman person," with a "vast experience with three other child abuse victims," who spoke "psychobabble" and ought to be "embarrassed by her conduct…" (Hardy even got in a dig at George Eskin. What a "wonderful" voice Eskin had, he remarked. "Mr. Eskin's voice is so wonderful," he said, "I wish I had his voice.")

"The most important piece" of evidence, Hardy said, was "the cool call." (He then played the tape again for the jury.) It proved that Veronica did more than "make sense." It proved she spoke the truth. Listen to the words, Hardy told the jury. Listen to the inflections. "[Y]our human judgment will tell you one thing. These two people were talking about [a] sexual relationship…" The defendant knew that was what Veronica was accusing him of. He didn't deny it. He refused to discuss it. He tried to change the subject. His evasions equated to an admission her accusation was true. The defendant had months to come up with an explanation for his failure to deny Veronica's accusation, and he had been unable to.

This is a man, Hardy said, who "likes to violate taboos." A man "who considers Chester the Molester to be social commentary." Who believes this cartoon "which is generally centered around dead babies, human excrement, and the female menstrual cycle" can be carried off "with sophistication and wit." He has an "incredible power of rationalization, and he has rational- ized what he has done to Veronica; but he is guilty of the offenses charged." "[H]e's guilty. He's guilty. On every one of the counts he's guilty."

After the lunch recess, George Eskin told the jury a different story. In it, Veronica Tinsley was a deeply disturbed young woman, involved with drugs and sex since elementary school, a thief, a liar, someone who craved attention, someone who repeatedly saw herself as a helpless victim — of her mother, of Ron Stratford, of Steven Gold — and, now, of her father. This Veronica had made up the charges against him out of a variety of needs and

for a variety of reasons. She resented being kicked out of the house. She was angry that she couldn't regain her car. She was jealous of his new baby. She saw a chance to play a starring role in a major drama. She saw that being known as an incest victim would provide her "the ultimate permission slip." All the mistakes and failures of her life would be excused.

Veronica should not be believed, Eskin said, because her story was riddled with inconsistencies and errors. She said she had not reported her father because she loved him, because she feared him, because she thought their conduct was normal. She said she hated her father, but she sent cards and made videos and inscribed photos professing her love. Nights changed to days in her accounts of what sexual acts occurred when. They shifted years. They altered durations from two hours to twenty minutes. Veronica may have been "fantasizing," Eskin said, or "purposefully lying." Her testimony may have been the product of "vivid imagination" or "excessive cocaine use." The one thing it was not was truthful.

As for the cool call, Eskin asked, how many times did Dwaine have to say "I don't understand" or "I don't know what you're talking about" to demonstrate his innocence. Dwaine, Eskin said, thought he was dealing with Veronica's drug abuse. For him, that was the sole issue. Eskin heard "sadness" in Dwaine's voice. He heard "betrayal." When Veronica says she has been going on "day to day thinking that I had a sexual relationship with you" and Dwaine sighs, Eskin hears "frustration" and "exasperation." When Dwaine responds "Then I suggest you stop thinking about it. I have," Eskin hears his hallmark "sarcasm." Dwaine, Eskin pointed out, never admitted to sex with Veronica in the cool call. When she threatened "to go into it somewhere else," he did not tell her not to. When she said the sex was bad, he does not say, "Hey, it was terrific." The entire case, Eskin said, "rests on Dwaine Tinsley's silence."

Eskin balanced the call with Veronica's diary entry of January 13, 1987. That, he said, documented her story as "a complete lie." When more than half the felonies with which Dwaine was charged had supposedly already occurred, she had nothing to accuse him of but "unreal" fights which they always worked through.

What this case came down to, Eskin told the jury, was a "gullible" policeman and an "eager and resourceful prosecutor," presented with sexual molestation charges against the creator of Chester the Molester and believing they

had a "slam dunk" of a case. They had attempted to cement over the holes in their case with the thousands of *Hustler* cartoons they placed in evidence. Where was the proof that Dwaine went through the cartoons with Veronica saying, "See how much fun this is"? What was the relevance, Eskin asked, of cartoons insulting Jews, Catholics and blacks, except the arousal of "outrage and disgust"? "Please try to resist the invitation to be insulted and outraged by cartoons that are in poor taste," Eskin said. "Taste should not be on trial in this case.… Dwaine Tinsley is entitled to your individual and collective verdict of not guilty."

"Poor, poor Mr. Tinsley," Matthew Hardy began his rebuttal, "He is… a victim of a conspiracy… [between] that bad old policeman and this bad old district attorney… [who] decided to inflame you [with] *Hustler* magazine." Such "character assassination," he said, was a typical defense attorney maneuver. Focus on the accuser, not the law or facts. Attack the police; attack the prosecution; claim they "are out to get Chester the Molester."

Hardy then turned to the rehabilitation of Veronica's story. If she had made it up, he said, she would have been consistent in its telling. If she was acting, she would have memorized her lines. Confusion about dates is common when people tell the truth. What difference did it make in what year she went to Sweden or when she worked at Domino's? Why, he asked, would she record incestuous acts she wished to conceal in a diary which could easily be found and read? Her inscriptions on the cards and pictures, he said, were consistent with her "love" for her father, which had enabled the incest to continue. All the classic signs of the incest victim were present in Veronica: secrecy; low self-esteem; love for a father; fears of family disintegration.

Again, Hardy emphasized the cool call. Saying "I don't know where you're coming from" or "I don't know what you're saying" was not a denial. Saying "I don't want to talk about that" when Veronica said "I'm talking about the sex," was not a denial. Those were evasions, so Dwaine could get her alone and convince her not to tell anyone about their relationship. Where Eskin heard "frustration" in Dwaine's silence, Hardy heard "the pain that comes from losing a love." Dwaine, Hardy concluded, had seduced Veronica into "a lifestyle in which… child molestation was accepted and acceptable." "It is time," he said, "too find the defendant guilty as charged…"

XVIII

Judge Storch began his instructions to the jury at 9:05 A.M. on December 29th.

He told the jurors it was their duty to decide what did or did not happen between Dwaine and Veronica. They were to determine this without pity or prejudice, solely and entirely from the testimony of the witnesses, the exhibits admitted into evidence, and the inferences that could reasonably and logically be drawn from them. In deciding whether to believe a witness, they were to consider that witness's bias, demeanor, ability to remember, prior inconsistent statements, reputation for honesty. While failures of recollection or innocent, mistaken recollections were common, a witness willfully false in part of his or her testimony was to be doubted as to the rest of it: and if a defendant had the opportunity to deny an accusation and not done so, that could be considered against him.

Once they had determined what had happened, the jurors were to match these determinations to the definitions of the crimes charged and, by those applications, reach their verdict. These crimes were child molestation, which the California Penal Code defined as the touching of a person under the age of fourteen with the intent of arousing or gratifying sexual desire; oral copulation, which was defined as contacting the sexual organ of one person with the mouth of another; and incest, which was fornication between a father and his daughter. In a criminal case, Judge Storch reminded the jurors, a defendant is presumed innocent. His guilt must be proved beyond a reasonable doubt. And to reach a verdict — guilty or innocent — on any charge, they

must unanimously agree.

After he had sent the jury to deliberate, Judge Storch addressed Eskin and Hardy. "It doesn't get any better than what happened here," he said. "This jury was treated to a couple of extraordinary lawyers."

It was now up to the jury — the seven men and five women, the physicist and Missionary Church member and revenue agent, the fans of *Cathy* and *The Far Side* — to pick and choose from two competing narratives and author their own finished work. This collaboration of one dozen individualized composites of experience and education, taste and training, voice and vision, of twelve different dyads of logic and reason, percolating over stifled pity and prejudice, had to result in a mutually agreed-to narrative, whose conclusion would imprison a pervert or release an unjustly accused. In composing that narrative, the jury would have to decide if it was more in character for an innocent man to fail to exclaim a denial into an accusatory phone conversation or a victimized girl to omit acts of her ravishment — or "special" love — from her diary. If it was plausible that a father who abused his daughter would seek a therapist for her or if cartoons he drew for a living established his capacity for the foulest of acts. If the classic tale of father-daughter incest remained more dramatically compelling — more likely to "play" — in late twentieth century Southern California than this edgier, more contemporary alternative: that a sexually precocious young woman receives an arm on her shoulder in her bedroom, imposed upon a history of some just-between-us margaritas and dinners for two and nocturnal visits from drunk old dad; and then, aided and abetted by a scam-seeking boyfriend — not to mention sustained snoot-fulls of pharmaceutical hot-wirings — believes or hallucinates or calculates them into a barrage of charges that, once made, cannot be withdrawn without their maker facing charges of perjury or malicious prosecution. The jury, in editing its final draft, could easily, one assumes, accept a father, facing sixteen felonies for shameful sexual acts, lying under oath to escape them; but could it credit the thesis that a vengeful daughter would fabricate her own participation in these acts in order to destroy him, even if that daughter was someone for whom sex was just another coin of exchange — "a coke whore," her own advocate had called her — and might be less easily repelled by this casting than they, the authors-in-waiting?

On January 5, 1990, at 4:35 P.M., the jury answered these questions.

It was unable to agree if Dwaine had intercourse with Veronica during the Pool and Bedroom incident (Count 4) or if the Carl's Jr./Sick Day intercourse (Count 8) or the Prom Dress oral copulation and intercourse (Counts 14 and 15) or the Last Time intercourse (Count 16) had happened. It acquitted Dwaine of the Back from Sweden oral copulation (Count 7), the Sister's Bed oral copulations and intercourse (Counts 9, 10 and 11), and the First Day of Twelfth Grade oral copulation and intercourse (Counts 12 and 13). It convicted him of child molestation (digital penetration) during the Lap by the Pool incident (Count 1), and two instances of child molestation (digital penetration and oral copulation) in the Pool-and-Bedroom incident (Counts 2 and 3), and the oral copulation and intercourse during the First Day of Ninth Grade (Counts 5 and 6).

How the jury concluded that it could believe Veronica with respect to three incidents and disbelieve her with respect to nine incidents, or that how it could be sure that the digital penetration and oral copulation of the Pool and Bedroom incident occurred but intercourse did not; and why the incidents it did believe were those that had occurred the longest ago, when her memory would have seemed the least reliable, is puzzling. These were, after all, incidents that had occurred before Veronica's diary entry but were not mentioned in it. They had occurred before Veronica saw Dr. Greenfield but were not reported to her. These were not the incidents she had mentioned to Del Dunnett. These were incidents about which Veronica had given varying accounts about dates and duration and in which she had garbed herself in a bathing suit she did not yet possess. These were even incidents that occurred, according to other testimony, when Debbie was home and Dwaine working in Century City, while other incidents more certainly placed him and Veronica alone together. And most puzzlingly, if these events occurred but the others hadn't, it meant that Dwaine had perpetrated them within a single twelve day period in 1984 and then, for five years, done nothing like them again.

Fifteen years later, I was able to speak to three of the jurors in *People v. Tinsley*: Robert Riendeau, the post-office supervisor; Albert Gonelli, the engineer; and Roy Sherman, the bank manager and father of seven, who had been the foreman. Riendeau and Gonelli remembered little about the case. Riendeau, who believed the verdict turned on "forensic experts" (there had

been none), identified himself as one of two or three jurors who believed Dwaine was innocent of all charges. But, he said, the others kept "pushing and pushing" until the hold-outs agreed to convict him of a few charges as a "compromise." Gonelli, who had thought Dwaine guilty of most counts, believed the final verdict resulted from the fine grindings of the deliberative process and denied it had merely been a let's-get-outta-here deal. Veronica had just been more believable about the earlier charges than the later ones, though he couldn't say why. (He also said, "I didn't know if the girl was telling the truth or not. She could certainly twist the facts.") Neither Riendeau nor Gonelli recalled the cool call or the diary or Dr. Greenfield or, for that matter, any of the witnesses. Riendeau thought Dwaine's *Hustler*-connection influenced some of the jurors against him, but neither he nor Gonelli considered the cartoons a significant factor. "As I recall, once we were in the room," Gonelli said, "the cartoons were never even looked at. It was just trying to sort through the testimony."

Sherman had the clearest memory. ("Chester the Molester," he said, the moment I identified about whom I was writing.) He recalled the jury as evenly split on the first vote; but the more they talked, the more people became convinced of Dwaine's guilt. He did not think Dwaine's employment worked against him — but what he drew did. Some jurors found his cartoons "repulsive." Sherman, himself, had concluded, "The fact he made a living portraying a person who molested others indicated that it would not have been difficult on his part to go the next step." But what impressed Sherman the most was how "ingrained" Veronica's hatred for her father had been. Dwaine had done a lot for her, he recalled. He had bought her a car. "Nothing could justify that hatred but that he had done those things."[56]

When the verdict was announced, it did not strike Veronica as puzzling or compromised or logically cock-eyed. All she heard was that she had been be-

56. Victor Vieth's analysis is "Maybe they got it right. Juries make compromise verdicts all the time. Maybe this one convicted him of the early offenses because these occurred before she began doing drugs and before a motivation to fabricate arose. It was a logical compromise."

I would agree that this was a compromise verdict. I would point out, though, that Veronica testified she did not begin using cocaine until the spring of 1988. By then seven of the nine incidents — and thirteen of the sixteen charged counts — had already occurred. I find Detective Galloway's explanation for the verdict more appealing. "The mind-set in this county is, at thirteen, fourteen, she may have been vulnerable, but by fifteen or sixteen, 'You should start waking up, dear.'"

lieved. It had been horrible to hear herself portrayed as a vile slut. Describing what her father had done in front of strangers — in front of HIM — had been the hardest thing she had ever done. But she had been believed.

When the verdict was announced, Dwaine caught Veronica's eye. He saw neither joy nor relief, neither regret nor vindication. It was like she stared into nothing. Then the prosecution swallowed her with its congratulations.

They never saw or spoke to each other again.

Judge Storch thanked the jury for its hard work. He allowed Dwaine to remain free on bail. He set sentencing for February 18th. He referred the case to the county probation department for its recommendations and, to assist in that recommendation, ordered Dwaine evaluated by Patrick Barker, PhD.

Matthew Hardy announced the county would dismiss the counts on which the jury had not agreed.

XIX

On January 15th, Dwaine made his first journal entry in almost two months. (He dated it "Dec. 15," but since he refers to the trial being over, this is clearly an error.) He described himself as "manic," "whine-y," "sprout[ing] tears." Friends now avoided him. George Eskin was pushing for payment of his bill. The I.R.S. was threatening to put the one hundred thousand dollars he and Debbie owed into collection. He was paying six hundred and fifty dollars a month for a hotel room in Sherman Oaks but living with Debbie, Lori and Kimberly in Woodland Hills. If Child Services found out, it would mean more shit for the fan; but separation from them at this point was "unthinkable." He might have enjoyed the freedom of hotel life once, but now it left him lonely and depressed. He needed his family for peace of mind. But when Debbie learned that even if he received probation, he would have to register as a sex offender and only be permitted supervised visits with the girls, she wept and threatened to move to Virginia.

"You want relief but you don't get it," Dwaine wrote. "You want it to go away but it doesn't…. You're helpless…. Your frustrations break you down."

He enjoyed what he could. He thrilled to Kimberly's first steps. He enjoyed Lori's delight at the Moscow Circus's dancing bears. He studied George Bellows, Thomas Hart Benton, Frances Bacon at the Los Angeles County Art Museum — their line, their building of colors, their feathering, cross-hatching and shading. (Bacon, he noted, doesn't just "see" people, "he punches them in the nose." And Benton, "this little, controversial, hell-bent

guy... [who] pissed off polite society," would have found Chester "right up his alley.") He found solace in this fellowship of artists who sought relief from their troubles in "the passion of [their] work." He found satisfaction in *Means of Ascent*, the second volume of Robert Caro's biography of Lyndon Johnson, which reinforced his belief that the rich and powerful always had — and always would — exploit ordinary people.

He thought of writing a story to consider how much a man could take before he fought back. He thought of doing a series of drawings derived from *noir* book covers and movie posters of the 1940s and 1950s. The central character would be a private detective since "we're all private eyes peeking in on other people's lives." The drawings would be related; but each viewer would have to make up his own story and draw his own conclusion, because people ought "not to care what I meant but what they want it to mean." He fantasized about moving his family back east to a farm. He would have a barn-sized studio, where he would combine elements of cartooning and painting like a "hyper-realistic Russ Heath." His humor would attract the viewer; then his message would hit them. "Messagism," he called it — an art that "would be at home in a Neo-Realist/Pop/Symbolist vernacular but nap in a humorist's bed."

Dwaine saw Dr. Barker January 31st and February 1st. (Dwaine thought him a "nice guy," reminiscent of Peter Breck in *The Big Valley*.) Dr. Barker said he was to determine if Dwaine's sexual inclinations made him a threat to society, requiring his imprisonment, or if he could benefit from a rehabilitation program while on probation. Dwaine tried to be "cordial" and "cooperative" without appearing to be "sucking up to him." He tried to control his "indignation [at this] absurdity." Dr. Barker gave Dwaine the MMPI-2, a complete-the-sentence test, a "pedo-scan" (the Problem Identification Checklist), and a "sex deviate quiz" (the 16-PF Test).

Their next sessions — February 14th and 15th — focused on Dwaine's mother. (Dwaine worried that Dr. Barker would transpose his feelings about her into a hatred of all women, when it was only "tramps" he disliked.) Dwaine told Dr. Barker he had hoped to protect his family from his experiences as a child. Now Lori was hearing him called worse names than he had heard his mother called. He told Dr. Barker his sex life was "adventurous but nothing kinky" — and always consensual. He called Debbie his "soul

partner" and remarked how well they shared and communicated. When Dr. Barker asked what he considered the most damaging part of the cool call, Dwaine said, "Easy. 'Put it behind you…' where I got sarcastic." He had meant that Veronica should "put the bullshit" of her unfounded charges behind her. He hadn't, he claimed, even been listening to what she was saying but had responded to her dramatics. "I made a mistake in my speech, but I shouldn't go to jail for it."

Dr. Barker told Dwaine the MMPI showed him "normal." The other tests found him "fine" — except for "a high paranoid level."

Which, under the circumstances, was to be expected.[57]

On February 15, Leesa Reynolds, the deputy probation officer assigned to Dwaine's case, interviewed Veronica at the Corrections Services Agency. Veronica called her father "a very sick man" and a threat to Lori. "I loved my father, and I thought he ruled the earth," she told Reynolds. "But now I see that he took advantage of me. How could he have loved me when he did all these things to me?" Veronica described herself as angry, depressed, and lacking in self-esteem. Sometimes she could not even bear seeing fathers and daughters together. But, she believed, her drug rehabilitation program would now enable her to "get [her] life together."

Granting Dwaine probation would hardly be sufficient punishment for what he had done, Veronica said. She wanted him to serve the maximum sentence. She hoped "that the animals in jail would make him feel one-tenth of what I had. He's out of my life anyway," she said, "and once he goes to prison, he's dead in my eyes. I don't want a thing from him. I just want to let this die."

The following day, Reynolds interviewed Dwaine.

She asked about his having said "I don't want to talk about that" during

57. Because he expected to be asked to testify at Dwaine's sentencing hearing, Dr. Chase had already given Dwaine the MMPI a second time. (He reported that Dwaine's "problem areas" looked better.) While it is possible that people, as they become familiar with the MMPI, can tailor their answers to achieve results they desire, it is more likely they would trip themselves up by manipulating their answers on obvious questions but failing to do so on more subtle ones, with the resultant inconsistencies red-flagging their efforts. However, it is nowhere stated that Dr. Barker was aware that Dwaine had been tested previously. It is likely he would have wanted this information — and these results.

the cool call. (She seemed, Dwaine reported, not to know he had heard the sex charge from Veronica at Thanksgiving or that he and Debbie had been speculating about what she might be up to.) She asked why Veronica would have put herself through this if the charges weren't true. (She seemed not to know that, following his arrest, Veronica had told friends to watch the evening news because she would be featured or that she had brought newspaper stories about the case to work to show customers, even though the district attorney had tried to keep her name out of them.)

And how, Reynolds asked, could he draw cartoons about child molestation? Dwaine gave his usual answers — "focal point," "social comment" — but, he suspected, she had missed the point. "I may be a scoundrel and a bit of a rogue," he told her, "but I'm no child molester. I am honest and truthful and not morally bereft." He promised to be cooperative if granted probation, provided he did not have to admit his guilt. He agreed to register as a sex offender, provided his name could be "scratched" when his conviction was overturned. Going to prison for something he hadn't done was incomprehensible to him, but he'd do it if he could continue to draw his cartoons.

Dwaine thought Reynolds a "paper-pushing bureaucratic puppet... [with a] Christer/do-gooder attitude."

He was convinced he was going to jail.

As his February 28th sentencing approached, Dwaine felt cocky. ("You can cook me but you can't eat me," he wrote.) Once inside the courthouse though, he became nervous, even "paranoid," and "disassociated." "Who are these people?" he thought. "Where did they come from? ... Why am I here?" But Dr. Barker wanted more time for his report, and Reynolds wanted to see it before she made her recommendations.

Judge Storch postponed sentencing until April 19th.

In mid-March, Dwaine's therapy sessions began to focus on an "anger" Dr. Chase believed had possessed him long before Veronica brought her charges. He suspected Dwaine kept people at a distance because he feared they would reject him due to something that made him unworthy of love or trust. Dwaine could not identify any "dirty" act, of which he was ashamed, that might make him act this way. He could see himself as "cynical," "guarded," "untrusting" — but he would never deliberately injure another person.

He wondered if he felt "not *worth* loving or trusting" and that this defect in his character could harm those who attempted to love or trust him. He wondered if he felt this lack of worth because he was a man and his mother had considered all men "no fucking good"? Or because he was a piece of her and she had been a drunken tramp? Or because he had loved and trusted her and she had crapped upon this love and trust?

As a young man, he now saw, his anger had set him on a self-destructive course that would punish him for his lack of worth. When he had righted himself, this same anger had driven him to become a good husband, a good father, a good cartoonist. All creative people, he suspected, were driven by anger. It let them see the world differently than the average person — to reject things as they were — to tinker with this world, to dissect it and re-connect it in a novel way. This anger was not the same as "hate." There were things he hated — war, inequality, bureaucrats — but even those he would not attack overtly. He used his art to vent his rage.

All he had wanted, Dwaine wrote, "was to be tried as a man and a father, not because of who I work for and what I do." He had not done or said or intended anything wrong. But everyone — the prosecution, the press, the probation department — had fixated on his work. ("Every time they mention me, they mention Chester.") He could not comprehend the split verdict. ("How in fuck does that make sense? You either believe her or you don't.") He could not accept that the liars and extortionists —Veronica and Steve Gold — would go on with their lives while he went to prison. The legal process sickened him. All lawyers had "the smell of shyster to them." They were consumed by "rhetoric, dramatics, maneuvering, lies, and hiding behind 'ethics,'" at the expense of "truth." Hardy, who had refused to have Veronica take a polygraph, was more interested in putting him in jail than learning what had happened. He had hidden the real Veronica — costumed her, coached her, programmed her with the idea of Dwaine's sickness and the need to protect Lori from him — and then inflamed the jury with his work. Dwaine threatened to reassert himself at his next court appearance — grow his hair long, wear his earring. Why should he conform now? He could have this small victory, at least.

His feelings about Veronica mixed anger and love, pity and regret. He would have spent every cent his defense had cost to have her restored to how

she was before she discovered cocaine. The Veronica with spirit and potential still claimed "a dear place" in his memory. But he could never trust her again. He despised the present Veronica. In his heart, she was dead. He believed she would be haunted by the guilt of having destroyed her family. He blamed himself for not recognizing that the selfishness, the rebelliousness, the rage, and "the desperate need for attention" she had brought from South Carolina had to collide with his need to guide her, nurture her, make her do well. He hadn't wanted her to make his mistakes — or, worse, turn into his mother. That would have made him loathe her.

One evening, he played out a scene between himself and Veronica in his journal. "Why are you doing this?" he wrote. "Why all these disgusting, absurd stories? Do you hate me that much?"

"You bet I do," his Veronica answered. "I loved you, dad. I counted on you. But you turned your back on me. I am like I am because you left me with that bitch. And I hate me. I hate what I am. Selfish and two-faced and weak-spined. I hate you for it. When I came to live with you, what a guy you were! Famous, fun, witty, a real pal. I thought I was the luckiest kid on earth to have a dad like you. You made me feel good about myself. I felt I was somebody. You gave me the impression I could do whatever I wanted. But that was a lie. Every time I wanted to spread my wings, you'd slow me down."

"Did you start doing drugs because you hated me?"

"No. I was partying. I was having fun. All my friends were doing it, and I wanted to belong. I was spreading my wings whether you liked it or not."

"You said I turned my back on you. Why would you care?"

"You didn't just turn your back on me. You rejected me. I always felt that as long as you were there I could stand anything. But you rejected me and I hate you for it. You threw me away like an old shoe — twice!! The last straw was when you took my car. I decided to destroy you. Destroy you in my mind and destroy your reputation. Everybody thought you were such a cool guy and I was shit. I wanted people to see you as a son of a bitch — but not just *any* son of a bitch. And the easiest way to destroy a man is to cut his balls off."

"That's Charlotte talking."

"You're the one who left me with her."

XX

Dwaine's friends, relatives, co-workers at Larry Flynt Publications, and others in the adult magazine world sent letters to Judge Storch urging a lenient sentence. These letters were often lengthy and heartfelt. They expressed shock at the charges and bewilderment at the verdict. They called Dwaine "a world-class artist with a unique sense of humor," "highly intelligent, thoughtful, articulate," "[full of] understanding, compassion and warmth," "loving, kind, considerate," "strong, fair and honest," "big-hearted," "generous," "loyal," "a vital, moral and good man," "a regular guy." They characterized him as a "very much concerned parent," an "overprotective" father, "totally incapable of these acts." (These same people portrayed Veronica as "mean-spirited," "malignant," "cruel.") William Reinhart, the private investigator hired by George Eskin — and a recently retired member of the Ventura County Sheriff's Department — wrote that he had interviewed over fifty people in connection with the case and had concluded Dwaine was innocent. Dr. Chase wrote that Dwaine was "a bright, creative, energetic, zestful, candid and insightful man... [who was] not interested in or motivated towards children as sexual figures... [His] personality profile, fantasy preoccupations and emotional states are not consistent with... child molester/pedophiles... [He] does not appear... capable of committing a crime of pedophilia and/ or incest/child sexual molestation." Dr. Greenfield took the opportunity to comment on the relevancy of Dwaine's work. It was, she said, "in no way a reason to suspect [him of] child sexual abuse since he is finding expression of his fantasies in his cartoons. More often than not... a child molester is

someone who is sexually inhibited and who may be extremely moralistic and religious and shows no outward or open expression of sexuality."

Dr. Barker filed his report — six pages, single-spaced — April 2nd.

He stated that he had been asked to answer three questions. Was Dwaine's imprisonment in Veronica's best interest? Would a treatment program rehabilitate him? Did he present a danger to her if granted probation? Dr. Barker noted the tests he had given Dwaine, the time he had spent interviewing him. He listed the material he had reviewed: police reports; investigative reports from the D.A.'s office; transcripts of the cool call and Dwaine's statement when arrested; letters from Dwaine to the probation department, Veronica and others; portions of Veronica's diary; Judge Water's decision in the custody hearing; letters from Dr. Greenfield and Dr. Chase; many of Dwaine's cartoons.

Dr. Barker concluded that Dwaine had been open and forthright with him. Their interviews had revealed no "delusions, illogical or magical thinking, over-valued ideas, obsessions or incomprehensible speech." They had shown him to possess "a good ability to think symbolically and to conceptualize and generalize. ... His intellectual functioning... [was] above average." (Dr. Barker did not find Dwaine's cartoons particularly probative. He commented that the sexual ones primarily depicted sex "in perverted, absurd and grotesque ways." The non-sexual cartoons he termed "playful.") While the psychological testing had indicated Dwaine was "self-indulgent, attention seeking, impulsive and sometimes manipulative," it also showed him as "self-sufficient, comfortable with himself and emotionally stable." Nothing, Dr. Barker wrote, "would give significant support to the conclusion that he is a pedophile or that he suffers from any other sexual disorder." In fact, Dr. Barker found Dwaine's account of their relationship "in many respects more plausible than Veronica's..." He termed the cool call "ambiguous... [with] at least two plausible interpretations... [It] could support the conclusion that there had been sexual molestation. It could also support the conclusion that Mr. Tinsley was trying to persuade Veronica to stop bringing up irrelevant and unwarranted accusations." Dr. Barker was more impressed by what Dr. Greenfield had written him: that Veronica had never expressly or impliedly revealed incidents of molestation to her; that it was "very unusual" for a molesting parent to bring his child to treatment; and that Veronica had ex-

hibited signs of a personality disorder which could easily render her capable of making and maintaining untrue accusations. "Lying," Dr. Greenfield had said "[was] a major issue at the time she was seen by me." (It should be noted that Dr. Barker never interviewed Veronica and could not assess her credibility himself.)

Since he had found that "Mr. Tinsley does not show any evidence of a propensity for the commission of sexual offenses against children," Dr. Barker concluded that the questions put to him were not relevant and did not answer them.

Dwaine hoped the report would mean probation.[58]

On April 19th, Judge Storch postponed Dwaine's sentencing again. He was displeased that Dr. Barker had not answered his questions. He thought another doctor might have to evaluate Dwaine. He also urged the prosecution to have Veronica seen by a psychologist for insight into what sentence would best serve her interests. Matthew Hardy refused. Veronica, he said, did not wish to be evaluated. And he did not want her subjected to further embarrassment and humiliation. Dwaine looked for "shame" in Hardy's face — for the recognition he had "fucked me over." Instead, he saw an overweight, middle-aged functionary, dressed "like the shabby working man's champion," laboring under the belief that everyone accused was guilty. The judge then decided against any further evaluations. He set May 5th as the new sentencing date.

Dwaine thought Judge Storch wanted to give him probation. He had to have been impressed by the findings of Dr. Barker and Dr. Chase and the strength of his character letters. He had to have doubts about Veronica's drug use and lies and refusal to be tested. He must have doubts about the verdict itself. He must be thinking, "What the fuck is going on here?" He hoped the judge would be angry at having his hands tied and would base his decision on his conscience and his sense of fairness.

But, he recognized that, in the face of the "witch hunt sensibility" and

58. The prosecution was unimpressed by Dr. Barker's findings. It had never contended that Dwaine was driven by a sexual desire for children. It viewed him as "a situational molester." "Just because someone molests a child," Detective Galloway says, "doesn't mean he's a pedophile. It depends on a person's life and what's going on in it. You can have a husband and wife, both working, their interactions limited, so interest can be skewed towards a minor. It's not a preference; but that's what's there."

reactionary climate that prevailed in Ventura County, without the "cover" of an expert's recommendations, it might take more courage that the judge possessed to give him probation. Realistically, the best he could hope for was to be allowed to stay free on bail while the verdict was appealed. "I'm glad I'm wired tight," Dwaine wrote. "If I weren't, the anger and humiliation would drive me nuts."

Leesa Reynolds filed her report May 3rd.

In favor of Dwaine's candidacy for probation, she wrote, were his age, education and health. He had fourteen years stable employment. He had not been convicted of a crime in twenty-four years. And prison was likely to affect him negatively and make his dependents suffer.

But granting him probation would harm Veronica. His offenses were serious, pre-meditated, involved an abuse of a position of trust, and appeared to have psychologically damaged her. (Reynolds expressed her belief that Dwaine's acts had been more extensive than the jury found.) While Dr. Barker's inability to evaluate Veronica had left him unable to determine what sentence would be in her best interest, he had said that probation and a treatment program would be of uncertain benefit to Dwaine, since these programs worked best when someone has admitted guilt, expressed remorse, and wanted to change; and Dwaine continued to insist he was innocent.

She recommended twelve years' imprisonment.

XXI

Before beginning the May 5th sentencing hearing, Judge Storch heard George Eskin's motion for a new trial. Eskin's primary argument was that the jury's verdict had been fatally tainted by the admission into evidence of the cartoons. Since the prosecution had not established that Dwaine had used them to induce Veronica to have sex, their relevancy was more than offset by their prejudice. Matthew Hardy replied that the cartoons documented the Tinsley lifestyle and that the jury needed to see them in order to rebut Dwaine's claim that his work was social comment. Though Eskin pointed out that the cartoons went into evidence before Dwaine had even testified, Judge Storch denied his motion. If the jury had been prejudiced, he reasoned, it would not have acquitted Dwaine of any of the charges. No trial was perfect; and if admitting the cartoons was an error, it had been a harmless one.

On the question of Dwaine's sentence, Eskin called Dr. Chase as his only witness.

He gave his credentials — Chicago Medical School; USC residency; consulting psychiatrist for Los Angeles County Superior Court; staff physician with its Parole Outpatient Clinic, where he had worked with about two hundred twenty-five pedophiles, half of whom were incestuous. He detailed his relationship with Dwaine. Based upon his professional experience, his knowledge of his patient, and the results of the psychological testing he had administered, he had concluded that Dwaine was incapable of committing an act of child molestation.

Judge Storch then allowed the attorneys' final arguments. He asked them to focus on what sentence would be in Veronica's best interest.

Unfortunately, George Eskin began, because the prosecution had not permitted Veronica to be psychologically evaluated, the court lacked adequate information to answer this question. Vengeful victims should not be permitted to block defendants from probation by such refusals, he went on; and if Veronica was lying, which he believed, imprisoning Dwaine could compound her problems. Someday, the reality of what she had done would wipe out any gratification she would gain now from seeing her father jailed. She has had the vindication of having the jury believe five of her charges. Further punishment would gain her nothing but would harm her family. Veronica had already received "more than her pound of flesh." Eskin refused to argue for even one minute of imprisonment. He believed the entire case had been "inspired" by his client's work. He believed Leesa Reynold's recommendation had been "predetermined," for she had ignored the findings of Dr. Barker, Dr. Chase, Dr. Greenfield, and the people who knew Dwaine and Veronica best. This was, Eskin said, "one of those rare occurrences where the justice system has failed... I firmly believe that an innocent man has been convicted... [and that] any incarceration of Dwaine Tinsley is unjustified."

Matthew Hardy urged that the recommended sentence be imposed. Otherwise the court would be sanctioning the defense's continued attacks on Veronica's credibility, sanity, ethics, and morality. To grant her father probation would be to deliver the message: "You're a slut. You're a druggie. You're no good." Dwaine did not deserve mercy because he would not admit guilt. Hardy had been outraged by what he regarded as the defense's tactic of demeaning Veronica in order to cover up what had happened to her. He poured this outrage into his final assault on Dwaine. He was, Hardy said, "a pathetic little man who goes into his room and draws dirty pictures all day. When he comes out, he can't get an erection unless he has it sucked by a little girl.... If he is not man enough to stand up and admit what he has done to his daughter,... the court should have no compassion for him."

When both attorneys had finished, Judge Storch confessed he had never presided over an incest trial. The defendants in other such cases assigned him had always pled guilty and begun a "healing process." This case was "particularly unique" because he did not consider Dwaine a pedophile. He posed no

threat to children in general or to Lori and Kimberly in particular. But his rehabilitation was unlikely in light of his denial of guilt. And Veronica's hurt needed to be "vindicated."

He sentenced Dwaine to six years in prison.

Two days later, Judge Storch denied George Eskin's motion to allow Dwaine to remain free on bail while his conviction was appealed. While the judge agreed that Dwaine was neither a flight risk nor a danger to the community, he did not believe there was any chance that the conviction would be reversed.

"You bend over backwards, and the bureaucrats cover you with shit," Dwaine wrote. "You comport yourself with honor and dignity and it doesn't make any difference with the weasels. Why do I keep expecting different?"

His journal ends with that question. But many pages later, undated, sits an idea for a story. Entitled "Blood on the Crib," it concerns a psychotic killer who has taken on the mission of killing the babies of "upwardly mobile" bureaucrats before they "bloom."

In the end, he gets away.

XXII

Dwaine could stay in county jail and have a bail hearing within ninety days; or he could enter the state penal system, while his lawyers prepared a more thorough appeal, which could increase his chance for bail when his motion was heard. He took the second option. If he lost his motion, he would have already served part of his sentence. If it went well, he could bail out then. The California Department of Corrections sent him to the California Institute for Men, a reception-and-diagnostic center at Chino, in San Bernadino County, where most convicted felons from the southern part of the state underwent four to six weeks of medical, psychological and aptitude testing — which could stretch to eight or twelve — to determine where they would serve the rest of their time.

Chino was hot, steamy, crowded, loud. Imagine a sweltering, summer Saturday night in front of a ghetto liquor store, he wrote John Billette. Then multiply that by a hundred, and jam it into a prison. Not much hope was expressed at Chino, just bullshit and aimlessness. The main topics of conversation were drugs, pussy and gangsterism. The most common words in these conversations were "y'know" and "motherfucker." If the government collected a dime each time one of them was uttered, it could pay off the national debt. These were men serving life on an installment plan. Five years here, five years there, one or two off in between. "It's quite an adventure," he said, "and a sad one."

He had a single cell. He got "yard" — and a shower — three times a week.

He could buy cigarettes and coffee — but was not allowed a mirror, so shaving was a guess. He could write letters and draw — but since sharp instruments were forbidden, only with a pencil. He could receive newspaper or magazine articles — but nothing "colorful or dirty;" and he was not permitted a radio, so news of the outside world was limited. He could receive pictures of girls — but no more than five at a time. (Debbie broke one shipment of thirty-nine into eight separate envelopes, and all got through.) On his wing were a man who stripped naked and sang "That Old Black Magic" whenever someone passed by; an Apache who chanted thirty minutes at a time, "Hey-yo-yo-yo. Hey-yo-yo-yo." ("If it begins raining in here…," Dwaine mused); a Satan worshipper with more hatred in his eyes than Charlie Manson; a cokehead from Ventura County whom Dwaine overheard reminisce about the "freak" Veronica Tinsley had been; a half-dozen young men who altered their CDC-issue underpants into ladies lingerie, shaved their legs, wore eye-liner and lipstick made from colored pencils. (The most striking had four-foot-long hair and silicone breast implants.) They took girls' names and chattered "girl-talk" as they glided to and from the mess hall like *Swan Lake* was playing. Each shipment of new prisoners seemed louder and more ignorant than the last.

When Debbie and the girls visited, he and they could not touch. Separated by a plate of glass, they spoke through phones. Lori cried each time she left. Debbie told him Kimberly still toddled into his studio, hoping to find him.

He discussed his case with no one. He said he was a commercial artist in on "drug-related" charges.

In mid-July, Dwaine was sent to the California Men's Colony at San Luis Obispo, a few miles east of Morro Bay. He was assigned to CMC-West, a minimum security facility built as an Army hospital during World War II and converted into a prison in 1954. (It reminded him of the camp in *Hogan's Heroes*, except the guards wore brown and green and the inmates blue.) The inmates lived in ninety-man barracks. Dwaine worried the lack of privacy in dormitory living would interfere with his art. The authorities worried — because of his notoriety, the nature of his offenses, and the attitudes of other inmates toward them — about him being that exposed. After a week, he was transferred to CMC-East, a Level Three/Four facility, where many inmates were in protective custody: informants; gang drop-outs; "ce-

lebrities," like the Manson gang's Tex Watson, Tina Turner's husband, Ike, Marlon Brando's son, Christian, one of the Bay Area's Zebra Killers — and those convicted of sex crimes.

Many inmates at CMC-East would learn what Dwaine had done for a living. (Since they were often fans of *Hustler*, it helped his status.) Few, if any, would know of what he had been convicted. His closest friend, Bill Nichols, a forty-eight year-old former high school basketball coach — whom Dwaine described as "smart, well-read, funny [and]... except for fifteen minutes of insanity... a great guy" — who was serving twenty-five-to-life for the murder of his fiancée and her lover, believed Dwaine's eldest daughter had shown his cartoons to a friend. Her parents had complained to the police, and an overzealous D.A. had taken it from there.

CMC-East was composed of several buildings, each with two tiers of cells. It had good food, a good library, a gym, lots of open space, softball, volleyball, a track, weights. It offered, through Chapman University, courses toward college degrees in Business and Social Science. Its jobs paid up to one hundred-fifty dollars a month, which, for a prison, was high. Many inmates were "lifers," who had adjusted to their situation. It was, Dwaine noted, "very mellow for an armed perimeter institution."

The inmates shared five-by-eight-foot cells that had been built for single occupancy. The second bunk, hinged to a wall, had to be folded up for them to move around. When both bunks were down, they slept six inches apart. ("Unbelievably tight quarters at night," Bill Nichols wrote me. "However E had a lot of homosexuals, and they rarely complained.") The inmates were locked in at night but, during the day, could come and go at will. (They even had keys to their cells.) They could make one phone call a week. They could have visitors daily. (At arrival and departure, a brief embrace and kiss were permitted. Hand-holding was allowed but lying together, lap-sitting, and body rubs forbidden.) They could have one seventy-two-hour conjugal (or "boneyard") visit every two to three months. ("It keeps the edge off and your balls working as God intended," Dwaine said.)

Dwaine was older than most of the inmates. (They called him "Pops" or "Old Timer.") He had also scored twelve-and-a-half points, out of a possible thirteen, on an intelligence test on which they had averaged six. They kept the TV in the day room tuned to *Love Connection* or *Days of Our Lives*.

("Dullard Central," he called it.) Most struck him as "low lifes with a 6th grade education." Prison was the best home they'd ever have: "Three hots and a cot, clothes, no bills [or] responsibility, twenty-four hour security, rent and all utilities paid."

Once an inmate asked him if he'd ever read a book.

Dwaine thought he meant the Bible. "Have I ever read *the* Book?"

"No, no. Have you ever read *a* book?"

"Well, yes," Dwaine said.

The man was impressed.

His first cellmate (or "cellie") believed he could stop thinking and become invisible. When he talked, he went "spinning into space like an astronaut's crumpled candy wrapper." He had three teeth and, each night, worked his way through a bag of hard candy. In the yard, inmates cranked their portable radios to full volume with heavy metal, rap, country. The walkway might have been a "Phlegm Obstacle Course." Softball games progressed around "dings" from the mental ward catching fly balls in between imaginary conversations. Dwaine met a sixty year old with a forty-two year sentence, a ninety year old with six, a man whose earliest release date (ERD) was 2057. ("His parole officer," it was said, "ain't born yet.")

The inmates rarely complimented anything. They complained about the noise, the clothes, the food. (Even their word for something "good" was "bad.") "If you don't like so-and-so," they would say, "don't come to prison." "Well," they would say about another disappointment or fuck-up, "that is CDC." Their code required they make everything difficult for "the man." They stole anything not bolted down. They slopped their meals into mounds and shoveled the mounds into their mouths, their mustaches, their beards. If Dwaine walked laps around the track, a "yard ape" would accost him, talking shit, reacting to his solitary thinking like a "lion that had spotted an antelope with a limp." Once he had believed that if he associated with smart, imaginative, creative people, he could absorb their intelligence. Now he feared the mental dullness, the arrested development, the rudeness would suck out his brain. (Wisdom does not come from suffering, he instructed Billette. If it did, Ethiopians would be the smartest people on earth.) "Prison," he wrote, "is a cafeteria of the insensate," "a cerebral wasteland."

In a lunch line, Dwaine noted a convict with Hodgkin's disease receiving

a laying on of hands from a convict with "Christer's disease." The line waited silently until they had finished. Two days later, Dwaine spotted the first man again, still palsied, still lacking facial muscle control and — "Guess what? — he still was a convict."

Once assigned a cell, he was permitted a mirror. He was allowed rolling papers, tobacco, a radio, a TV. (He became adept at rolling his own cigarettes — but cut his smoking to a pack a day.) He could receive books and magazines, even hardcore porn. (He asked Debbie for *Newsweek*, *S.I.*, *National Lampoon*, *Hustler*, *Golf Digest*, *Rolling Stone*, *Heavy Metal*, *Ring*.) He read Douglas Adams's *A Hitchhiker's Guide to the Galaxy*, Michael Herr's *Dispatches*, David Halberstam's *The Powers That Be*, a Huey Long biography, Hunter Thompson's *A Generation of Swine*, some Elmore Leonard and Jim Harrison. The "wigged out, fried brain, fuck 'em up the ass" Thompson made him think his work had grown soft. He needed to stop being "clever" and return "to ramming a big ol' horse cock down society's throat." The Harrison showed him that poetry could work for "regular guys," not just the "limp-wristed." (He, then read Robert Duncan, e.e. cummings, Anne Sexton.) He could order art supplies — a forty-pound "hobby" package per quarter — and stocked up on pads, paper, felt-tip pens, erasers. A sketchbook or diary or journal was not a good idea, though. Someone might see something that would lead him to conclude you had to be killed.

He had hoped to work on the prison newspaper or be a teacher's aide or library clerk. Instead he was assigned to the laundry, bagging dirty clothes. He bent; he lifted; he twisted. He returned to his cell and tuned in jazz or rock. He drew; he read; he wrote. He did one hundred push-ups a day. He practiced his golf swing with a broom. He sought a routine so time passed quickly. He did not look at the days ahead, only the days behind.

He taped to the wall a *New Yorker* poem:

Maybe all we wanted was a woman with legs spread
in a wheelbarrow of twenty-dollar bills, and beer foam
falling from the sky: life should be so easy.

SOS — DD, the inmates called it. "Same Old Shit — Different Day."

If his appeal failed, his earliest release date was May 21, 1993. His approach was to work within his situation. He would not question; he would only conform. (You wear blue, he recognized, you're the bad guy.) The system was designed to strip away humanity, individualism, confidence, honor. But he would stay balanced. He would use his anger at "the injustice, the maneuvering, the politics, the pain" to focus on returning to his family, his work — and "golf courses yet unplayed." He would retain his dignity. They could lock him up, but they could not take his soul. Midway through his sentence, he read *Zen and the Art of Archery*, followed by *The Way of Zen* and *Zen Practice in Daily Life*. We are bound with things we dislike, he learned, and parted from things we love. We cannot control our lives, but we can control our actions. Everyone in here is guilty of something, he wrote John Billette. "Either we're guilty of our commitment offense or we're guilty of something a judge or 12 people didn't like or understand about us."

Twenty-three years earlier, he realized, while in solitary confinement, he had decided to make his living through art. Against all odds, he had become a world-famous cartoonist. But now a character his art had created had helped return him to prison for something he had not done.[59]

The young in prison, Dwaine noted, feared coming out old and scared and beaten. He recorded his own hair whitening, flesh growing slack, facial lines deepening. He wondered if he saw himself in his mirror or if someone else had taken possession of his body. He recalled that he once had worn a belt buckle shaped like a phoenix to remind him of the ashes from which he had risen. Now he used every ounce of discipline and logic and drive he possessed to distinguish himself from his surround. "I've spent twenty years rubbing the shit off me," he wrote Billette. "I don't want to get any of it back." (In place of the phoenix, he now wanted "Matt Hardy's dick in my pocket.")

The prime lever for this separation was his art. He could prove he still stood apart through its pursuit. ("The only published cartoonist in captiv-

59. Dwaine was pleased to learn that, throughout the CDC — and perhaps in prisons nationwide — perverts, degenerates and child molesters were knows as "Chesters." He had, he thought, assassinated a name. "Ah well, it's a fucked up name anyway."

(In what may or may not have been another tribute, the Oakland Raiders [1977-86] five-time Pro Bowl cornerback, Lester Hayes, was known to players, sportswriters, and NFL fans everywhere as "Lester the Molester." And if any professional sports team was apt to have been a fan of *Hustler's*, it would have been that era's Raiders.)

ity," he called himself.) He thought of a strip, "In the Can," that delivered the message that everyone, whether behind bars or on the street, was caged. He considered a series of paintings, "Norman Rockwell Goes to Prison." (In one, three murderers sit at a table, heads bowed, waiting to eat, while a fourth says grace.) He considered mammoth Chuck Close-like portraits, beneath each face a CDC number, a Penal Code citation, a sentence and ERD. He envisioned a painting, "The Hearts of Man," as in "Who knows what evil lurks within..." He envisioned another, "Perverts," depicting Hansel and Gretel in a forest of degenerates in the "style of Roy Carruthers meeting Rousseau." He completed several cartoons in which Judge William Nichols imposed a variety of sentences — each more disgusting, sadistic and hilarious than the one before — on assistant district attorney Matthew Hardy. (The only one Nichols could recall depicted Dwaine's prosecutor "being fucked up the ass by a half-dozen buck niggers.")

Because Dwaine was not allowed pens, he could only do pencil drawings. After other cartoonists had inked and colored them, *Hustler* published some. But because corporate higher-ups worried about public reaction to seeing Dwaine's name in print, this work appeared unsigned or, at his suggestion, as that of "John Proctor," the wrongfully convicted protagonist of Arthur Miller's *The Crucible*.

About a year into his sentence though, prison authorities banned Dwaine from sending out cartoons. His work, they said, required constant review and approval, which consumed too much staff time. It presented a "security concern," since he sometimes depicted guards abusing inmates. And it had been a significant "seductive" element in his offense. Dwaine fought the ruling; and after a few months, his privileges were restored. "He couldn't stop creating any more than he could stop breathing," Bill Nichols says.

Dwaine kept contact with his former life through letters and phone calls. Friends told him about snow storms and heat waves, fractured fibulae and slipped discs, children's successes and ball games enjoyed, mothers hooked on pain meds and boyfriends who couldn't get it up. They encouraged him and reaffirmed their belief in him. They told him jokes ("What's the difference between a penis and a bonus? Your wife will blow your bonus"). They joined with him in railing against the state of the world. (John Billette suggested as

a monument to veterans of the Gulf War "a shallow pool filled with tarry, bubbly oil with the names of our boys lost, adrift on floating name tags.")

Meanwhile, news from work was not good. A recession — and the availability of X-rated videos — had hurt *Hustler*'s sales. Larry Flynt had withdrawn from an active role in the business, leaving in charge cost-cutting, profit-obsessed men, who lacked his vision or courage. The suits had placed unqualified, inexperienced people in decision-making positions. "Journalism majors," the cartoonists complained to Dwaine, "secretaries…" Quality work was passed over. Shabby editing prevailed. Four cartoons on the same subject could appear within a single issue. The same cartoonist's work would appear on facing pages. Work that screamed for color appeared in black-and-white. The magazine was rerunning photo shoots and filling pages with ads for phone sex and porn videos. The artists were treated like "hired hands," denied respect or consideration.

Dwaine urged the cartoonists to fight back. "An artist *never* apologizes for his art," he wrote. "We may be whores, but it's up to us how good a fuck to give." He believed he was paying for his association with the company by his imprisonment, and he expected it to make it up to him by hiring him back as editor. When he returned, he promised to correct its course. He knew "what the fuck [was] up" and had the "kick ass personality" to get things done.

Debbie was as frustrated by the company's direction as the cartoonists. Dwaine urged her to hang on too. Their dream, he reminded her, was to be together on that farm. For that to happen, they would need LFP as a source of steady income.

But by September 1991, Debbie had had enough. The IRS had garnished her check, and she could not live in Los Angeles on the $1750-a-month that remained. She quit her job, filed for unemployment — which the company fought against her receiving (it lost) — and emptied most of the house with a garage sale. She loaded what was left into a U-Haul, and moved with the girls to her sister Terri's in Virginia. Dwaine was devastated. Debbie had, he complained, a "bad habit of turning her back on things." For her, it was "out of sight/out of mind." One night he called while she was making dinner and the girls were chattering in the background. She asked him to call earlier, when the kids weren't around, not recognizing his need to talk with them too. It was as if "once she's away from this shit, the shit doesn't exist."

Toward the end of February 1992, Dwaine began a journal. Titled *Thoughts, Happenings, and Whatever Strikes Me*, it consisted primarily of cartoons (Rodrigues' *Charlie*, Dan Piraro's *Bizarro*); an occasional *New Yorker* cover; and quotations that ranged from Vincent Van Gogh ("Which is worse — danger or the fear of danger?") to Robert Rauschenburg ("Every day is a surprise, not always a good one"); from Thomas Paine ("Society is produced by our wants and government by our wickedness") to Thomas McGuane ("America has become a dildo that has turned berserkly on its owner"); and from H.L. Mencken ("I write what I write because it was my nature to do so, and for no other reason") to William Faulkner "[A man] writes about himself as — perhaps he presumes himself to be, maybe he hopes himself to be, or maybe as he hates himself for being.").

Dwaine's first personal entry was in reaction to the film *Lolita*, which the prison's video channel had piped into the cells for prisoners with TVs. ("The irony of it," he noted, "can be considered mind blowing.") He had seen it before, when he was eighteen, but had not understood "what the fuss was about." Now he found it "painful to watch Humboldt's [sic] life get away from him. Didn't feel sorry for him. Realized his sickness but kept wanting him to stop." He had hoped to sympathize with Lolita but couldn't. "[S]he seemed to enjoy what she was doing. She knew she was unraveling [his] life. She worked her deal on everyone."

Watching it felt "very weird."

XXIII

Dwaine had spent his last dollar — and a hundred and eighty thousand borrowed from Larry Flynt (at ten percent interest) — on his defense. Because he could no longer afford a lawyer, the California Appellate Project, a non-profit organization that represented indigents, handled his appeal. CAP assigned him to Vanessa Place, a 1984 graduate of Boston University Law School. She had been on staff only a year and had handled fewer than a dozen cases. Her supervisor had thought this one's difficulty would make it a valuable learning experience.

Place's first reaction was that Dwaine's chances were not good. Criminal convictions were rarely reversed. In he-said/she-said sex crimes, jurors almost always believed the victim; and appellate courts were loath to second-guess them. Even Eskin's argument that the cartoons had prejudiced the jury seemed weak. Crime-scene photographs so gory they could only set a jury screaming for equal blood regularly came into evidence, whether the butchery they documented was disputed or not. In Place's view, criminal trials were often unfair; but reviewing courts regularly brushed aside this unfairness as inconsequential. "I thought, 'No chance,'" Place recalls. "'You're representing Chester the Molester. Who's less likely to get a reversal than him?'"

Then Place went to the Ventura County courthouse and saw the boxes of magazines that had been the prosecution's evidence. "The smartest thing I did," she says, "was to have all those cartoons transferred to the Court of Appeal." She had recognized that, in the abstract, the terms "shock" or "offend" could mean little; but most people, face-to-face with thirty-two hun-

dred cartoons, whose entire point was the jamming of a horse-cock down society's throat, would be outraged or revolted; and it was likely the justices would too. For Place, the cartoons were no more relevant to the charges against Dwaine than the contents of an architect's files would be to similar charges against him. They were simply the product of a fifteen-year career, ideas transferred to paper to satisfy an employer and meet a market's demands. "But the way the prosecution had presented it, it was, 'This is a bad guy. Look at the creepy things coming out of him. These are the outpourings of a pervert, an all-around soulless person.'"

She was gambling that the justices would be jarred by their reaction to the cartoons into realizing that no juror who had seen them could view their creator with the presumption of innocence a fair trial required. The risk was that the justices would become so incensed themselves they would gleefully tighten the noose around her client's neck.

On February 22, 1991, Place filed her opening brief in the California Court of Appeal's Second Appellate District in Los Angeles. The case was assigned for hearing to a three judge panel, the composition of which appeared both hopeful and problematic for Dwaine. Two of the justices, Arthur Gilbert and Steven J. Stone, had been appointed to the bench by Jerry Brown in 1980. They had established reputations as excellent, progressive-minded jurists — but they were also close friends of Judge Storch, whose decision they would be reviewing. And the third justice, Kenneth R. Yeagan, had been appointed in 1990 by the Republican governor George Deukmajian. As a trial judge in Ventura County, Yeagan had been considered *very* conservative in criminal matters.

Place first argued to the panel that Dwaine's conviction should be reversed because any probative value the cartoons had cast had been overwhelmed by the prejudice they spawned. The prosecution, she noted, had first justified the cartoons' admission on the grounds that they had demonstrated Dwaine's "intent" and "overall scheme." It had then claimed he had used them to induce Veronica to have sex. Finally, it had "collapsed" these two claims into the argument that they documented the Tinsley "lifestyle of incest."

But, Place said, the only intent the cartoons established was Dwaine's wish to make a living as a cartoonist. In any event, intent was not an issue. Dwaine's defense was that the events had not happened, not that they had

occurred by accident — not that he had mistakenly slipped his penis between Veronica's lips. If the jury had believed her, his intent would have been established, regardless of what fantasies his cartoons expressed. If the jury had believed him, these fantasies would have been irrelevant since no crime would have occurred. (Place contrasted Dwaine's situation with the defendant's in *People v. Stewart*. There, the court had allowed into evidence photographs of him sexually molesting his daughter because these photographs showed his "lewd disposition" toward his specific victim. But Dwaine's cartoons revealed nothing about his attitude toward Veronica.) The cartoons did not establish any "scheme" of Dwaine's because there was none to establish. They captured no "bizarre details [of] or striking similarities [to]" the crimes of which he had been accused. And, unlike *People v. Haslouer*, where the defendant had shown young girls playing cards that depicted assorted sex acts and asked them to pick one to perform, there was no evidence that Dwaine had used his cartoons to make Veronica do anything. Finally, Place referred the justices to *People v. Valentine*, in which the conviction of a man charged with marijuana cultivation had been reversed because the state had introduced into evidence a hypodermic needle and syringe found in his home. That court had ruled Valentine's involvement with one type of drugs did not tend to prove his involvement with another. Similarly, Place said, Dwaine's involvement with one form of socially questionable behavior — the creation of transgressive cartoons — no matter how extreme — should not have been used to convict him of abusing his daughter. The prosecution's Chester the Molester "lifestyle" theory, she said, was clearly improper. It was "simply a sociological buzzword posing as an evidentiary justification... an attempt to camouflage the prosecution's primary motive for introducing this material," which was to "deluge" the jury with thirty-two hundred cartoons of abortion, bestiality, defecation, feces, mutilations, and racial and religious defamation. "Whatever probative worth the drawings may have had," she said:

> they were not introduced for that purpose.... [T]he manifest rationale for admission was the state's thesis of guilt by creation.... These cartoons were guaranteed to prejudice appellant's jury. Virtually every segment of the population would have found something in these cartoons denigrating their group or some cherished belief.

Then Place raised her argument into a higher realm. The First Amendment to the United Stats Constitution, she reminded the court, had established freedom of speech as a defining aspect of our national identity. For free speech to flourish, it had to be protected from governmental efforts to stifle it at whim. And Dwaine's cartoons, while outrageous and offensive and, perhaps, even "immoral," were within the class of speech which the First Amendment valued and protected most. His work was not frivolous; it did not pander; it was not compromised to court the easy buck. It was politically and socially engaged. "Appellant," Place wrote, in what may have been the first — and most astute — critical analysis of Dwaine's work ever written:

> skewers sacred cows. He attacks what he sees as hypocritical social mores, religious pretense, racial sensitivities, and sexual peccadilloes. He chronicles the ludicrous machinations in which man will engage to satisfy his sexual desires, and the breadth of those desires. More fundamentally, [he] rips the cloak of civility from private habits and practices, confronting man with the absurd humiliation of his most primitive functions, and mocks that humiliation, exposing as false the pride that causes us to blanch. [His] drawings celebrate the disgusting and embrace the repugnant, reveling in the uncomfortable fact that man is, after all, only human.

By using Dwaine's cartoons against him, Place said, the state had not only improperly imposed itself on one side of a sociopolitical debate, it had made his expressions of unpopular ideas appear indicative of criminal acts. If it was allowed to hang Dwaine with a rope woven in part from his creations, all artists would be discouraged from describing, in song or film or on the printed page, actions that might be used against them by other vengeful district attorneys.

Place was no First Amendment "absolutist." She would allow even clearly political speech to be curtailed. But, she said, for the state to use speech that would otherwise be protected by the First Amendment as evidence a speaker had committed a crime, there must be "an overriding and compelling" governmental interest justifying this infringement; and "stringent procedural safeguards" must exist to insure that the infringement is "no greater than necessary to serve that interest." "The evidentiary door [should be

opened only]… the slightest crack necessary… to limit admission of First Amendment protected materials to only those which are substantially relevant to the state's case…. [Here] the door was blown off its hinges."

In California, responses to appeals of criminal convictions are the responsibility of the state's Office of the Attorney General. Deputy attorney general David F. Glassman, who had joined the A.G.'s office shortly after graduating Loyola Law School in 1983, filed his on August 1st.

The cartoons were relevant, Glassman said, for they were "used by appellant to perpetuate his crimes." He regularly allowed Veronica to watch him draw them. He showed them to her every month. He discussed them with her. He permitted her "unlimited access" to his studio, where she could view them at her leisure. He provided her collections to give her friends. Since many of these cartoons showed sexual relationships between adult men and young girls, they were clearly used to "indoctrinate" Veronica into accepting such relationships as appropriate and "facilitate" her having sex with him. Furthermore, since Dwaine had created the cartoons, they provided striking evidence of his intent. The behavior that consumed Dwaine at his drawing board was the behavior he inflicted upon Veronica.

Glassman cursorily dismissed Place's First Amendment argument. Dwaine was, he said, neither prosecuted nor punished for his speech. A voluntary confession would not be excluded from evidence on free speech grounds. Neither would a painting depicting a stabbing an artist had committed or a novel describing how an author had planted a car bomb. Similarly, here, the cartoons were relevant to prove the commission of a crime.

Place's reply was even more succinct. Glassman, she said, missed the point. The question was not if protected speech was admissible evidence in criminal cases, but what standard determined its admissibility. She believed the speech had to be "substantially relevant;" and, unlike a confession, whether verbal or on canvas, these cartoons were not.

Place said the state's "leap of faith" in its theories of relevance "simply [did] not fly." There was no basis for its conclusion that creation of a work was probative of intent to perform an act expressed within it. Nor did the fact that Dwaine showed Veronica some cartoons and did not prevent her looking at others mean he had used them to commit a crime. This consti-

tuted "pretend proof," "daubing on an evidentiary gloss to support an un-supportable theory of admissibility." (Place also pointed out that Dwaine's "use of the older male/younger female theme... was hardly an original or even particularly interesting sin." If it was to be used to convict him, then Jane Austen (*Emma*), George Bernard Shaw (*Pygmalion*), and Louisa May Alcott (*Little Women*) might also be said to have aided and abetted felonies.)

And how, she asked, did any of the state's arguments justify showing the jury the cartoons that dealt with feces, cannibalism, racial stereotypes, and dead fetuses?

On February 25, 1992, the court, in an opinion written by Justice Stone, unanimously reversed Dwaine's conviction on the grounds that the cartoons had prejudiced the jury. [60]

The prosecution, the court said, had presented no evidence that Dwaine had used the cartoons to induce Veronica to have sex with him. All it had proved was the existence of the cartoons and, according to Veronica, the sex. The fact that she had seen the former in his studio, however, failed to establish that they had led her into the master bedroom. No expert had testi-fied that this was a likely effect of such cartoons on such an adolescent. Even Veronica had been unable to specify which cartoons she had seen, when she had seen them, or how they had affected her. She had not even said that her father had shown or discussed with her the one cartoon that depicted an incestuous relationship. Indeed, the court noted, there was no evidence that, when it came to sex, Veronica required inducement. Her own testimony was that it had been sufficient for her father to ask.

The prosecution's inducement argument, said the court, was "disingenu-ous," not only because it had produced no evidence to support it, but be-cause, at trial, it had repeatedly used the cartoons to attack Dwaine's "life-style." The prosecution's position seemed to be that anyone depraved enough to have created these cartoons would be depraved enough to sexually debase his daughter. But it was basic law that evidence of a person's character could not be used to infer his likelihood to commit a crime.

Still, the court went on, not every evidentiary error warranted the reversal

60. Because of this holding, the court did not have to address Place's First Amendment argument. "It didn't want to hear it," she now says. "It just wanted me to focus on the prejudice. I thought it was pretty good. It had me very excited. But I had no takers."

of a conviction. The critical question became whether the error had caused "a miscarriage of justice." In answering this question, the court dismissed Judge Storch's reasoning that nothing significant could have resulted from any error he may have made because the jury had acquitted Dwaine of more charges than it had convicted him. If he was acquitted of that many counts, the justices wondered, why was Dwaine convicted of any? The evidence on all the charges was equal. On each the jury was asked to weigh his credibility and character against Veronica's. The inescapable conclusion was that the cartoons had so outraged the jurors that they had decided he had to be guilty of something. "[I]t is reasonable to conclude" the court said, "that the cartoon evidence tipped the scales of justice against appellant.... [I]t is not reasonably probable that the same verdicts would have resulted had the repugnant cartoons not been admitted."[61]

In a separate, concurring opinion, Justice Yeagan, the judge about whom the defense had been most concerned, went out of his way to express his dissatisfaction with the prosecution's conduct. The district attorney, he wrote, "should have recognized the potential for reversal" in urging the cartoons into evidence. Prosecutors, as well as judges, must protect defendants' constitutional rights. Their job is not simply to convict. They have an "entirely separate duty" to insure that trials are fair.[62]

Dwaine got the news the next day.

Indescribable emotions swirled within him. He walked the yard with new energy and "a glorious glow. Even the air smelled clean." When he asked the tower for permission to call his wife, the guard said, "I guess I could give a free man a phone call." The words "free man" dropped on him "proudly, like a ton."

Debbie reacted with stunned silence. Then her voice cracked.

One female guard, he reported, would have hugged him, if it would not

61. When I reported to Vanessa Place the statement by Roy Sherman, the jury foreman's, about the role played by the cartoons in persuading him of Dwaine's guilt, she responded, "So, justice was done."

62. Some who had viewed Dwaine's conviction as proof of *Hustler*'s fetid soul were disinclined to trumpet this decision as a blow in favor of individual freedoms and against a treacherous state. He had escaped, the Mills professor Diana E. H. Russell sneered, via "a legal technicality."

have meant her job. His inmate friends slapped his back and shook his hand. They changed his nickname to "Short-timer," and asked for autographs and cartoons. The reversal had confirmed his innocence for some. For others, it made him more acceptable. But, they all advised him, "Watch your back." Ventura County had spent lot of money to convict him. The court's opinion had humiliated it. The prison was full of people who would court its favor by hurting him with violence or lies.

The county's official response, as voiced by Chief Deputy District Attorney Vincent O'Neill, Jr., was that it had been "disappointed" by this "unexpected" turn of events. It had ninety days to recharge Dwaine. He was eligible for bail; but he knew that since it "mainline[d] on its conviction rate," it would play all procedural cards at its disposal to delay him. He counseled himself to rein his thoughts and not get too high. Debbie, the girls, his work remained outside his grasp. When newspaper reports of the DCA's opinion seemed to focus on "the juicy bites" of his case, rather than "the cleansing of the reversal," he remembered Larry Flynt had told him, "Once the accusation is made, you can never live it down. Once they have you, they don't want to let you go." When the papers reported Matthew Hardy's outrage at the court's decision, Dwaine saw confirmation that he had desired his conviction more than truth or justice.

He had, he admitted, not expected to win his appeal. Knowledgeable cons had told him less than one percent of convictions were reversed. (In actuality, the figure was slightly higher — but not much.) Bill Nichols had never seen a full reversal in his nine years inside. Another fellow on their tier had seen one in his eleven. The decision had not established his innocence, Dwaine knew; but it had confirmed his case had been about Chester and *Hustler*, not him. The county had won its conviction unfairly. He could expect it to offer a deal. But no deal could repay him for the time he had lost from his family and career. It could not erase the stigma of his conviction. He could not live with himself if he accepted a deal. He had done nothing wrong. If charges were not dropped, he would go to trial again.

His bail hearing was set for March 13th, then postponed two weeks. When that day arrived, each time the PA system squawked, he expected to hear himself summoned. ("My ears," he wrote, "get like Dumbo's.") He imagined himself arriving in Richmond: Lori rushing to embrace him;

Kimberly wondering who he was; Debbie with a sparkle in her eyes. He envisioned his return to LFP. He was astounded by the idea that he could be in prison bagging dirty Fruit of the Looms for the state one day and in Century City, at the center of a publishing empire, the next.

In *Thoughts, Happenings*, he inscribed a poem, "Thoughts of a Free Man in Prison." A portion of it reads:

> not the patience that waits for death,
> a live patience, fueled by hope.
> But the mind's eye is searching wild,
> the psyche gnaws on the bones of wonder,
> the ears fire with the noise of despair...

XX IV

At the March 27th hearing, Dwaine's bail was set at fifty thousand dollars. He was ordered returned to Ventura County Jail from CMC-East. Four days later, he was released.

As a first-time offender, Dwaine would have been entitled to a fifty percent reduction in his sentence for "good time." Because of this — and because Veronica was living out of state and did not want to go through a second trial — Ventura County decided not to reprosecute. On September 17th, it moved to dismiss all charges. Bail was exonerated, and Dwaine was freed. "He dodged six months and having to register as a sex offender," Detective Galloway says.[63]

Upon his release, Dwaine resumed working for *Hustler* as a contract cartoonist. (He was instructed, however, not to come to the office, except to deliver his cartoons, because his presence would be "disruptive.") Debbie and the girls rejoined him; but once the charges were dropped, he and they moved back to Richmond. She found work as a clerk at a convenience store. He cared for Lori and Kimberly, drew, hung out with old friends, golfed — tried to acclimate to life outside prison.

But his work, which had always been his salvation, was lacking. "Been doing the same old thing for years," he wrote:

Staring at the blank white, thinking of colors to add,

63. If Dwaine's own estimated ERD is correct, he actually "dodged" fourteen months, — and Veronica says she was not asked but would have testified again.

visions no one ever thought of before,
something simple but profound, with bite,
something risky and devastating.

Now he seemed to be merely recycling old ideas. The "fun and attitude" were gone.

Then, in December 1993, Dwaine learned Debbie had become involved with a co-worker. When he confronted her, she asked for a divorce. Dwaine agreed to support her for ninety days and to pay eight hundred dollars a month for Lori and Kimberly. (He was also paying two thousand dollars a month on his and Debbie's debts to the IRS and Larry Flynt.) He asked for custody of the girls, but Debbie, who wanted the child support, refused.

Dwaine planned to live with John Billette in Michigan, once Billette, who was going through his own divorce, sold his house. He took the Greyhound to Bay City with his only possessions: two suitcases of clothes; four trunks of cartoons and art supplies; a CD player and CDs. But Billette was living in a trailer barely big enough for himself. He found room for Dwaine at his mother's.

Two weeks after Dwaine arrived, Billette's sister's boyfriend, following a round of golf, invited him to stop by the home of his business partner. The partner was also divorcing — but his wife was in the kitchen making coffee. Something in the way Dwaine said "Heyyy" caught her attention. There was something too in how he walked down the hall. Then he started talking. There was really something in that.

By July, Dwaine and Ellen were living together.

In August, Dwaine and Ellen drove to Virginia and brought Lori and Kimberly back to Michigan for a two week visit. They spoke to the girls every week after that and visited again during their Christmas vacation. When the one year post-separation waiting period that Virginia required before parents of minor children could petition for a divorce had passed without Debbie acting, Dwaine filed in Michigan. On October 29, 1995, one hour after it became final, he and Ellen were married. As a wedding present, Larry Flynt forgave Dwaine's debt. Dwaine wiped out others by declaring bankruptcy.

Dwaine and Ellen spent that fall and winter in Virginia Beach to be near the girls. Debbie's new boyfriend, a twenty-four year old, was, in Ellen's

words "putting the child support up his nose." Debbie would leave Lori and Kimberly alone in their apartment with little food, the droppings from their pets on the floor, the odor of crack cocaine in the air. Child protective services had found the girls neglected and ordered the family into counseling. Debbie had missed so many appointments it was threatening to place the girls in foster care, with no guarantee they would be kept together.

Then Debbie was evicted. She asked Dwaine and Ellen to take Lori and Kimberly for a few days while she found new housing. They picked up the girls, some clothes, and a laundry basket full of toys. When two weeks went by with no word from Debbie, Dwaine decided to seek custody. Because his criminal convictions had been reversed, his offenses could not be used to disqualify him. Debbie did not oppose his request. Once the change was granted, Dwaine and his family returned to Michigan.

Dwaine had tried to break out of his work malaise with ideas for stories (usually about more psychotic killers), by submitting cartoons to other publications (*The New Yorker*, *National Enquirer*, even *Good Housekeeping*), pitching a new collection (*That's Rats*), and designing t-shirts and coffee mugs. Nothing worked. Then, in February 1996, Larry Flynt asked him to resume *Hustler's* cartoon editorship. In May, after their lease was up, Dwaine, Ellen and the girls moved to California. It took him two weeks to clean the office of Burger King wrappers and soft drink cans and organize the art which had been piled haphazardly on every open space.

After stop-gap rentals in Sherman Oaks and Woodland Hills, Dwaine and Ellen settled below San Simeon, in Cambria, an ocean-side arts-friendly community with a population of four thousand. The ex-wife of Elton John's guitarist sold them a large, grey, Colorado mineshaft house in the hills. It was far enough from L.A. to avoid its pace and expense — and to shield Dwaine from the pressure of daily contact with the company. It Fed Ex-ed him cartoons. He went in once a week to fight for his selections.

Dwaine's first major project following his return was a collection of the best cartoons from *Hustler's* first twenty years. (The finished work — *Two Decades of Our Best Cartoons* — would contain no Chester — though Dwaine would return him to the magazine, absent an identifying banner, a few years later.) He believed that an entire generation of stand-up comics, shock jocks, and sitcom writers had reaped the acclaim and pocketed the rewards of the

battles that he and the other *Hustler* cartoonists had fought — and the blows they had suffered — in expanding the boundaries of acceptable humor in America.[64] He hoped the country was ready to credit them for their achievement. (In his most personal fantasy, he dreamed of a parade in Richmond welcoming him home. He hoped to see the chino-madras crowd eat the shit they had put him through.) With Ellen's assistance, he lined up radio and television interviews to coincide with the book's release. *The New York Sunday Times* promised a feature review.

Then executives at LFP decided to sell advertising on the collection's cover — and a dozen inside pages. The ads were for penis pumps and phone sex and videos: *Chicks with Dicks*; *Lesbo Lick-Fest*; *Tina's First Blowjob*. Full-color nipples and vaginas were rampant.

Dwaine threatened to throw the suit who gave him the news out the window. He said the ads would turn the book to porn. He said he would go to Larry Flynt.

"Good luck," the suit said. "Larry's already okayed it."

Within twenty-four hours, Dwaine had cut and relaid out the book to accommodate the ads so it could ship on time. He had the pleasure of being interviewed on a Richmond radio station about it, but the larger, grander promotional campaign vanished. The cartoonists never heard a word of praise — or saw a cent in royalties. After the book was out, Larry Flynt told Dwaine he hadn't known about the ads and apologized.

It was a different America now. The X-rated was no further away than a click on the living-room remote. There were about seven hundred million rentals a year of hardcore sex videos. The industry was grossing eighty billion dollars annually. The level of sexual activity and sexual humor and sexual discussion available on network television and at the neighborhood multiplex and corner newsstand would have awakened a Rip Van Winkle who had dozed off in 1965 with a wet dream that could have impregnated Kansas. He would not have seen many men with sheep or women with horses —

64. I don't listen to shock jocks or go to comedy clubs, and I watch little television. But the evening I wrote this sentence, the weekly episode of the one family comedy I favor featured an uncle delivering a lengthy testimonial to the joys of masturbation to his eleven-year-old nephew. (The following week, the uncle took him to a prostitute so he might experience a professional hand-job, a plot point by which, legalistically speaking, the authors found humor in child molestation.) So I do not dismiss Dwaine's claim lightly.

or fathers, for that matter, with teenage daughters; but he would not have missed much else. As a measure of this alteration in national consciousness, Hollywood had even celebrated *Hustler*'s publisher with a biopic that had won Oscar nominations in 1996 for its director (Milos Forman) and star (Woody Harrelson). (When the studio that had released the film succumbed to feminist/right wing pressure and dis-invited Flynt from the presentation of the Academy Awards, he hired a sky writer to post "COLUMBIA SUCKS" in the heavens above the ceremony.)

In this new America, *Hustler* seemed marginalized — or taken for granted — or, worse still, deliberately disengaged from the struggle that had made it noteworthy to begin with. It continued to achieve journalistic breakthroughs in its fashion — developing an artificial jism with which to enliven its photo shoots; delivering visuals of models in mid-urination; and, in early 1998, showing actual penetration. (The company had hoped to inflame authorities by this action since, in the past, when prosecutions had come, sales had jumped. "We broke the taboo," George Trosley says, "but no one cared.") But its "investigative" journalism now ran from informationals-of-the-absurd ("How to Pick-up Feminist Dykes"), to peculiar niche consumers' guides ("My Beautiful Balloon: Testing the '97 Model Blow-Up Sex Dolls"), to dire warnings about calamities of questionable menace ("Babies Raping Babies: Pint-Size Sex Predators Stalk Playgrounds for Prey"). Its biggest score, publicity- and social consciousness-wise, came during the Clinton impeachment hearings, when Larry Flynt, striking a blow against Capitol Hill hypocrisy, offered a million dollars for proof of adulterous behavior by a congressman; and House Speaker-elect, Bob Livingston (R. La.), fearing he was about to be outed, resigned. But Flynt's offer of ten million dollars for nude pictures of presidential daughter Jenna Bush bought him nothing but scorn; and the money he laid out for nude shots of conservative radio talk show host Laura Schlessinger ("Dr. Laura's Furburger Furor") produced yawns. The lesson seemed to be that, in *fin de siècle* America, the human behavioral equivalents to caged gorillas flinging feces through their bars was no longer enough. Busted again in Cincinnati for pornography, Flynt quietly pled guilty and — without resorting to inflammatory t-shirts or diapers — claimed victory. His interest now had the X-rated videos his company was producing, its *Hustler* clubs and *Hustler* stores and *Hustler* casino (a Gardena card room) to engage it.

Dwaine's own work continued to evolve. He became more experimen-

tal in his style, varying his holding lines, using different dyes and markers. He placed even more emphasis on political and social comment. (Some higher-ups in the corporate hierarchy complained he was no longer funny.) But given the magazine's direction, this expansion did not gratify. He had been proud of the *Hustler* which had taken on Big Tobacco and Big Coal — which, in June 1983, had been among the first national magazines to call the country's attention to AIDS.[65] Now the number of feature articles per issue had shrunk by sixty percent. The editorial thrust, under the direction of Alan MacDonnell, appeared to be the streamlining of *Hustler* into a straight shot of porn and smut and gossip. ("If you whack off," one of his prolocutors would tell Lukeford.net, "do you really want to read about what happened in Iraq?") Dwaine saw it becoming just another skin mag, with a sprinkling of cartoons and a drop or two of text spotted among the flesh. And he suspected MacDonnell wished to eliminate the cartoons entirely, so he could squeeze more hardcore between the covers.

Dwaine's suspicions may not have been unfounded. MacDonnell had already dropped cartoons from other LFP publications; and in *Prisoner of X*, he would term the official *Hustler* line about its cartoons — that they served a social purpose — "facile rationalization." No company, he wrote, governed by reason could have tolerated as fit subjects for humor the topics it selected. He summed up the magazine's true relationship with its cartoons with the image of Larry Flynt ogling a drawing of black men being towed behind cars driven by Ku Klux Klansmen and exclaiming, "I love that shit." (When I asked MacDonnell if he believed *Hustler* was, in fact, pursuing a racist agenda, he replied, "'Racist' is an ugly word people throw around to discredit people who address touchy subjects. I have met all of *Hustler*'s staff cartoonists, and I never had any impression of them other than as decent, hardworking, perceptive, intelligent and fair-minded people. As for Larry's 'I love that shit,' your guess is as good as mine.")

In any event, Dwaine felt *Hustler* had surrendered its claim to being an outspoken, provocative, and informative voice. MacDonnell, in turn, believed *Hustler* had already "gone shitty immediately after Larry's shooting...

65. As I read *The Reader's Guide to Periodic Literature*, it had trailed *Newsweek, Time* and *Rolling Stone* to the story but had scooped *Harper's, The Atlantic Monthly, The New Yorker,* and *The New York Review of Books*. (Its story also appeared twenty-seven months before President Reagan mentioned the disease in public.)

Have you looked at those magazines?" he asked me. "Crap." He said that its profits had revived — even "peaked" — during his tenure. It is not, of course, self-evident that a magazine's profits directly correlate to the quality of its contents.[66]

Otherwise, Dwaine's life was good. Ellen's college-age son had joined them in Cambria — followed by his older brother — and both boys' godfather. (Dwaine and Ellen also added two cats to their ménage.) Once Debbie's life had cleaned up and stabilized, Dwaine allowed Lori to return to live with her. But he doted on Kimberly, walking her to school, attending her PTA meetings, taking her to zoos and museums. Then after a summer visit with Debbie had gone well for Kimi, he agreed that she too could attend school in Virginia, while spending summers with him and Ellen. Tiring of small town life and their household emptying, they began to consider moving to Las Vegas.

But pressures at work continued to build. LFP was canceling magazines and laying off staff. People with jobs schemed how to keep theirs while eliminating someone else's. Larry Flynt now had a daughter and some nephews on the payroll. (It was like, one ex-employee says, his eyes were everywhere.) He refused Dwaine's requests for an experienced assistant editor; and as soon as he had trained someone for the position, she would be fired or promoted. Dwaine was constantly ordered to make last minute changes in the size of cartoons — or to change cartoons that were to run in color to black and

66. In early 2003, Larry Flynt fired MacDonnell and replaced him with Bruce David, a long-time loyalist — whose near-thirty years of service had been blemished only by a short stint writing for *Family Ties* — with orders to re-politicize his magazine. By running articles on the Bush-Saudi royal family connections, the threat to free elections from right wing corporate control of voting machines, and the dangers of the Patriot Act, David had soon restored *Hustler's* edge and substance. (David's approach should not be deemed a blanket rejection of the MacDonnell School of Editorial Policy, so much as a sort of Picasso-standing-on-the-shoulders-of-Cézanne-and-seeing-further extension of it. You know, a sort of see-that-the-apples-don't-quite-look-like-apples-and-the-next-thing-that-you-know — presto-chango — cubism! Or, as David has said: *Hustler* "now has material you might want to read *after* you finish jerking off.")

But like most print publications, *Hustler* had been savaged by the Internet. While it retains its proportionate market share, its circulation has been estimated to be one-eighth what it was at its height. (I would also note *Hustler's* return to the barricades has not been welcomed by all. One staff cartoonist e-mailed me: "We have to deal almost exclusively in political stuff if we want to get picked for the magazine. Frankly, I and my compatriots would like to do just funny cartoons for a change. It feels like we are beating the horse of political cartoons to death and then burying it and then digging it up to beat it some more.")

white — or to change black-and-white cartoons to color. Ellen often found him asleep at his drawing board, collapsed after working thirty-six hours straight to meet a deadline. He ran on cigarettes and coffee; he was drinking again. He was finding himself again seeking what he had once termed "the Devil's own water, a river which transports me to the gates of Hell." At least once, according to his half-brother Doug, that "and his big mouth got him badly beaten up in a bar."

He began complaining about indigestion. He would take baking soda and declare himself fine. Ellen wanted him to see a doctor, but he always had an edit to complete or a call coming from Larry Flynt he could not miss. Finally, she made an appointment for Dwaine — but due to her anxiety, sent him a month early. Advised of his mistake, Dwaine told the receptionist, "Wives always fuss about this stuff" and left.

Three days later, on May 22, 2000, while lifting weights at home after dinner, another stomachache hit. He took baking soda and a Xanax; the pain did not stop. Coming back from the kitchen, he cried "Ellen," grabbed his stomach, and collapsed to the living room floor in cardiac arrest.

He laid unconscious, his pulse faint, his breath shallow and strained. Ellen performed CPR for ten, fifteen, maybe twenty minutes, before the ambulance arrived.

Something warm fluttered through her hands and touched her cheek as it rose.

Dwaine was cremated.

There were two memorial services. The first, in Cambria, for a few town friends, featured a lone bagpiper. Afterwards, Kimberly and Ellen's sons wrote messages to Dwaine on his golf balls and threw them into the Pacific.

The second service, two weeks later, was at Beverly Hills Presbyterian Church, a sprawling Spanish-style complex on North Rodeo Drive. (Dwaine, who had not expected to live beyond the age of his parents, had planned his own funeral. He had chosen Beverly Hills Pres. because Jimmy Stewart's had been there.) A hundred people — mostly from the adult world — attended. Ellen used Dwaine's life insurance money to fly out Doug, his girlfriend, and Lori from Virginia, and put them up at the Beverly Hills Hotel. Larry Flynt had flown in the contract cartoonists and given all *Hustler* employees

a half day off so they could be present. The people who ran the restaurant in the Flynt Building provided a buffet. Dwaine's favorite music was played: "Stairway to Heaven;" "Dimming of the Day." A woman from accounting sang "Amazing Grace." Someone read Auden's "Stop all the clocks..." People told funny stories about Dwaine. He had wanted that too.

To some among the mourners, a church service seemed ironic. "Dwaine would never have set foot in there while alive," Dan Collins says. "Without his actual body, it felt as if, somehow, he may not really have died and, perhaps, had engineered the whole thing. He was larger than life, and his absence at his own funeral made it seem this could have been his final joke at a world that never appreciated his humor."

Ellen sat in the front row, between Kimberly and John Billette. Larry Flynt sat at the end of their pew in his gold-plated wheelchair. Ellen held Billette's arm so tightly she left it black and blue. They had been up all night, drinking beer and swapping reminiscences; and Ellen was too shaken by the death to read the eulogy that she had written. George Trosley read it instead, fearing God would strike him dead for saying "shit" in church. When it was Larry Flynt's turn to speak, he called Dwaine "my brother."

Then this man, who had not cried at his own mother's funeral, wept.

Ellen stayed in Cambria for five months. She felt Dwaine haunt the house, tipping candles, drawing her attention to a dew-covered spider web, a bright flower in the meadow next door. Then she sold their home and returned to Bay City. She brought Dwaine's ashes, planning to have them mixed with champagne, Marlboros and — when the time came — hers and scattered in the Smokys where she had been raised.

The ashes were with her when Hurricane Katrina hit Louisiana. "[T]hey got damp in the flood," she told me, "but Mike rescued him and tucked him onto a top shelf. 'He's heavy,' he said.

"Yeah, Dwaine was one heavy dude."[67]

67. In mid-2005, Hustlingthefirst.com, an Internet site devoted to branding Larry Flynt and his magazine as "misogynistic, pedophilic, racist, anti-Semitic, [and] homophobic," posted a "gallery" of *Hustler* cartoons which, it believed, proved its point. Over sixty percent were Dwaine's. Five years after his death, the ability of his work to shock and disturb — and outrage — held.

EPILOGUE

The essential question that is behind every good story: what is the nature of reality?
— *Dwaine Tinsley. Journal note. 1992.*

Almost everything we know, we know incompletely at best.
— *Janet Malcolm,* Two Lives: Gertrude and Alice.

Adele and I flew into Ontario on Rose Bowl Wednesday, 2005. Apparently, Dollar Rent-A-Car had not anticipated a number of Texans might be interested in the Longhorns' match with USC that evening — Vince Young vs. Reggie Bush — thirty miles to the east, for it took as long to round us up a Taurus as Southwest had taken to deliver us from Oakland.

When I called Veronica's cell phone to say we would be late, a recording implanted since the evening before announced her number was blocked to incoming calls. Since the only other number I had for her had been disconnected, we would drive the fifty miles on faith that she had not changed her mind or tired of waiting and gone to yoga or small-arms practice. Debbie Tinsley had not responded to my interview requests. Larry Flynt had ignored me. Bruce David had e-mailed he was too busy to talk. None of the dozen Steven Golds I turned up admitted any connection to the case. Alan Yahr had said no. David Glasman had said no. My letter to Larry Ross had come back "Addressee Unknown." Judge Storch was gripped by dementia, and

Danny Sloope was three years dead. Veronica, for sure, won't speak to me, I had thought. "I'd love to talk to you," Veronica had said.

"We've come this far," Adele said, as I got behind the wheel. She wore jeans, a floppy off-green hat, a chocolate leather jacket faded cocoa in places. She put her copy of *A Way of Life Like Any Other* into her backpack. She took out the map and the CDs for consideration: Bob Dylan; John Coltrane; The Pogues. "You'll get a couple paragraphs. Take notes on local color."

"Orange," I said, looking at the Texans.

"Buy me a flute and a gun that shoots," Dylan sang. "Tailgates and substitutes... You ain't going nowhere."

The last fifteen years had placed Veronica at the end of a six-lane highway, through scrub brush and storage barns, auto salvage yards and cactus patches, inside a gated community in Riverside County. The developers had sold the community in the 1970s as second homes for summer vacations. It had a man-made lake for swimming and fishing and water skiing. It had tennis and golf. But most of its current residents stayed year round, commuting to jobs in Los Angeles or Riverside or San Diego, spending more time in their cars than on the links or water. It had a population of ten thousand, ninety percent of which was white and ninety-six percent of which was native-born American. The median household income was seventy thousand dollars. The median house cost the owners three-and-a-half years of their working lives. There had not been a homicide within the community since 2002.

When I gave my name, the security guard told me I was not on the visitors' list. When I told him I had come to see Veronica Tinsley, he told me no resident had that name. I was believing myself the victim of a sadistic practical joke when he punched the street address I had into his computer. I had forgotten Veronica had a married name. I had forgotten she had a life since Dwaine. "There you are," he said.

LEZIM, the computer told me.

GOD BLESS THIS HOME said the plaque by Veronica's front door.

Veronica lived with Keith, her husband of five years; Tessa, her thirteen-year-old daughter; three cats; two dogs; and a turtle in a one-story, three bedrooms. (Her eight-year-old son, Harrison, lived with his father about two hours away.) Keith was studying to become a personal trainer and nutrition-

ist. Veronica worked from home as a marketing representative for an insurance company. Their living room held a fireplace, a *faux* grandfather clock, ficus plants that reached the ceiling, a sixty-five-inch flat screen TV. These possessions — and their polish — seemed an effort to anchor the house to earth. They seemed the striving for a seal of approval from an authority I barely recalled.

Veronica had met Keith in June 2000, when she was a cashier at a Wal-Mart and he its manager. She had spent most of the previous decade drunk or high. She had been arrested twice. She'd held over thirty jobs. She had been through bad relationship after bad relationship. Within a week of meeting, she and Keith were living together. Fourteen months after that, having helped each other off alcohol and crystal meth, they had married. Veronica's hair, worn long and loose, was now platinum blonde. She wore an azure, scoop-neck blouse. A diamond-studded cross dangled between her breasts. This is décolletage, I thought, that does not belong to someone whose primary emotional set features regret or shame. (To tell the truth, I did not think "décolletage.")

A few months earlier, Veronica said, she had told her story to a friend. The friend had Googled Dwaine. When she had told Veronica he had passed, she had danced around her living room, singing, "Ding-dong, the witch is dead." Until then, she had always scanned crowds for her father, dreading she would find him. If God wanted them to have contact, she had thought, it would happen. Thankfully, he had been merciful. Now she had nothing to fear.[68]

68. Later, reviewing my notes, I saw that Ellen had told me that Veronica had sent Dwaine a certified letter in 1999 or early 2000 in which she had spoken of "forgiveness" and "putting her past behind her." She had wanted to meet with Dwaine and had enclosed a picture of her children, on which she had written, "You'd be a great grandad." Dwaine had taken the letter to Larry Flynt's attorney. Alan Isaacson had said Veronica probably wanted money. He suggested that if Dwaine met her, it be in public with an independent witness. "Do you really want to open that can of worms?" Isaacson had said. Dwaine had not answered the letter.

When I e-mailed Veronica, she replied that she remembered the letter "vividly." "It was a short one-page letter. I did a 'p.s.' that alluded to the fact that he was a grandfather.... I NEVER SAID THAT HE SHOULD MEET HIS GRANDCHILDREN OR THAT HE WOULD MAKE A TERRIFIC GRANDFATHER. Never would I say something like that. Yes, I forgave him so I could move on. But I will never forget."

When I looked at what Ellen had told me again, I saw that she had recalled that Veronica had a son and a daughter; she had recalled the age differential; she had even recalled the son's name. It may be this proves nothing about Veronica's credibility. It may be "alluded" was only a poor word choice on her part.

Alan Isaacson did not respond when asked for his recollection.

We spent two hours with Veronica. During this time nothing in what she said or did — no word nor tone nor nuance nor gesture — suggested any deviation from her testimony in Ventura County Superior Court. Some of what she said, I have integrated into my narrative. Here is the crux of what remains.

"I hadn't told anyone about what he had done because, first of all, I was humiliated. It was so horrible and such a betrayal of love and innocence and so totally wrong, I could not speak of it. And second, I was afraid of what was going to happen to me. I didn't want to go back to my mom. I didn't want to go to foster care. I figured, you know, I had already dealt with my mom. I'll just deal with him; and then, when I'm eighteen, I'll be done. Basically, it was just my lot in life.

"I loved my father very much. He was the only symbol of love that I had in my life. My step-mother always ridiculed me. My step-father beat the crap out of me. My mom beat the crap out of me. I spent endless hours talking to my father, listening to my father, watching him draw. He was my hero; he was like God to me — and the other stuff, I just blocked it out. I was a woman, a daughter, a lover, a friend, sometimes in the same afternoon. I lived totally behind him. I mean, he plain-and-simply mind-fucked me. He had me believing that I had no worth, that I couldn't be a responsible person, that I couldn't have my own thoughts. Consequently, when I went out into the world, the damage that my father had done had left me without the tools of honesty and discipline and respect for other people that I needed. I had to learn all that.

"And I learned it by getting in a lot of trouble and burning every bridge I came in contact with and hurting many people. There were so many times I should've OD'd or been beaten or raped or maimed or even murdered. I went so long feeling like someone had taken a gigantic knife and split me open and left me full of pain. I hated everyone. I was pissed off at God. Why had he given me these parents that didn't love me? I so desperately wanted to be a good person: to be able to look at someone with clear eyes and love in my heart and care about another person and help other people.

"Then a friend told me about Barabbas, the blind man in the Bible, who said to Jesus, 'Why was I born blind?' and Jesus said, 'So I can heal you.' I took that to mean that I was put on earth to these parents — my dad with his

bad upbringing, my mom with her poor one — so I could break the chain. I could know the true meaning of love and valuing yourself and healing, and I'm bound and determined that what happened to me is not going to happen to my daughter and my son."[69]

Veronica's life had been built from straw and wind, dust and thorn before she came to live with Dwaine and Debbie. It had remained of that evolvement during her time in Simi Valley. It had become no more for a decade after she had left. This failure can be seen as proof of what she said had happened to her in Simi. As easily, it can be ascribed to what she had endured before she arrived and viewed as proving nothing. Now she had built a life of hope from love and faith — and hatred. This hatred, which, when directed against Charlotte, had broken Debbie Tinsley's heart, and which, when directed against Dwaine, had blown away twelve jurors' reasonable doubts, still raged beside the ficus plants and grandfather clock. It barked louder than the dogs beyond her patio door. This was a hatred strong as steel, vicious as a lash, as free of forgiveness as a blasting cap. It bore conviction into your soul in a way that a transcript — words on pages — marks on paper — cannot. It carried credence into the marrow of your bones. It screamed of truth — some truth — any truth. I do not know how you can carry such hatred with you so long and so far if it is based on imagination. I do not doubt though that some imaginations can gestate such hatreds. I am aware that just as Dwaine can be accused of having fabricated his journal as an island on which he could dwell without having to face the truth of what he had done, Veronica may be suspected of maintaining her hatred as a shield against the falsities she had leveled. Indeed, her rigid hold upon her sense of rightness might be viewed as proof of the existence of such falsities. By now, the soft-hearted among us might expect — or hope for — some perspective, some shading, some sense of — unlikely though it might be, damn it — compassion, no matter what Dwaine had done. She had been running wild before she arrived in his home. And to say she had continued amuck for ten years after she left was all

69. Interestingly, Barabbas was not the blind man but the prisoner whose life the crowd allowed to be spared instead of Jesus'. (So if Veronica was Barabbas, the jury was the crowd, and Dwaine was...) The blind man was unnamed. He had been born blind, Jesus explained, so that he could cure him and prove to others that he was the Son of God. Interestingly, again, when the blind man told his story about what Jesus had done, people did not believe him.

because her father had sex with her — her father who had been locked in a Texas death-cage struggle with his own demons since birth — might appear a need-driven oversimplification. But the power of this hatred to clear a path through the jungles Veronica had walked merited respect as well.

A trial, Adele reminded me, on our way to our plane — from Rose Bowl and Riverside toward Berkeley and home — can only provide a partial record from which decisions can be made. Rules of evidence forbid juries and judges from considering certain information. The strategic decisions of attorneys may withhold sizable portions of the otherwise allowable. And while a writer has more freedom to investigate a claim, he still may run into people who will not talk — or who, when they speak, from innocence or malice, from memories that have frayed or addled, from synapses that have fried or tangled, may say things that are not true. Even if none of this is so and the writer's effort at information collection lushly rewarded, he may be congenitally ill-equipped to decide who is guilty of what. This is particularly the case when he is dealing with people whose lives — whose needs and drives and views of the permissible — differ vastly from his own.

"It is hard to believe," Adele said, "that the Dwaine we meet in his journal and letters and whom we see through Ellen's eyes did the things of which Veronica accuses him. But having heard her — while she may have been confused about years and bathing suits and where semen was deposited — while she may have wandered lost in a cocaine fog and rolled in depravity's bed — it is hard not to believe he did do something. Incest is never a good idea, your Incas be damned; and if he molested her, the law — and she — demand his punishment. But even if he was a molester, he was so much more. He was smart and talented; he was sweet and caring and giving. But as he well knew, even if he did not abuse Veronica in the ways she said, he *had* abused her when he had walked out on her. And fondling her, drunk or sober, even treating her as a beautiful adornment was abusing her."

She looked out the window, through the afternoon haze, at the San Gabriels. "But she was also, I believe — hard as it is to think — deplorable as it is to utter — a willing participant. He was, she said, her 'God.' She says that even about the times she says the sex was as frequent as the evening news. She forgets how much she thought, 'I'll do what he wants, and it will earn me the love and attention I crave.' It was no big deal because she

already believed that was what her body was for. Sometimes I think people like him and people like her may not even know what incest is — or maybe it is people like you and I who don't. Incest may be just a crime people like us lay out for others to run afoul of, to service our own needs and defray our fears. It may be just a word into which a jumble of acts, performed under an assortment of circumstances, have been crammed, as into a madman's closet, without a logic or discernment or particularization that would allow rational benefit to be withdrawn upon a re-opening of the door. And just when I think that, I think she made the whole thing up; and I am sick."

From the CD player, Kirsty MacColl was calling Shane MacGowan "a bum" and "a punk," and Shane was calling Kirsty an "old slut and drunk." "Fairytale of New York": A love song, in its fashion.

"It's okay," I said. "Look at it logically. Forget what we don't know. Concentrate on what we do. Dwaine fathered Veronica. Dwaine left her with Charlotte. The Veronica that resulted was the drug-riddled, sex-riddled Veronica that delivered him to prison. If Veronica was lying — if he did that and no more — if nothing happened on any of their shared beds — does he not still bear some culpability for loosing her, so-flawed, upon the planet? Didn't his punishment fit that crime? He did to her, and she did to him; and as Baba Ram Dass almost said, what came out of it was what came out of it. True, legislators have never made parents criminally liable for damaging their children in this manner, but that may be an oversight occasioned by too many legislators having too many children for whose acts they do not wish to be accountable. There is no God or natural law-commanded absolute that says people should not be punished for acts of their children as they are, say, for those of their pit bulls. Here, the 'crimes' that Dwaine committed squarely resulted in the creation that did him in. And I'm not talking about Chester."

"People with starts like theirs…" Adele said and paused. A sixteen-wheeler on our left, hauling hogs to the yard, threatened to suck our vehicle beneath its belly. "People like Dwaine and Veronica must have elements festering within them that, no matter how good things become, can, at any time, destroy them. It may be cocaine. It may be indiscriminate sex. It may be stepping over the next available line. I feel sad for them both, whether it happened or it didn't. But he got jail, and it didn't kill him; and he came out to find five years of love with the best woman in his life. And Veronica survived

ten more years of horror to find a life of dignity and purpose. In a way, this is a story of the triumph of the human spirit.

"It's inspirational in its way."

Some, more mystically developed than I, speak of this dance of life. Surrender, they propose, to its rhythm; achieve harmony and totality of being. I am more inclined to hear a melodic waltz begin — then the first balcony collapse upon the string section. The band strikes a hearty march; a passing condor lobs a watermelon into the tuba's bell. It is — life is, to me — a murky pool in which our many nerved-lines dangle, pulling to the surface for our contemplation — we never know which; we never know when; we never know what. Dwaine, Adele said on another occasion, should have understood whatever love Veronica had for him could turn swiftly and deeply to hate, because he'd loved his mother once and hated her since. But like all of us, he couldn't look backwards one generation and forwards into the next and predict its outcome with accuracy. We all think we are doing things differently — undetermined, unlimited, freed by our own intelligence and insightfulness and generosity of spirit — but that is rarely the case. Dwaine tried to woo and craft Veronica into an excellence of his own design — either with words of praise and trips to Disneyland or with his tongue and member — rather than to ignore and berate her; but it came too late to come to any more than the same thing.

Ellen Tinsley hoped that I would exonerate her husband. Veronica wished me to eviscerate him. I have sat in courtrooms for three decades and heard my clients swear convincingly that events happened, while other witnesses swore just as convincingly they did not. In my cases, these disagreements have concerned falls from ladders or down stairs or the slippage from truck beds of pieces of heavy equipment, events which seem insignificant compared to five years of a father's sexual abuses; but the dilemma they present is of a kind for people who wish to believe the world of human behavior is knowable beyond a reasonable doubt or even through a preponderance of evidence. Sometimes, I think, it is not knowable at all. Well, one and one are usually two. Most dropped rocks do fall. But beyond that...?

In Berkeley, we live in a house on a hill that straddles the Hayward fault. In 1991, we exhausted our savings replacing our foundation. Seismic shift-

ing had so weakened it, our walls shook when a bus passed by. "Do we have to stand so close?" an engineer had asked, surveying our problem from the adjoining pavement.

In our living room is a redwood table I purchased my first year in Berkeley from a fellow I had known in Philadelphia when I was in law school. Pumps, an all-Suburban I long jumper, had been expelled from Villanova for stealing a safe, an incident which, when reflected upon, had produced my first published short story, as well as the novel that followed from that. At the time I bought the table, Pumps lived in the Santa Cruz mountains and came to Berkeley weekends to sell his work from the sidewalk on Telegraph Avenue. A year or two later, he fell to his death from a cliff in the mountains on his way home from a bar.

On this table of Pumps's is a catalogue from a Jonathan Borofsky exhibit Adele and I attended in 1985. We set the catalogue down then and have not opened it since. Beyond the table is an orange sofa purchased from Fraser's, a store once prominent on Telley but now as terminally absent as Pumps. Beyond the sofa are drapes we have not changed since we took possession of our house. I mention this to note that the replacement of drapes, the shelving of books have never been high on any "To Do" list that we maintain. I mention this, too, because beyond the drapes and the floor-to-ceiling window, whose view they do not block, are the bay and the bridges and the horizon which, at certain sunsets, creases the black and blue with violet and crimson, rose and gold, pink and blood orange — no combination of which you ever see again. There is not a week that goes by that I am not struck by the luck and wonder of living in a house that possesses such a view.

I lay a hand on each of Adele's shoulders. I look into the distance, holding on.

Only two people know what happened between Dwaine and Veronica, and one of those is dead. The rest of us render our verdicts — make our determinations, our guesses — as we make all decisions in our lives. We calculate from private graphs and tables, consult internal charts, utter silent incantations, whisper secret oaths and prayers, read tea leaves and entrails and chicken-bone castings of our own devise. Then we turn thumbs up or down, write the check or skip the charitable contribution, pick the phone from the cradle or ignore the ring, step left or right or not at all. We never

know where our foot will land or at what moment the ground beneath that landing will decide to crumble all things in its vicinity down.

In his journal, Dwaine had written about his never-acted upon collection of *noir* drawings: "[W]e're all private eyes peeking in on other people's lives." He wanted his viewers to make up their own connectives, create their own narratives, reach their own climaxes. People, he believed, should not care what he meant by what he had set before them. They should care what they made of it. Why, they should ask themselves, had they made these choices? Why had they come to their conclusions? What did *they* want his leaving to means? It is an axiom of at least one school of critical thought that the finest art always forces such resolutions upon its audience.

"Writers," Joan Didion famously said, "are always selling somebody out." Would that ending absolve me?

ACKNOWLEDGEMENTS

I could not have written this book without the help of Ellen Tinsley. I am most appreciative of the help she provided and the trust she showed in allowing me to tell Dwaine's story. She wishes it known that his work is available for purchase at rfalcoa@cox.net. I am happy to oblige.

Doug McNealy and "Charlotte Lambert" helped reconstruct Dwaine's Richmond years. Dan Collins, George Trosley and John Billette provided insights into Dwaine's art — and what working at *Hustler* was like. Bill Nichols supplied details of Dwaine's years at CMC-East. (Dwaine's letters to and from John Billette were a major source of information about this period as well.) The Hon. George Eskin, Det. Gary Galloway, Vanessa Place, Robert Riendeau, Albert Gonelli, Roy Sherman, Amy Adler, Victor Vieth, and Alan MacDonnell were kind enough to share their thoughts and recollections about Dwaine, his case and life. I am grateful to them all.

Chris Parise helped me locate people and my old friend Larry Greenberg documents. Peggy Yost, Court Program Manager for Ventura County Superior Court, and Alan Langville and the staff at the Foster Public Library in Ventura helped fill holes in my research. Adam Grano perfectly realized the sensibility of this book with his superb graphic-design skills. Kristy Valenti did a bang-up job as my editor and Rebecca Bowen was her usual amazing self as a proofreader/stylistic consultant. (The overwrought sentences that remain are over their loud protests.) Mark Kimmel, PhD, helped with psychological issues, Ann Ma with matters of criminal procedure, and Richard Weber those of theology. Sarah at the Crown Plaza Hotel made Adele's and

my stay in Ventura especially pleasurable.

Adele's intelligence, wisdom, humor, sharp eye and ear were indispensable to this book's realization. And they don't begin to compare to what her love and support along these twisty roads provided. Like all journeys, some of it was fun and some was painful — and her companionship made the better best and soothed the other's sting.

Matthew Hardy refused to speak to me because, as he put it, Dwaine now "stood innocent in the eyes of the law," a judgment he did not share but did not wish to challenge. That was too bad, but I believe others made the case for the prosecution well. "Debbie" Tinsley's silence was not a major problem in one regard, since I had her trial testimony and copies of letters she wrote to the probation department and others about the case to draw from; but I would have liked to know more about her personal life with Dwaine. (Some have speculated that she divorced Dwaine — and would not speak to me — because she had come to believe in his guilt. Certainly, the first part of this speculation is hard to credit, since she did not resist his gaining custody of their two daughters.) Why no one in management at Larry Flynt Publications would agree to be interviewed is puzzling. Was it because they did not know me and did not trust me to tell Dwaine's story in a way that would properly honor him? Did they believe him guilty and not wish to be stained by my calling attention to their former association? About the only thing of which I can be certain is that it was not because they were shy about publicity.

I am, of course, deeply grateful to "Veronica," who had the courage to talk to me about the painful times of her life. When I had decided to alter people's names, I had offered her the chance to pick her own. When she told me her choice, my first association was to that whole Archie Andrews/ Riverdale scene. Cool, I thought. Irony. Then Adele reminded me "Veronica" was also the title of a song by Elvis Costello. It begins:

Is it all in that pretty little head of yours?
What goes on in that place in the dark?

Sometimes, the world is too weird.

PARTIAL BIBLIOGRAPHY

Acocella, Joan. *Creating Hysteria: Women and Multiple Personality Disorder*. Jossey-Bass Publishers. 1999.

Armstrong, Louise. *Rocking the Cradle of Sexual Politics: What Happened When Women Said Incest*. Addison-Wesley Publishing Company. 1994.

Buchbinder, David. "Drawing Ire in Pain and Ink," *Hustler*. July 2001.

Bureau of the Census. *1990 Census of Population and Housing. Population and Housing Characteristics for Census Tracts and Block Numbering Areas: Oxnard-Ventura, CA. PMSA*. 1993.

Burnham, Walter Dean. *The Current Crisis in American Politics*. Oxford University Press. 1982.

Continuing Education of the Bar. *California Criminal Law: Practice and Procedure*. 2005.

Craven, Thomas, ed. *Cartoon Cavalcade*. Simon and Schuster. 1943.

DeMause, Lloyd. "The Universality of Incest." *Journal of Psychology*. 1991

Dines, Gail. "King Kong and the White Woman: Hustler Magazine and the Demonization of Black Masculinity," *Journal of Violence Against Women*. Vol. 4 No. 3 (1988).

Downs, Donald Alexander. *The New Politics of Pornography*. University of Chicago Press. 1980.

Flynt, Larry. *An Unseemly Man: My Life as Pornographer, Pundit, and Social Outcast*. Dove Books. 1996.

Frum, David. *How We Got Here: The 70's: The Decade that Brought You Modern Life (For Better or Worse)*. Basic Books. 2000.

Garrison, Arthur H. "Child Sexual Abuse Accommodation Syndrome: Issues of Admissibility in Criminal Trials." Vol. 10 *Institute for Psychological Therapies* (on-line). 1998.

Gross, Samuel R. "Make Believe: The Rules Excluding Evidence of Character and Liability Insurance." 49 Hast. L.J. 843 (1998).

Hechler, David. *The Battle and the Backlash: The Child Sexual Abuse War.* Lexington Books. 1988.

Heidenry, John. *What Wild Ecstasy: The Rise and Fall of the Sexual Revolution.* Simon & Schuster. 1997.

Hendra, Tony. *Going Too Far: The Rise and Demise of Sick, Gross, Black, Sophomoric, Weirdo, Pinko, Anarchistic, Underground, Anti-Establishment Humor.* Doubleday. 1987.

Herman, Judith Lewis. *Father-Daughter Incest.* Harvard University Press. 1981.

Horstman, Barry M. "Larry Flynt: He Built an Empire as the Barnum of Smut." Cincinnati *Post.* Nov. 12, 1999.

Kelly, Sean and Weidman, Dean, ed. *Cartoons Even We Wouldn't Dare Print.* National Lampoon, Inc. 1979.

Kipnis, Laura. *Bound and Gagged: Pornography and the Politics of Fantasy in America.* Duke University Press. 1999.

Lederer, Laura, ed. *Take Back the Night: Women on Pornography.* William Morrow and Co. 1980.

Lee, Judith Yaross. *Defining* New Yorker *Humor.* University Press of Mississippi. 2000.

Leonard, David P. "The Perilous Task of Rethinking the Character Evidence Ban." 49 Hast. L.J. 835 (1998).

Levine, Judith. *Harmful to Minors: The Perils of Protecting Children from Sex.* University of Minnesota Press. 2002.

MacDonnell, Allan. *Prisoner of X: 20 Years in the Hole at* Hustler *Magazine.* Feral House. 2006.

Mayer, Adele. *Incest: A Treatment Manual for Therapy with Victims, Spouses and Offenders.* Learning Publications, Inc. 1983

McCormick, Charles T. *Evidence.* West Publishing Co. 1954.

Mendez, Miguel A. "Character Evidence Reconsidered." 49 Hast. L.J. 871 (1998).

Myers, John E.B. *A History of Child Protection in America.* Xlibris. 2004.

Ofshay, Richard and Waters, Ethan. *Making Monsters: False Memories, Psychotherapy, and Sexual Hysteria*. Charles Scribner's Sons. 1994.

Orenstein, Aviva. "No Bad Men! A Feminist Analysis of Character Evidence in Rape Trials." 49 Hast. L.J. 663 (1998).

Reisman, Judith. *Images of Children, Crime and Violence in Playboy, Penthouse and Hustler Magazines* (Executive Summary). United States Department of Justice. 1987.

_____. Volume I . Huntington House, Inc. 1990.

Renvoize, Jean. *Incest: A Family Pattern*. Routledge & Kegan Paul. 1982.

Russell, Diana E. H. "The People vs. Larry Flynt: A Feminist Critique and Protest." (1998). Posted at HustlingtheLeft.com.

_____ *The Secret Trauma: Incest in the Lives of Girls and Women*. Basic Books. 1986.

Salter, Anna C, *Predators: Pedophiles, Rapists, and Other Sex Offenders: Who They Are, How They Operate, and How We Can Protect Ourselves and Our Children*. Basic Books. 2003.

Santiago, Roberto. "The Funny Shot." Clipping from unidentified magazine. April 3-10, 1997.

Schulman, Bruce J. *The Seventies: The Great Shift in American, Culture, Society, and Politics*. The Free Press. 2001.

Spigot. "Chester the Molester Sequestered," Gapingmaw.com. Undated.

Smolla, Rodney A. *Jerry Fallwell v. Larry Flynt: The First Amendment on Trial*. St. Martin's Press. 1988.

Steinem, Gloria. "Hollywood Cleans up *Hustler*." *New York Times*. Jan. 9, 1997.

Tillers, Peter. "What is Wrong with Character Evidence." 49 Hast. L.J. 781 (1998)

Tinsley, Dwaine. Hustler *Presents the Best of Tinsley*. Larry Flynt Publications. 1979.

_____. Hustler *Presents the Best of Tinsley No. 2*. Larry Flynt Publications. 1986.

_____, ed. Hustler: *Two Decades of Our Best Cartoons*. Larry Flynt Publications. 1996.

Tinsley, Ellen. "Dwaine B. Tinsley: America's Most Outrageous Cartoonist." Unpublished.

Topliss, Iain. *The Comic Worlds of Peter Arno, William Steig, Charles Addams and Saul Steinberg*. The John Hopkins University Press. 2005.

Vieth, Victor I. "Unto the Third Generation: A Call to End Child Abuse in the United States Within 120 Years," *Journal of Aggression, Maltreatment & Trauma*. 2004

_____. "In My Neighbor's House: A Proposal to Address Child Abuse in Rural America," *Hamline Law Review*. Vol. 22, p143. 1998.

Wald, Michael. "State Intervention on the Behalf of 'Neglected' Children: A Search for Realistic Standards," *Stanford Law Review*. Vol. 27, p. 985. 1975.

Wright, Laurence. *Remembering Satan*. Alfred A. Knopf. 1994

Zurchner, Jr., Louis A. and Kirkpatrick, R. George. *Citizens for Decency: Antipornography Crusades as Status Defense*. University of Texas Press. 1976.